WHAT IT TAKES TO BE AN ENTREPRENEUR

Leon Presser

First edition

ISBN: 978-0-615-32190-5

Library of Congress Control Number: 2009909422

Published by Resserp Publishing
www.whatittakestobeanentrepreneur.com

Distributed by SCB Distributors
www.scbdistributors.com

**TO MY FATHER AND MOTHER
Nuñe and Raquel**

Whatever I have accomplished in life I owe to them.

TABLE OF CONTENTS

ACKNOWLEDGEMENTS

The idea for this book came from many informal discussions with young people who wanted to start their own business. Whether they came to me in search of funding, or whether I encountered them in universities when I spoke to student groups, their question was always the same: *What can I read to obtain a pragmatic overview of what is involved in being an entrepreneur?*

That was the same question I had when I started my own company. I did not have a satisfactory answer then, and I had not found one by the time this next generation of entrepreneurs was looking to me for the answer.

I mentioned this serious need to my two daughters who are enterprising in their own right. My younger daughter, a lawyer who works with investors and entrepreneurs, prodded me until I agreed to write this book. My older daughter, a physician who felt that professionals should have a better understanding of business issues, then took over and encouraged me until I finished it.

Throughout this process my wife provided the environment and support that made it possible, as she has done with every project I have undertaken since we married.

My brother (and business partner) also encouraged me to complete the book.

As my life has evolved, a number of people have extended a generous mentoring hand. In particular, I am grateful to Harry Schrage, Burt Cohn, Richard Perrin, Gerald Estrin and Michael Melkanoff. They each had a positive impact on my life. I hope this book represents another link in the mentoring chain.

I am thankful to Rich Hug who was at my side as we faced many business challenges and to all those employees without whose support and dedication I would not have succeeded in business.

A number of individuals read the manuscript and provided invaluable suggestions. They included successful entrepreneurs, lawyers, accountants, money managers, venture capitalists, a banker, a motivational speaker, marketing professionals, authors, professors

and students. Any biases as well as any mistakes of commission or omission that may remain are solely mine.

I am grateful to Harvey Barish, Ed Bersoff, Eric Boehm, David Cygielman, Mike Dwyer, Don Engel, Judy Engel, Abe Glatzer, Irwin Gross, Walt Harasty, Gerald Harter, Jean Horton, Naum Lusky, Lee Maliniak, John Markel, Barbara Mintzer, Deborah Naish, Laura Nixon, Abe Presser, Anita Presser, Beth Presser, Liza Presser Belkin, Josh Rabinowitz, Bernardo Saruski, Michael Schmidtchen, Jaime Suchlicki, Claude Vidal, and Steve Worzman. Thank you to Phyllis Amerikaner and Kendall Lynch for their editorial comments and advice.

I apologize to all those whose names I have not mentioned, and to those who helped me along the way, although I may not have realized it.

Santa Barbara, California

PREFACE

ABOUT THE AUTHOR

The author is an experienced and successful entrepreneur, a self-made man who has lived his educational and business dreams, and who has savored every moment of his journey.

The book is written in a frank and informal style, replete with personal business stories that make it easy to understand the relevance of the issues being discussed.

Leon Presser obtained a B.S. degree in Electrical Engineering from the University of Illinois in 1961. He then moved to Los Angeles, California, and went to work in the nascent computer industry as a computer designer. At the same time, he pursued a master's degree in Electrical Engineering (Computer Science), which he received from the University of Southern California in 1964. At that time he joined the computer research group at the University of California at Los Angeles (UCLA), where he simultaneously commenced his studies for a Ph.D. in Computer Science, which he received in 1968.

In 1968, he joined the Computer Science faculty at UCLA. In 1969, he moved to the Engineering faculty at the University of California at Santa Barbara (UCSB), where he was responsible for the initial development of its Computer Science program. He remained at UCSB until 1976.

In 1972, he co-edited and co-authored one of the first books on computer science [Card 72]*.

While at UCSB, he founded and led a research group working on software development methodologies and tools. During this time he also served as a consultant to the United States government and to industry. By 1976, he had published over thirty research papers in the software field, and he had organized and participated in a

* This is the format of the abbreviation that will be employed throughout the book to cite references.

number of national and international conferences on software. He also served as National Lecturer on Computer Operating Systems for the Association for Computing Machinery. He was the editor of the Institute of Electrical and Electronics Engineers 1976 Special Issue on Computer Operating Systems.

In 1977, Presser founded Softool Corporation, a software products company based in Santa Barbara, California. Softool was dedicated to the creation and marketing of software tools. Besides a presence throughout the United States, Softool owned subsidiaries in Great Britain, France, Germany and Italy.

In 1989, L. William Seidman and Steven L. Skancke wrote a book entitled *Productivity: the American Advantage* [Seid 89] in which they selected fifty U.S. companies and discussed how they were regaining the competitive edge for the United States. Softool was one of the selected companies.

Among other product lines, Softool created and marketed a family of software tools to manage change. These change management tools led to the creation of a whole new segment of products in the software industry. Softool was sold in 1995.

In 1987, Presser co-founded Compass Corporation, a software services company based in Vienna, Virginia. After rapid growth, Compass was sold in 1990.

In March 1989 *Software Magazine* published a special issue listing Presser as one of the 100 people who have had the greatest impact on the software industry [Soft 89].

In July of 1992 Presser was honored at the White House by President George H. W. Bush as one of a group of outstanding Hispanic leaders in the United States.

Presser has been, and continues to be, an investor in a number of start-ups in different industries.

Presser has written this book to provide prospective and current entrepreneurs with a pragmatic overview of what is involved in being an entrepreneur and to help them improve their chances of success.

Currently, Presser lives in semi-retirement, actively involved in various community activities.

CHAPTER 1

INTRODUCTION

WHO IS THE AUDIENCE FOR THIS BOOK?

This book is intended for those who would like to start and develop their own business, or who have already started their own business and welcome the practical guidance of an experienced mentor.

The material covered here applies whether your objective is to create a small home-based business or a large multinational corporation. Many large corporations began as small businesses; however, the book is written for those individuals whose goal is to create a business of substantial value and in particular, a business that sells products.

This book can also be used as the foundation for a course in entrepreneurial training. A section with exercises is included at the end of the book.

WHAT IS THIS BOOK ABOUT?

When I created my first company, I was apprehensive to say the least. I had no business experience. Although I had some ideas, I did not know what to expect or how to deal with employees, lawyers, accountants, consultants, government entities, bankers, potential investors, competitors, salespeople, landlords, and many others who became part of my daily business life.

I felt I was on a trajectory toward my destination. In order to reach that destination, I had to travel through an unknown city. As I turned every corner, I did not know what to expect. Would I encounter a friendly group of people who would invite me for a nice home-cooked meal? Or would I encounter a monster that would devour me? The worst part of the trip was that I did not know what I would find when I turned a corner, and consequently I did not know

how to prepare. How I wished that I could have had a map to guide me in my journey!

This book represents such a map and will serve as a navigational guide providing an overview of the issues, the challenges, the people, and the risks you will face. It will also make you well aware of the rewards you will obtain if you succeed.

After you read this book, you will have a good idea of what to expect during your trajectory, at each corner, before you make the turn. You will be able to prepare for different eventualities.

You must be clear on a critical point before you continue reading. Notwithstanding the existence of a multitude of books on how to become a successful business person or of tests that will predict whether or not you will triumph, there is no formula for success and there is no psychological test you can take that will provide the answers you seek. **What you can do is to learn from the successes and the mistakes of others who have traveled the path ahead of you.** Take note of what successful people did right. Learn from the experiences of those who reached their destination and who then asked themselves, "What could I have done differently to get here faster, more effectively, and with a greater degree of success?"

That is what this book is all about.

This book is not based on research, and it is not based on surveys. It is based on the author's experiences, observations and opinions gained through his business journeys, as well as on those of others he met along the way.

DO YOU HAVE WHAT IT TAKES TO COMPLETE YOUR PERSONAL BUSINESS JOURNEY?

Only you can answer that question.

The facts are that we each have our strengths and our weaknesses. The challenge for each one of us is to understand what we do well and accept where we need help. The intelligent person builds on strengths, minimizes his/her dependency on weaknesses,

and finds ways to change weaknesses into strengths. The fool does not recognize his/her weaknesses and eventually fails.

This book will provide you with a good understanding of what is required for success in your personal journey—of the opportunities, the tribulations, the time frames, the risks and the potential rewards. In the process, you will identify a number of key questions you will need to answer in order to decide whether or not you have what it takes to succeed. But you must be fair to yourself. This is a very important decision that you must make standing on a foundation of pragmatic and pertinent information.

This book will provide that information for you.

WHAT WILL YOUR REWARDS BE IF YOU SUCCEED?

If you succeed, you will have:
- secured your financial future for yourself and your family
- created job opportunities for many others
- created or advanced a new field or business area
- made contributions to your community and society at large
- contributed to your country's position of leadership
- become a respected member of your community

Entrepreneurs are the engines of our economy. They create the majority of new jobs, not the large established corporations.

The personal satisfaction that comes with entrepreneurial success is exhilarating.

I sincerely hope this book serves its purpose for you.

CHAPTER 2

WHO IS AN ENTREPRENEUR?

AN OVERVIEW

In this chapter I outline and discuss the personal characteristics that distinguish an entrepreneur from others. These are the traits that make an individual successful in identifying, creating, and growing a new business.

BACKGROUND

In the last one hundred years we have witnessed incredible transformations in our world. We transitioned from an agricultural society to an industrial one. Then, in the last fifty years or so we have transitioned to an information-driven society. In the last twenty-five years we have seen the Internet, and the ease of access to it, permeate every aspect of our lives. The number of computers in use around the world that are connected to the Internet is approaching the one billion mark [Gate 06]!

The Internet has had another profound effect on our culture. It offered, and continues to offer, many opportunities for individuals to create new businesses. Consequently, a substantial number of visionaries not only have given birth to large enterprises but have also amassed impressive personal fortunes in the process. Their successes have received much publicity, and deservedly so.

A good example of the result of these events can be seen by examining the mind-set of college students. It was not long ago that if you asked a college student what his/her plans were after graduation, the answer given by the overwhelming majority would have been to find a position in a large corporation. Today, when you ask the same question, many say they would like to start their own business. They want to be one of the visionaries, one of those people we call entrepreneurs.

In a thought provoking article in *The Wall Street Journal*, M. Malone [Mal1 08], postulates that the United States is currently going through another transformation: it is becoming the world's first Entrepreneurial Nation!

The purpose of this chapter is to examine in some detail what makes an entrepreneur.

ENTREPRENEUR

Webster's New Collegiate Dictionary defines *entrepreneur* as "the person who organizes, manages and assumes the risks of a business enterprise."

This is a business-centered definition. Many impressive individuals fall outside of this definition. For example, a physician who works for a medical center and develops new surgical techniques, a lawyer who is employed by a law firm and brings in a large number of profitable clients, or a physicist who teaches at a university and develops a new device are not entrepreneurs in the sense that I use this term. They become entrepreneurs when they create a business enterprise. There is no question that such distinguished people took major risks in their careers in order to meet their goals. However, I wish to make the distinction here that it is the business dimension that makes one an entrepreneur.

An entrepreneur has a vision of what his/her business opportunity is. Later on I will discuss the vision and how it evolves.

CHARACTERISTICS OF AN ENTREPRENEUR

There has been much written about what makes a successful entrepreneur. What follows is based on my personal experiences, observations, and opinions on some basic characteristics that distinguish an entrepreneur from others. This list is neither exhaustive nor presented in order of importance. The implication here is not that every entrepreneur has all of these characteristics but that these seventeen characteristics are typical of an entrepreneur.

1. ABSOLUTE NECESSITY TO BE THE MASTER OF YOUR DESTINY

Although you may have been working for others for years and advancing within a company or institution, you have a strong belief that you need to create your own business and be your own boss. You are disappointed with yourself when you have to be physically present at work when you feel it is not necessary. Or you are frustrated when you work on a project or in a direction that you feel is a waste of effort, particularly when you have a good idea of what should be done instead. *You must be the master of your destiny.*

The following story offers a good example.

The nurse

Some time ago I met an entrepreneurial young woman who was trained as a nurse and as an ultrasound technician. She told me that a few years earlier she was working in a physician's office performing ultrasounds on expectant mothers. She was treated as a professional and was making a decent salary. The office was a busy place, and she often worked long hours. This was not a problem for her because she enjoyed her work. However, she told me she was extremely unhappy with the fact that others decided what she would do and when she would do it. She had an unbridled desire to become her own boss and be the master of her destiny.

She wanted to find an opportunity that would allow her to utilize her background while achieving her goals of financial and personal independence. The challenge she faced was that all her experience was in the medical arena, and she was not a physician. Well, here is what she came up with.

She approached a large maternity shop in her city. She proposed to the owner of the store that she install an ultrasound machine in the store to provide a prenatal portrait of the fetus to an expectant mother. Further, if the expectant mother returned at various times during her pregnancy she would at the end of her pregnancy receive a video showing the development of the fetus.

The store owner loved the proposal. They entered into an agreement. In essence, the store offered a free ultrasound to every client that made a certain minimum purchase from the store. In turn,

the store owner paid this young nurse a percentage of the associated sales.

She resigned from her job at the physician's office and concentrated on her new business.

Her cost of running this business was minimal, and within a few months she was making more money than ever before. She had accomplished her goal: *she now was the master of her destiny.*

Eventually, the United States Food and Drug Administration and the American College of Radiology took the position that fetal ultrasound should be performed only for medical purposes with a prescription from an appropriately licensed provider. Consequently, she decided to terminate this business and moved on to other successful entrepreneurial activities.

2. STRONG SELF-CONFIDENCE

You believe in yourself. You know what you are capable of accomplishing. You are not afraid to act on your convictions. Negative comments by others are of little consequence. In fact, most entrepreneurs are at one point or another in their trajectory the subject of ridicule or jokes. In my own experience, it happened several times.

The following stories emphasize this issue in real-life contexts.

The laugh

Early in my career, I was having dinner with someone I considered a friend. When I confided to him that I was preparing to start my own company, this individual (who was not an entrepreneur) giggled and remarked to me, "YOU are going to start a company? Ha, ha! Good luck!" His comments did not bother me. I felt confident in what I was doing.

The turkeys

Another incident occurred in late December, when my company was in its early stages. I employed six people, had no revenues, and was very tight on cash. Although my employees were paid a competitive salary, I was not drawing a salary. Recognizing the

custom of providing some sort of a bonus to my employees at that time of the year, I gathered my group together and explained that it was too early in our business evolution to provide a cash bonus. I emphasized that I certainly expected that the next year we would be in a position to provide cash bonuses, depending on profits and on each employee's contribution. Nevertheless, I wanted to make sure everyone understood that I truly appreciated their efforts. As a token bonus I had ordered six turkeys and gave one to each person. My employees, who were an excellent group, understood the situation and had no problems with it.

A few days later, while attending a social gathering, someone (who was not an entrepreneur) mentioned rather loudly that he had learned that we gave turkeys as bonuses in our company. Then he laughed sarcastically. His derision did not bother me.

The aptitude test

There is another pertinent story to tell here. In 1961 I graduated from the University of Illinois with a bachelor's degree in Electrical Engineering, but in fact my training was in what is now called Computer Science. I moved to Los Angeles after graduation, in need of a job.

At that time, International Business Machines (IBM) was the overwhelming power in computers. They were looking for people to hire, and I went to the IBM office in Los Angeles for an interview. After meeting a polite recruiter, he told me that as part of the interview process I was required to take an aptitude test they had created to determine if computers were an area of work appropriate for my talents. I took the test and then went back to meet with the interviewer. He informed me that the results of their test showed I had no talent for the computer field, and he suggested that I look for another area of work. We shook hands and I left.

I had full confidence in what I was capable of doing, and I not only felt comfortable in the computer field, I loved it. I simply disregarded this event and went on with my life.

Moving the clock forward to 1968, I had earned a Ph.D. in Computer Science, had written a number of research papers in the

field, and was part of the UCLA Computer Research group. This group was becoming world renowned for its pioneering work, including some of the early contributions to the creation of the Internet.

IBM had a recruiter dedicated to recruiting UCLA graduates with advanced degrees in Computer Science. I interviewed with IBM anew. This time I was flown, first class, to a number of IBM facilities around the country to meet with different IBM managers. I received an outstanding offer of employment with a choice of locations and jobs. The most enticing and challenging one was to move to New York to take responsibility for the design and development of a major component of the IBM 360 Operating System, which was then under development. The 360 effort was the largest software effort IBM had ever undertaken, and one of great importance to the corporation.

It was ironic that the same company that had told me seven years earlier I was not qualified to work for them was now offering me a choice of opportunities. It felt good. I turned down the offer, not because of any ill feelings, but simply because I was already planning my entrepreneurial journey. Besides, I loved California and did not want to leave it.

The boss's opinion

A friend of mine, a highly successful entrepreneur, told me the following story.

From a young age, he wanted to have his own business, but he had not figured out how to do it. After graduation from the university, he joined a middle-sized company. He quickly progressed through the ranks until he became a member of the senior management team. Not long after that, the president of the company confided in him that he was planning to retire in the near future, and he believed that my friend was the right person to succeed him. My friend was excited.

Later that year the president called him to his office and told him that he had changed his mind and was going to be handing the reins of the company to someone else. He explained that although he felt

that my friend was an excellent project manager, he did not believe that my friend had what was required to be a company president. My friend was confident that he could run a company and disregarding the president's comments, he decided to leave and start his own company. His company became very successful.

Postscript to the story. While my friend's company thrived, his former employer went out of business not long after he left.

Psychologists employ the term 'self-efficacy' to refer to the belief some people possess that they have what it takes to succeed [Band 94]. In an excellent short article in *The Wall Street Journal* [Beck 08], Melinda Beck, discusses self-efficacy. She lists some interesting examples of highly successful people who display strong confidence in their capabilities. These examples include:

- Julie Andrews took a screen test for MGM studios when she was 12 years old. MGM determined at the time that, "She's not photogenic enough for film."
- J. K. Rowling's book about a boy wizard was rejected by 12 publishers before a small London publisher picked up "Harry Potter and the Philosopher's Stone."
- Decca Records turned down a contract with the Beatles, saying, "We don't like their sound."
- Walt Disney was fired by a newspaper editor who said he "lacked imagination."
- Steve Jobs and Steve Wozniak were rebuffed by Atari Inc. (a leading personal computer manufacturer at the time) and Hewlett-Packard Co. when they tried to sell an early Apple computer.

These examples not only illustrate the exceptional self-confidence that highly successful people have, it also illustrates the poor common sense others in positions of power can have.

3. ABILITY TO SEE WHAT OTHERS DO NOT SEE

This is a most important characteristic. Frankly, I believe that it is a birth gift. You either have it or you do not. Moreover, you may possess it in different degrees.

Opportunities are passing us by all the time. It is what we recognize in the panorama that we see that makes the difference between someone who will be successful as an entrepreneur and someone who won't. **Entrepreneurs see a picture of opportunity with manageable risks.** Others viewing the same picture either do not recognize the opportunity, or they visualize a situation burdened with obstacles and insurmountable risks. A few short stories will be helpful.

Real estate

Real estate offers ubiquitous examples of entrepreneurial vision. How many times have you heard someone say something like this: "See that house over there? Today it is worth over a million dollars, but thirty years ago I could have bought it for $30,000." Well, why didn't they buy it thirty years ago? If you asked them, the answer would probably be, "I did not have the money." The fact is they probably could have borrowed the money even though they would have had to assume serious debt. Those who did are the successful entrepreneurs who own a fortune in real estate today. The point is that they both saw the same house. The entrepreneur recognized a great opportunity with manageable risk. The others could not see themselves in control of such a situation or only thought of great danger and risk. In many cases they walked by the house every day and never perceived a business opportunity.

Let me tell you about a personal story when I simply failed to see the opportunity. I realized this years later.

Restaurants

When I moved to Los Angeles after college graduation in 1961, it was a difficult economic time for me and my parents. We all lived

15

together in a small apartment, and I was eager to find a path to economic success.

Because I was deeply immersed in a high technology job, all my thinking and searching for business opportunities centered in high technology. More mundane opportunities were not of interest to me, and I never gave them any consideration.

Across the street from us lived a family who had recently emigrated from Cuba. They were wonderful, hardworking people. The young husband and wife both worked to pay the expenses for themselves and her parents, who lived with them. The older man was desperate to find a job, but at 65, he was told repeatedly he was too old.

Because the older man had been the head chef at one of the finest and better known restaurants in Havana, and because he was at home all the time, he often cooked and regaled us with some incredible dishes. There was no question about his culinary credentials. My taste buds were his best reference.

Now, here is the opportunity that was in front of me that I failed to see. Over time, Cuban restaurants became a great success in Southern California and elsewhere. Today, there is a chain of highly successful Cuban restaurants in the Los Angeles area. Besides providing seed money, finding the chef is the greatest challenge in opening a successful restaurant. I could have scraped together the seed money, and I knew a great chef who was desperate for work. Yet, at the time, I did not see the potential for a successful business.

The shoes

This is an anecdote I heard years ago.

One day the media reports that a new island has just been discovered in the Pacific Ocean. Amazingly, it is well populated. As a result, businesses become interested in expanding their operations to this island, particularly two of the world's largest shoe manufacturers.

Each of these manufacturers promptly sends a representative to the island to explore the opportunities for the sale of their shoes. The first representative realizes right away that the inhabitants of the

island do not wear shoes. He immediately contacts his head office and states, "What we have here is a population of natives who do not know what shoes are. There is no market here. I will be returning immediately."

The second representative also realizes that the natives do not wear shoes. She, however, reports back to her head office, "Tremendous opportunity. Virgin territory. Send reinforcements."

Two people observe the same panorama. Yet only one person sees the business opportunity.

The eye-opener

I once met an entrepreneurial young man who came from a family of successful professionals. His father and uncles were distinguished physicians and architects. He told me that when he would walk into a restaurant with his family, they would discuss the architecture of the building, any art that was displayed, or the vintage of the furniture.

In his early twenties, he was befriended by an entrepreneur who would walk with him into a restaurant and would see a totally different panorama from what his family would see. For example, the entrepreneur would comment that the restaurant appeared to be processing about fifty customers a night at an average tab of $30 per customer, or $1,500 per night. Then he would estimate that the take-out window was probably generating another $2,000 per night. Given the number of waiters and the location of the restaurant, their cost of doing business was probably about and so on. The young man told me this was an eye-opening experience for him. Again, the point here is that an entrepreneur and a non-entrepreneur, when presented with the same situation, will perceive totally different pictures.

4. COMMON SENSE

One of my father's favorite quotes was from Will Rogers, the early twentieth century American actor, commentator and philosopher. "Common sense is so uncommon." You see examples in everyday life.

In business, you are continually faced with the challenge of making decisions that can determine the fate of your company. You need to make logical decisions based on good common sense, without suicidal consequences.

An entrepreneur must possess sound, innate common sense.

Throughout the remainder of this book I will point out examples of good as well as poor common sense.

5. SETS HIGH GOALS

When you identify your vision, it had better be one with great potential. Successful entrepreneurs pursue major accomplishments. In a large majority of cases, although these entrepreneurs only achieve a fraction of their original goals, their original goals were so lofty that they are still very successful (of course, there are exceptions to those who meet only a fraction of their goals: cases in point are Oracle, Microsoft, Google, and Starbucks). Most of the time, however, successful entrepreneurs will achieve only a small percentage of their vision.

For example, your vision may be the creation of a wristwatch with unique characteristics that should appeal to the whole wide world of sports. If you multiply the number of people participating in sports by the estimated selling price for your wrist watch, you come up with a pretty substantial number. If you only penetrate 2% of that potential market, you will have a successful business, assuming you are selling your watches at a decent profit.

Let us look at my personal experience.

Software tools

I founded a company to provide tools to professional programmers for the creation of programs (i.e., software). Our target market was the staffs of large corporations or government agencies. Our tools were software that would run on our customers' computers. That is, we sold computer programs that were utilized to automate the software development process.

The software development process can be viewed as consisting of the following phases:

1. Determine the requirements of the software that is needed.
2. Design the software.
3. Carry out the actual programming.
4. Test the software.
5. Optimize the performance of the software.
6. Maintain the software (i.e., fix errors and enhance the functionality of the software).
7. Produce appropriate documentation throughout the previous phases.

Our original goal was to create and market a set of tools for each one of the phases of the software development process; this was a high goal indeed. Although we originally believed we could deliver on such a large undertaking, pragmatically we could not succeed in such an overwhelming endeavor. So, well after our company had become an established concern, we decided to focus on specific families of tools that had emerged as leading sellers. When we did, we ensured the survival of a successful enterprise.

6. NOT AFRAID TO MAKE DECISIONS

Life is a continual decision-making process. When you get up in the morning and decide what to wear that day, you make a series of decisions. When you sit down for breakfast and decide what to eat, you make decisions. These decisions have repercussions. All decisions do. For most people these are easy decisions to make and without wasting time, they make them and move on to the rest of their day. For many people, however, once they arrive at their jobs, they struggle with decisions such as having to tell their bosses they are behind on an assignment and need more time.

An entrepreneur, on the other hand, promptly evaluates the situation facing him/her at that moment and makes a decision.

A key point here is that an entrepreneur makes a decision with the information at his/her disposal at the time, feels confident that an

appropriate call has been made, and is prepared to live with the consequences of the decision. If additional information surfaces later on that indicates that the previous decision was not a good one, an entrepreneur does not hesitate to reassess his/her previous decision. An entrepreneur does not dwell on a problem. Entrepreneurs do not suffer from the analysis/paralysis syndrome.

Entrepreneurs are focused on success, not on being right.

The following story, which is extracted from an article that appeared in the magazine The Costco Connection, describes an entrepreneurial family with the courage to make timely decisions.

Baking your way to success [Jone 09]

In 1979, 24-year-old Andrew Ly arrived in the United States as an immigrant with $1 in his pocket. Over the next two years Andrew's parents and four brothers also made their way to the United States as new immigrants. All the members of the family went to work as kitchen assistants, dishwashers and newspaper carriers, lived very modestly and saved money for a future business. By 1984, five years after Andrew's arrival, they had managed to put together $40,000.

At this point in time they came across an opportunity to buy a little coffee shop that was not doing well. They made the decision to use their savings to buy it, and Sugar Bowl Bakery was born in the Richmond district of San Francisco.

Every member of the family pitched in to make the business a success. Part of the family worked at other jobs to make ends meet and moonlighted at the bakery.

By 1986, the shop had expanded its reach, selling not only to local customers but to convenience stores and other coffee shops and netting about $150,000 annually. At this time, they made another key decision to invest in a second bakery. In 1990, they expanded again, buying a third bakery.

In 1993, they began a frozen-dough division, complete with a fleet of trucks serving Las Vegas casinos as well as other businesses throughout Northern California. Subsequently, they expanded into packaged items for retailers such as Costco. Presently, the company

operations have grown into three plants. The business now serves about 90 percent of hospital pastry departments and 60 percent of hotels in the San Francisco Bay Area, as well as cafes, national warehouse clubs, major supermarket chains, retailers, restaurants and many other types of customers as far away as Japan, Korea and Mexico. Sugar Bowl Bakery has been the fastest-growing private company in the San Francisco Bay Area for 10 of the past 11 years. The small doughnut shop is now a $45 million company.

Discussing his business philosophy, Andrew stated "There is no substitute for hard work," and "Marketing opens the door, but quality keeps it open." He further stated "I'd rather sacrifice margin than sacrifice quality. You lose quality, you lose the faith of your customer."

It is relevant to note that the Lys consider their family and its values a key to their success. Further, it should be clear that this family is not afraid to make decisions when an opportunity arises.

7. WILL COMMIT

There is a classic story that says: when you make ham and eggs, the chicken is involved; the pig is committed. Entrepreneurs commit.

In my own case, everything I owned, including my home and my savings, was committed to the business.

A friend of mine, a successful entrepreneur, told me a wonderful story that illustrates the difference between involvement and commitment.

The vice president

A friend of mine had founded and was the president of a fast-growing software company that had over seventy-five employees at the time of this story.

A year earlier he had hired a vice president of research and development he had recruited from a large software company. It took a hefty compensation package to recruit this fellow. One morning this vice president walked into my friend's office and stated, "I believe that I am now a key executive in this company and

very important to its continued growth and success. Accordingly, I should be given a substantial percentage of ownership." My friend did not think this vice president was indispensable, but the man was doing a reasonable job, and he did not want to have to find a new vice president at that time.

Let me pause at this point in this story, and before you read on, ask yourself how you would have responded to this vice president if you were the president of the company.

-
-
-
-
-
-

Here is how my friend responded.

"You are right. You should become a substantial partner. As you should know, we have a bank line of credit that is being fully utilized. We could use a larger line of credit, but everything I own has already been signed over to the bank as collateral for our existing credit line. With you becoming a partner, we will be able to increase our credit line. First thing tomorrow morning, please bring me the deeds to your house, your boat, and your two cars as collateral for the bank."

My friend told me the vice president's face turned white as he said, "This is a decision I need to discuss with my wife."

My friend replied, "Of course. Do that and come back to my office tomorrow."

The next morning the vice president came to see my friend and said, "I have thought this through, and I have decided that I am happy with my current arrangement. I no longer wish to be a partner." My friend replaced him a few months later.

Besides illustrating the difference between involvement and commitment, this story also exemplifies the vice president's poor common sense.

8. DOES NOT RETREAT

Entrepreneurs are totally committed to success. They just do not give up. They do not retreat. When faced with a wall of fire, they somehow find a way through or around it. This does not mean they do not get knocked down. They do. The point is that they get up and keep going.

To be clear, this also does not mean that entrepreneurs are suicidal. When necessary they will adjust their plans, their time frames, or whatever else they decide must be modified to achieve their goals. But they will not give up.

9. PRIDE

Entrepreneurs tend to be proud people. They treat others with respect, and in return they like to be treated with respect. Since success breeds respect, bringing their goals to fruition is very important to them. Thus, they are self-driven and incredibly persistent in their efforts. On the other hand, their egos bruise easily.

Entrepreneurs tend to have very high standards. They only value the opinions of the few who have met the criteria they use to evaluate others and themselves.

10. WILLINGNESS TO ACCEPT RESPONSIBILITY

Entrepreneurs do not like to play the blaming game, and they do not participate in finger pointing. If something fails, it is their responsibility. Their attitude is to fix it and move on. They learn from the experience so they do not make the same mistake again. This does not mean, however, that they would not fire or disassociate themselves from people they consider incompetent. As good decision makers, they would do this rather promptly.

11. FOCUS

There is a well-known rule referred to as the 80/20 rule. According to Anderson [And1 06], this rule originated with Vilfredo Pareto who, in 1897, was studying patterns of wealth and income in nineteenth-century England. Pareto found that about 20 percent of the population owned 80 percent of the wealth. Since then, this

observation has received many interpretations. One is that 20% of the employees of a company do 80% of the work. Another is that 20% of the code in a computer program consumes 80% of the execution time. Another is that when faced with a collection of issues constituting a problem, 20% of those issues will represent 80% of the problem.

When confronted with challenges, entrepreneurs have the innate ability to zero in on that crucial 20%. Further, they can iterate to identify the 20% of the 20% of the 20%, until they have dealt with the crux of the problem and found a satisfactory solution.

12. INTENSE DISLIKE OF BUREAUCRACY AND BUREAUCRATS

Typically, entrepreneurs do not do well on committees, unless they feel that the committee in question can have an impact and that its members are not bureaucrats. Moreover, they do not have patience when dealing with bureaucrats who make mountains out of molehills.

When interviewing potential employees, entrepreneurs will promptly terminate an interview if they become convinced that the candidate is a bureaucrat. They know that employees who are bureaucratic will not survive long in an entrepreneurial environment.

As an example of how a bureaucratic employee behaves, consider the following story.

Bureaucracy in action

One afternoon one of our vice presidents stopped by my office and informed me that he was terminating a recently hired manager who reported to him.

I asked why. He told me that his people were a focused and productive group, but that this new manager was making everyone unhappy with his bureaucratic behavior. He had repeatedly explained the problem to this new manager to no avail. He then told me what had just happened.

He had gone to the manager and asked him to solve a problem. He told the manager that this problem was not expected to occur again and that it should take him a short time to take care of it.

Instead, the manager spent a week writing a procedure and creating forms to be filled out to address this problem. Then the manager assigned someone else to follow the procedure he had created. The procedure and forms were so elaborate that it took the assigned person three days to complete them. My vice president estimated that it should have taken one to two hours to resolve the problem. Instead, it took about ten full days.

13. INSPIRES CONFIDENCE

Entrepreneurs have the natural ability to motivate people, and they convey a feeling that they are bound for success. Entrepreneurs inspire confidence that they are honest and trustworthy. Consequently, others are drawn to them and want to be associated with them.

In my experience, different entrepreneurs possess this characteristic in different degrees.

14. WISDOM IN SELECTING TEAM MEMBERS

Whether or not an entrepreneur's business efforts succeed in the long term will be directly dependent on the people he/she picks to be on the team.

I do not know any successful entrepreneur who has not made serious errors in the selection of some team members. However, overall they have done a good job in selecting their team members, or they probably would not have been triumphant in their business journey.

Successful entrepreneurs have excellent innate feelings in deciding who to bring onto their team. They are good judges of character. Further, they understand their own weaknesses and their strengths, and they select their team members accordingly.

15. LEADERSHIP

Leadership is an aggregate of the characteristics already discussed. In addition, a leader has the ability to influence the behavior of others. In a business environment, a leader will direct

the enterprise so that its business objectives are successfully accomplished.

Most entrepreneurs are strong leaders. Leadership is earned. It is not legislated.

16. IT IS IN THE BLOOD

The entrepreneurs I have met have always had a strong current flowing through their bloodstream urging them to embark on their business journeys. The feeling varies in strength at different times in their lives, and it is more intense in some people than in others. But it is there. Eventually, they commit to their entrepreneurial trek. They cannot help it. It is in their blood.

A couple of related stories are appropriate here.

Living the dream

A friend of mine is a very successful entrepreneur. Before committing to his journey, he was a hardworking engineer in a top management position with a small firm. He had identified his vision and was itching to execute it; however, he was married with two children, and he enjoyed a comfortable standard of living. When he told his wife what he wanted to do, she panicked. Her response was that they had a good life, they were saving for their children's education and for their old age, and what he wanted to do was insane. He could not change her mind. She could not understand his vision or the opportunity.

From that point on, his life was a very unhappy one. After a while, he came to the conclusion that he had to pursue his entrepreneurial vision. When he informed his wife, she asked for a divorce and relieved him of over half of the assets they owned. Now, his hurdles had just telescoped in magnitude. Nevertheless, he resigned his management position and started a one-man company, which was all he could afford at that point.

Shortly after starting his company he met a woman who not only fully grasped the potential of his vision, but encouraged him to pursue it. She worked with him and provided invaluable support. Eventually, his company's sales approached one billion dollars. He

sold his company. He married this woman, and they have been happily married for many years. He has continued on a very successful entrepreneurial path.

Now, to the second story.

Blaming others

A number of years ago my wife and I were invited to a wedding. Sitting next to me at the reception was a woman I had met before but did not know well. I did know she was married with two children and that she was a banker with a mid-level position. After ingesting a couple of glasses of wine, this woman turned to me and told me how she admired me for having the guts to start my own business. She went on to make a series of comments that indicated she knew quite a bit about my company. This was surprising to me since I had never had any business dealings with her or her bank. What happened next was even more surprising. She went into a confessional mode and began to tell me how, because of her position with the bank, she was constantly exposed to attractive entrepreneurial opportunities. She said that every time she considered leaving the bank to join one of these ventures, her husband would have a panic attack. They had a comfortable standard of living, and he did not want to risk that (remember the previous story?). Thus, she had never left the bank. Then she said bitterly, "I am not a wealthy businesswoman today because of my husband. It is all his fault. I will never forgive him for holding me back."

I saw this woman briefly a couple of years after the wedding confessional, and she was still at the bank, working in the same position.

This woman was not an entrepreneur. She failed on a number of counts. She lacked self-confidence, she was afraid to make a decision and a commitment, and she was blaming someone else for her failure. Most important of all, it was not in her blood.

17. NOT MOTIVATED BY MONEY ALONE

In my case, money alone was not the only driving force in deciding to become an entrepreneur. When I had discussions with other successful entrepreneurs, I found this to be true for them as well.

To be sure, money and financial independence are extremely important motivators. However, other important factors include the need to fulfill your dreams, to be the master of your own destiny, to make a difference, to be respected, and to create new opportunities.

SUMMARY

In this chapter, I discussed the personal characteristics that distinguish an entrepreneur from others. I pointed out that not every entrepreneur has all of these characteristics, but possessing many of these traits is typical of most entrepreneurs.

KEY POINTS COVERED

- An entrepreneur is the person who organizes, manages and assumes the risks of a business enterprise.
- Characteristics that distinguish an entrepreneur from others:
 1. Absolute necessity to be the master of your destiny
 2. Strong self-confidence
 3. Ability to see what others do not see
 4. Common sense
 5. Sets high goals
 6. Not afraid to make decisions
 7. Will commit
 8. Does not retreat
 9. Pride
 10. Willingness to accept responsibility
 11. Focus
 12. Intense dislike of bureaucracy and bureaucrats
 13. Inspires confidence
 14. Wisdom in selecting team members
 15. Leadership
 16. It is in the blood
 17. Not motivated by money alone

CHAPTER 3

ASSEMBLING A WINNING TEAM

AN OVERVIEW

The purpose of this chapter is to help the entrepreneur in the selection of his/her team members.

I will discuss the characteristics of a solid team member and what you should expect from such a team member.

My objective is to provide you with insight into the type of person you should seek.

BACKGROUND

One of the most critical decisions an entrepreneur makes is determining who to select for his/her team. Thus, it is important to focus on the characteristics of the successful team member.

Keep in mind that typically you will not start your business efforts with a team. You will build your team in time as your business evolves. Thus, the selection of team members is a long-term process.

The list that follows is neither exhaustive nor presented in order of importance. The implication is not that every team member has all of these characteristics but that these five characteristics are typical of a successful team member.

CHARACTERISTICS OF A TEAM MEMBER
1. IS READY FOR THE CHALLENGE

There is no simple way to determine whether or not a particular person is ready for the challenges of an entrepreneurial team.

A sound way to proceed is to evaluate how this candidate came to your attention.

Often, this person has been working for you and has earned your respect. Or this individual has joined your company or approached you because he/she believes that you represent the right opportunity

for him/her. Or you hire this new team member because he/she has the personality and experience that you need at this point.

In any event, the better you understand the motivation of the candidate you are considering for your team, the greater your chances are of making a good selection.

I always tried first to promote a current employee whose strengths and weaknesses I understood and who I believed was ready for the new challenge. This approach worked well for me.

The few times that I hired directly into my management team, I did not have good results.

2. Has a clear understanding of his/her role

You must be very clear on the type of relationship you will have with your team members. First and foremost, a team member is there to solve problems and not to create them for you or other team members. The value of a team member to you is directly proportionate to your ability to turn over problems to the team member and feel comfortable that they will be resolved properly and promptly. That is—and this is a very important point—you must be able to delegate responsibilities to a team member and feel confident about it.

The smart team member clearly understands his/her role as being a member of the general staff but not the commander-in-chief.

You must make certain that all of these points are well understood by the members of your team.

Another personal story is appropriate at this time.

The executive officer

At the early stages of my company's life I hired a young fellow who came to us from a large corporation. We had only a few employees at the time. He accepted a reasonable salary but not as good a salary as he could have obtained had he gone to work for another large firm. This was a positive flag for me and I kept my eye on him. In addition to being a good problem solver, he was intelligent, personable, and respected by others in the company.

One day he accompanied me when we drove to visit a customer some hundred miles away. During the return trip I asked him what his goals were. I was impressed with his response. He said, "I believe this company has a great future, which is why I joined it. I am confident that I can contribute to its success. I am ready for the challenge and I can be a first-rate executive officer."

He grew and matured with the company. He earned my complete trust. He was dependable and remained at my side at every turn. When the company was sold, he was one of two senior vice presidents, and he became a wealthy man.

A team member needs to grasp the strengths and weaknesses of the entrepreneur. A team member helps the entrepreneur change his weaknesses into strengths.

The young fellow mentioned above was deeply involved in the actual development of our products and had a much better understanding of the technical details than I did. When we needed to address large potential accounts, we formed a team. He would give the technical presentation, and I would concentrate on the sales strategy and watch the reaction of our potential clients as our presentation unfolded. This turned out to be a winning combination. It is an excellent example of how a team member can help and complement an entrepreneur.

3. HAS A REALISTIC HANDLE ON HIS/HER WORTH

The worst problem that many employees have is a distorted perception of what they are worth to their employer. The main reason for this is that they do not understand the whole picture and what it takes to put it together, hold it together, and succeed. Let me narrate a simple exercise I carried out years ago and its results.

At the time I had a good handle on the value of my company, as substantiated by informal offers from potential buyers. I continually interacted with my employees and carried out many coffee and lunchtime conversations. Also, I conducted many employee salary reviews. I felt I had a good feeling for what my employees thought they were contributing to the company. I came to the conclusion that

if I added up what each employee honestly felt he/she was contributing to the company and translated that into dollars, the amount would have approached at least three times the worth of the business.

This indicates that most employees do not have a true idea of what their contribution is to the value of the company that employs them.

Thus, when searching for a team member for your inner group, look for an individual who understands that no one is indispensable—not even the entrepreneur. You want someone who has a realistic handle on what he/she will be contributing to the company. Only then will his/her compensation expectations be in the right domain. Further, as long as the compensation plan justifies it, the potential team member should be looking at the long term for the big-time financial rewards.

Another short story is pertinent here.

The bragger

Although at the time my company already had a full-fledged sales organization, it goes without saying that I would do whatever I could to bring in revenue. It so happened that one particular quarter, through personal friendships, I made two substantial sales in a salesman's territory. In each case, I called his manager and told him to send over this lucky salesman to pick up the order. It was more than clear to the salesman that these orders, for which he was receiving commissions, were a gift from above. His overall sales performance was mediocre. A couple of months later we held a national sales meeting. During the social hour, this salesman made it a point to chat with me, and he bragged about how good he was and how much he was contributing to the company. He used the two gift sales as examples of his contribution. This showed his poor common sense. He was not meeting his sales quotas, and he did not last long with the company.

4. IS LOYAL

When you are in a committed relationship with another person, it is critically important that this person be faithful to you at all times. It is no different in an entrepreneurial team. The issues are trust and loyalty. The entrepreneur and the other members of the team are sharing their most important business ideas, strategies, and information. A team member is a key component in the process that will determine the future and well-being of each of the team members and their families. A team member must never do anything that might cast doubt on his/her loyalty.

In my experience, the members of an entrepreneurial team are almost always dedicated and loyal. There are exceptions, however, and you must be prepared to handle them. It is in such painful times that you need the support of all the loyal team members. Remember that you, as the entrepreneur, picked each team member. When there is a betrayal of trust, you will hurt the most.

I will tell you about one of the most painful incidents in my journey.

Disloyalty

Early in the life of the company we hired a young man without experience and background in our industry and trained him in our business and our products. We made that decision and took the risk because we were impressed with him and thought he would develop quickly. We were right. He was personable, extremely bright, and articulate. His responsibilities increased rapidly, and over time he became a member of our entrepreneurial team. He grew with the company. By this time we were considered the leading company in our field, with the leading products. A number of competitors had come into the picture.

One day I received a call from a friend who was close to someone in management at one of our competitors. He informed me that this young man was making the rounds of our competitors and offering to provide inside information on our company—including product plans—to the highest bidder. I could not believe it. This young man had on more than one occasion told me how the

employment opportunity we provided him had changed his life and how grateful he was.

I called him to my office and asked if the information I had received was true. After nervously wiggling in his chair for a while he responded, "Yes. . . but you have to understand that I have to do what is best for me." I terminated his employment.

There was a positive side of this story. As a result of this individual's betrayal, the other team members closed rank in an incredible manner. We became a stronger and more formidable team.

Postscript to this story. About two years after I terminated his employment, I received a letter from this individual telling me how sorry he was for what he had done and how much he wanted to work for our company again. I had learned that he had gone through several jobs and was not doing too well. I ignored his letter. I consider ethical behavior a most important human characteristic.

5. IS DISCREET

A team member should never be a yes-person. However, a team member needs to think carefully before criticizing or offering unsolicited advice to the entrepreneur. It is important that any criticism or advice be sound and be provided in private.

I always encouraged my team members to come forward with any concerns or advice they had for me. Many times I did not agree and would say so, but it was clear that I appreciated their concern. Often I would solicit their advice, which I considered indispensable in making decisions.

TEAM MEMBER VS. ENTREPRENEUR

The previous chapter provided you with an overview of who is an entrepreneur and some of the challenges that the entrepreneur has to face on a daily basis. It should have helped you decide how much of an entrepreneur there is in you.

Not everyone who seeks financial independence has to be or needs to be an entrepreneur. Intelligent individuals, despite a strong desire to succeed in a business enterprise, may recognize their

strengths and limitations and conclude that they are not entrepreneurs. In fact, for these individuals becoming a member of an entrepreneur's team is a great way to proceed and become successful. Companies like Google, Oracle and Microsoft turned members of their entrepreneurial teams into multimillionaires. Microsoft and Google have been extraordinary cases. Google alone created five billionaires and one thousand millionaires [Farz 05].

A company does not have to be in the technology field to transform their entrepreneurial teams into millionaires. There are many such companies that are not as well known or as large as Oracle, Microsoft, or Google.

SUMMARY

In this chapter I discussed the characteristics of a successful member of an entrepreneurial team.

The objective of this chapter was to help you, the entrepreneur, in the selection of your team members in order to assemble a winning team.

KEY POINTS COVERED

Characteristics that distinguish a successful member of an entrepreneurial team:

1. Is ready for the challenge
2. Has a clear understanding of his/her role
3. Has a realistic handle on his/her worth
4. Is loyal
5. Is discreet

CHAPTER 4

THE VISION

AN OVERVIEW

The vision defines the business that you want to create. In this chapter I discuss how you may identify your vision and how other successful entrepreneurs have identified theirs.

BACKGROUND

Your vision will represent the guiding framework of your business. Will you manufacture shoes, build contemporary furniture, develop software products, design medical instruments, start a commercial airline…? Associated with your vision must be your strong conviction that it represents an opportunity you can fulfill. Equally important, it must be an opportunity that you will enjoy fulfilling.

The question is, how do you find this vision?

It is fascinating that some entrepreneurs have a vision, albeit fuzzy, from a very early age. Others have an intense desire to identify the business opportunity that will become their vision. One way or another, an entrepreneur must pinpoint his/her vision. An entrepreneur will prepare for the time when all the component pieces are in place to make a move and to commence the business journey.

There are successful entrepreneurs who will say, "I really never thought of myself as an entrepreneur, but the opportunity presented itself," or "A series of events led me to start this business." I do not agree with such assessments. I believe they were entrepreneurs all along, although they may not have realized it.

Identifying your vision is somewhat analogous to identifying your spouse or partner. It could be love at first sight or love after an incremental process of getting to know one another better. As you grow older and your life experiences accumulate, you develop an

implicit set of criteria that outline the person you will choose as a spouse or the opportunity that will be your vision.

So, back to the fundamental question: How do I identify my opportunity?

Webster's New Collegiate Dictionary defines *opportunity* as "a favorable juncture of circumstances" or "a good chance for advancement or progress."

I do not know of any formula that will identify an opportunity for you. I do not believe that any such formula will ever exist; however, there is no question that multiple opportunities are passing you by all the time. Your challenge is to recognize them, evaluate them, and iterate until you find YOUR opportunity, the core around which you build your vision. Of course, as we have discussed earlier, **it is not enough to identify your vision. You must have the personal characteristics that differentiate an entrepreneur from others, particularly the common sense to come to the right conclusions and the self-confidence to act on your convictions.**

How many times have you heard others say, "I have a great idea for a business," yet they do nothing about it?

One way to identify your vision is through a product-driven approach. That is, you start your business with products addressing an area in which you have experience or have developed an affinity. Later on in this book I will discuss the need to do a market analysis to confirm that there is a sufficiently large market for your products before you commit to your new enterprise.

Another way to identify your vision is a market-driven approach. You select a target market and research it to determine what products it wants. Assuming you identify a market of sufficient size to satisfy your business goals, you create your new business around those products.

In practice, you must combine both of these approaches.

Next, I will relate a few short stories of how some entrepreneurs arrived at their opportunities. Then, in the next chapter, I will cover some problem-solving concepts and techniques that I have found helpful not only in the process of identifying opportunities but also throughout my business journey.

SHORT STORIES
The wholesale man

This story concerns a friend, a successful entrepreneur, who was living in Boston in 1961 when he was in his early twenties. He was married. He had graduated from high school but had not gone to college, and he had already completed his military service where he served as a cook in the army. He was fluent in Spanish.

He was a fellow with a great deal of common sense who was not afraid of the uncertainties of life. He and his wife lived in a modest rented apartment and had very little money in savings. Although he had previous work experience in the wholesale business, at this point he was working in a manufacturing plant in what he felt was a reasonably good job. His boss had already told him that that it was only a matter of time before he would become a section supervisor.

Since he was a teenager, he had dreamed of having his own business. Knowing and liking the wholesale business, he wanted to own a large wholesale operation. At this point in his life he was anxiously seeking a way to make his dream come true. He was ambitious, and his definition of success went well beyond being a plant supervisor. He wanted his financial independence. He wanted it badly.

Then he received a call from his brother-in-law who had moved to Puerto Rico. He was buying merchandise from wholesalers and selling it to small stores. Needing help, he encouraged my friend to come to Puerto Rico. Without much hesitation, and with the full support of his wife, he left his job in Boston, and they moved to Puerto Rico.

All they could afford was a small unfurnished apartment in San Juan; however, he was excited by the opportunity to bring his vision to fruition and was not afraid of hard work. He started doing the same type of sales as his brother-in-law. He also began to sell to stores in the various Caribbean islands near Puerto Rico. It was not easy. What little money he had, he used for merchandise and basic living necessities. He had to stay in some rather unsavory places as he hopped from island to island. Moreover, to minimize his travel

expenses, he combined trips and was consequently away from home for weeks at a time.

After a while, in partnership with his brother-in-law, he opened a wholesale business and continued to sell to retail stores. Then they started opening their own retail stores. By 1971, they owned a sizable wholesale business and twenty-seven retail stores throughout Puerto Rico. At that point he decided to sell his share of the business to his brother-in-law. He moved to Miami with a respectable amount of money.

In Miami, he started a real estate development operation, but by 1976 he had lost all his money. He had, however, learned a lot about the real estate business. Undeterred, he started once again in what he knew best. He opened a retail store, and by 1981 he owned a chain of thirteen retail stores throughout the Miami area. Then he sold them all and returned to the real estate business. This time he was very successful. He amassed a substantial fortune and currently lives in semi-retirement in Miami Beach.

Postscript to this story. My friend told me that when he went to his supervisor at the plant in Boston to resign and explained to the man what he was doing, his supervisor told him he was crazy. He had a future with the company. My friend did not waver.

After he was well-established in San Juan with several retail stores and a very comfortable home in an elegant section of town, he invited his former supervisor to visit him. The former supervisor, who was still in the same job, was of course flabbergasted by my friend's success.

My own story

When I was in junior high school, I used to dream about creating a large successful business. I read some magazine articles about computers and, totally fascinated, I decided I wanted to work with computers. Keep in mind that this was the mid-1950s! Looking back, I realize how innocent I was. I had little idea of what was involved in creating or running a business, and I certainly had no idea of what a real computer was.

When I finished high school, I went on to study engineering at the University of Illinois. It never occurred to me to study anything else. Again, looking back I knew very little about engineering at that time. Although I cannot explain it, I had no doubts about my decision. While at the University I took the few courses that were offered relating to computers. This was in the late 1950's, and not much was available on this subject. My fascination intensified.

When I graduated with my bachelor's degree in Engineering, I had a strong desire to create my own business but knew that I had no vision for it yet. I wanted to continue my education, and I needed to pay bills, so I decided to work and attend graduate school simultaneously. After earning my Ph.D. in Computer Science, I began to feel frustrated because I had not yet identified my business vision.

I decided then that it would not be in my best interest to go to work for a company. There were two main reasons. First, I was concerned that I would not have enough flexibility to continue the search for my vision. Second, my vanity was getting in the way, and the idea of being a hot shot in computer science was very appealing. I therefore accepted a position as a faculty member in Computer Science at the University of California—first at the University of California at Los Angeles (UCLA) and then at the University of California at Santa Barbara (UCSB). My area of expertise was software development and the management of software projects.

At UCSB, in addition to my teaching duties, I led a research effort on software. At the same time, I was doing consulting work for government and industry. In my consulting activities I was often asked to do a post-mortem on failed large software development projects in an attempt to understand what went wrong. After a few of these post-mortem efforts, I made an interesting observation. In a software development and maintenance effort, changes are ubiquitous and continual. Yet there was almost nothing available to manage the software change process. Further, a large percentage of the errors that contributed to the failure of these software development projects could have been avoided if a change management process had been enforced.

In addition, it became clear to me that software developers employed few tools to automate the software development process—an ironic situation in an industry that was automating the work of others.

Equally important, software was a fast-growing industry. In fact, it was the key to the successful utilization of computers.

I had found my vision!

I soon left university life and founded a company called Softool Corporation to design and market software tools. Although we created and marketed a variety of software tools, our line of change management software became our best seller and was without a doubt the reason for the success of our business. In fact, we started a whole new segment of the software industry.

I want to point out that when I left the university my savings were quite limited, and I had a wife and two infant daughters. Yet I did not have the slightest hesitation to place everything I owned on the line, including my home. I was indeed fortunate that my wife supported my vision and helped in every way she could.

Oceania Cruises [Ocea 07, Oce1 08, Oce2 08]

Frank Del Rio joined the executive ranks of Renaissance Cruises in 1993. He served as Executive Vice President, Chief Financial Officer and Co-Chief Executive Officer until 2001 when the company ceased operations due to financial difficulties. During his tenure at Renaissance, Frank learned a tremendous amount about the cruise line business, and he personally learned much from its failure.

He was not deterred by his experience at Renaissance. On the contrary, he had identified an opportunity in the marketplace, and he had a vision on how to go after it.

Frank's vision was to create a cruise line that offered the best-in-class cuisine, itineraries addressing the needs of discerning, well-to-do passengers with time to travel, personalized service, comfortable ships that carried a limited number of passengers, quality entertainment and lectures, and that offered all of this at a competitive price. He wanted to create and position a new cruise

company as the cruise line of choice for traditional, premium, and luxury category passengers.

To start a cruise line requires large amounts of money which represented a formidable challenge to Frank and his vision. Frank joined forces with Joe Watters, another cruise industry veteran, and together they founded Oceania Cruises in January of 2002.

They approached Cruiseinvest, a company that had taken possession of various Renaissance Cruise line ships after that firm went out of business and was simply maintaining those ships at a substantial cost. Cruiseinvest agreed to sell two of the ships to Oceania at very favorable terms with a time schedule that allowed Oceania to implement its plans. Now, Frank and his partner needed to raise money to refurbish those ships. Their story was a compelling one and they managed to raise $14 million from a group of investors. They were in business!

Oceania became a very successful cruise line.

In February of 2007, Apollo Management, a large private equity fund, valued Oceania Cruises at approximately $850 million and acquired a reported 65% of Oceania.

Oceania, now consisting of three operational ships plus two more in construction, was folded into Prestige Cruise Holdings, which also owns Regent Seven Seas Cruises, another high-end cruise line. Frank Del Rio became Chairman and Chief Executive Officer of Prestige Cruise Holdings, a subsidiary of Apollo Management.

What an impressive business trajectory for Frank Del Rio and his vision. In just five years he implemented his vision and brought it to fruition!

SUMMARY

The *vision* is the guiding framework for the business you want to create.

KEY POINTS COVERED

You can identify your vision in three different ways:

1. *A product-driven approach.* You create a product and confirm that there is a market for it.
2. *A market-driven approach.* You select a market and research it to determine what products it wants.
3. *A combination of the product-driven and the market-driven approach.* This is the most practical way to proceed.

CHAPTER 5

TOOLS TO FOCUS ON THE VISION

AN OVERVIEW

In this chapter I introduce some powerful problem-solving techniques and show how they can be employed to help develop and/or fine-tune your vision.

These are methodologies that are generally found in mathematical and philosophical contexts. I present them here in simple terms and illustrate how they can be used for entrepreneurial purposes.

WARNING

The material in this chapter may require that you read it at a slower pace to understand the concepts being presented. I believe that if you do so, you will find that the techniques you master will more than justify the extra effort.

At any rate, none of the remaining chapters require this chapter as a prerequisite.

PROBLEM SOLVING

My purpose is not to dwell in depth on problem-solving techniques. This is a topic that has been the subject of discussion by philosophers and mathematicians for thousands of years. According to George Polya, a famous mathematician of the previous century, a philosopher named Pappus was already working in this area in the year A.D. 300 [Poly 45]. R. Descartes (1596-1650), the famous mathematician, is rumored to have had a mental breakdown working on this topic. So, let us be modest in our goals.

Most of the serious treatments of problem-solving techniques are presented in mathematical and/or philosophical terms. My objective here is to present in a simple manner some concepts and techniques that I have found quite useful in dealing with problems, both

business problems and problems in general. My focus in this chapter, however, is identification of a business opportunity, and I shall keep that in mind.

I will cover four different problem-solving techniques:

1. Variables vs. constants
2. Life cycle diagrams
3. Binding time
4. Data structures

1. VARIABLES VS. CONSTANTS

The best way to communicate this concept is through an entertaining story I heard a long time ago.

The elevators

A brand new office building was completed in Manhattan. Within a few months it was all rented to different businesses, and there were a large number of office workers in the building. There was one set of eight adjacent elevators.

As the months went by, the owners of the building began to receive a growing number of complaints from their tenants that there were not enough elevators or that the elevators were too slow. Some of the tenants threatened to leave, and the owners became alarmed. They contacted the architectural firm and the construction company that designed and built the building and asked how much it would cost to add more elevators. The response they received was even more alarming. It would not only cost a substantial amount of money, but the disruption to the normal operation of the building would be major and lengthy. The owners did not know what to do. They were desperate.

A friend of the owners recommended that they hire a consultant who specialized in solving problems. The owners felt that the cost of the consultant was minor compared to the issues at stake, and they hired the consultant.

They described their predicament to the consultant who said she needed a few days to study the problem. A week later the consultant returned with a solution.

Before you learn about the consultant's recommendation, I encourage you to ponder the problem and try to come up with a solution of your own. Then you can appreciate the proposed solution.

-
-
-
-
-
-

The consultant advised the owners that the solution to their problem was simply to place some attractive mirrors in front of the elevators at each floor. The owners were incredulous. How could that solve their problem? Since the recommended solution was quite inexpensive, they decided to try it. They promptly installed the mirrors.

Months went by and the complaints from their tenants about the elevators ceased. The owners were ecstatic. Let us now analyze the solution.

Most people, when considering the problem, would focus on the elevators as the only adjustable variable, either by adding more elevators or by making the existing elevators faster or bigger. Everything else appeared to be a constant. But that was not the case at all.

The consultant identified another important variable—the amount of time it takes a person waiting for an elevator to become impatient.

By placing mirrors in front of the elevators, people entertained themselves with their images in the mirror, fiddling with their appearance as they waited. The result was that the amount of time

after which they became impatient was extended enough to eliminate the frustrations that had led to the complaints.

The fact is that there are many other variables that could be identified in this situation, such as the working hours, the color of the carpet, the intensity of the illumination, the type of furniture in front of the elevators, the color of the elevator walls, and a multitude of others.

This leads me to the following observation: **One person's constant is another person's variable.**

This is a profound observation and one that now allows me to discuss a simple and interesting technique for problem solving and for opportunity identification.

When faced with a problem, list as many variables as you possibly can. Then examine each variable and ask yourself if adjusting that variable could help you solve your problem.

In practice this is an iterative process. As you list more variables and evaluate them, you develop better insight into the problem. As you develop better insight, you identify new variables that were constants in the previous iteration. And so on.

The following is another pertinent story.

The inventor of pens

Years ago I was fortunate to meet a gentleman named Nathan Zepell. He was a successful inventor who held a number of patents on different pen designs he had created. He once described to me a simple process he used to conceive new pens, or writing instruments, as he used to call them. He told me he would place a standard pen in front of him and start listing characteristics (in our terminology, *variables*) that defined the pen. For example, he would list the size, the shape, the position of the clip, the color of the ink, the cost to manufacture, and so on. He would then evaluate the possibility of changing each of these variables and imagine what the resulting pen would look like.

Through this process he came up with a number of pen designs. As a present he gave me one that was marketed under the name Pentastic®.

48

The standard ball point pen has a tubular shape. The Pentastic is a flat pen. It has the same length as a conventional pen, but it is in the shape of a long triangle with a small base and two long sides. The writing tip is at the opposite end of the base. It is very comfortable to hold. Standard pens typically contain a single ink color since pens with more than one ink color tend to be more expensive to produce. The Pentastic, because of its flat design, easily accommodates two different colors of ink. But most important of all, it is inexpensive to manufacture and has space for quite a bit of easy-to-read writing (i.e., advertising) to be placed on the flat surfaces. This pen design appealed to companies that wanted an inexpensive, attractive pen to give to clients.

What I wish to illustrate with this narrative of Zepell's approach is that he knew that his expertise and opportunities were in the area of writing instruments. He used the technique I have called *variables vs. constants* to pinpoint a specific business opportunity.

If you believe that a particular area may reveal an opportunity that will give birth to your vision, you can use the *variables vs. constants* approach to try to identify your opportunity.

The next example is another case in point.

Lieutenant Columbo

Lieutenant Columbo was the hero of a highly successful series of TV movies and episodes that ran off and on from 1968 until 1993.

Frankly, I have no information on how the originator of this series created this character; however, there is no question in my mind that explicitly or implicitly this writer employed what I have called here the *variables vs. constants* approach.

The reasons are as follows. In a typical TV series, the hero is tall, handsome, smartly dressed, and so on. Lieutenant Columbo, on the other hand, was short, average looking, and poorly dressed. He even smoked a cheap, smelly cigar and drove a beat-up car. Thus, the creator of the character identified a number of aspects of a detective story that are constants to most of us and turned them into variables. It is interesting to note that the originator of the character

left one constant intact. Rather than having Columbo fumble his cases, he chose to let Lieutenant Columbo solve his cases, like a typical TV detective hero.

The result was a hit TV series.

To illustrate further the power of the *variables vs. constants* technique, note that humor is often based on this approach.

Humor

Mother knows best [Source: The Reader's Digest]

I bought two ceiling fans, one for our home and one for my parents. While installing our fan, I had to stand on a chair on my tiptoes. As she watched me struggle, my wife let me know the reason for my troubles. "You are too short."

Later, my mother watched me on my tiptoes as I was installing the other fan for my parents. Her comment was, "The chair is too short."

The rabbi [Source unknown]

A rabbi was opening his mail one morning. Taking a single sheet of paper from an envelope he found written on it only one word: *Idiot.*

At the next Friday service, the rabbi announced, "I have known many people who wrote letters and forgot to sign their names, but this week I received a letter from someone who signed his name . . . and forgot to write the letter!"

The choice [Source unknown]

I just read an article on the dangers of heavy drinking…Scared the heck out of me. So that's it! After today, no more reading.

Aging

Recently I encountered an acquaintance that I had not seen for over ten years. She looked at me and said, "Amazing, you look the same way you looked the last time I saw you." I responded, "Yes, I aged early."

50

As should be apparent from the discussion thus far, **the *variables vs. constants* technique is not a formula to create your vision. However, it can be of assistance in focusing your vision if you have an initial general idea under consideration.**

Next, I discuss a diagramming technique that I have found useful in conceptualizing potential business opportunities.

2. LIFE CYCLE DIAGRAMS

Diagrams can be used to represent visually the actions or processes that are of interest to you.

When you view events in a graphic way, you often gain insight and a better understanding of your problem. This in turn may allow you to pinpoint your business opportunity. This diagramming technique provides another way to help you focus your vision.

You can diagram any process or event from any desired viewpoint and to any level of detail that serves your objectives.

Let me introduce life cycle diagrams with an example. Suppose I wish to diagram the life of a human being. I do so in three steps as shown in Figure 1.

Fig. 1 Human Life Cycle

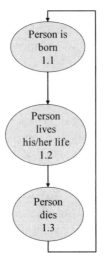

An oval is used to represent an event. An arrow is used to denote the sequence of events. For convenience I have numbered the ovals.

Now, assume that my interest is in the type of education a person receives during his/her lifetime. I can refine oval number 1.2 as shown in Figure 2.

Fig. 2 Educational Life Cycle

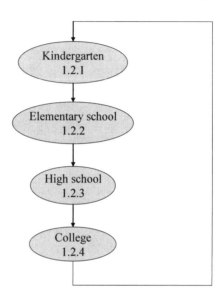

I could break down oval 1.2.4 further as shown in Figure 3.

Fig. 3 College Life Cycle

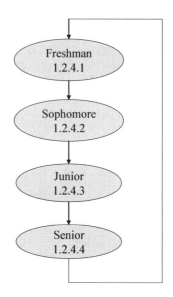

I could further break down any of these ovals as I feel is necessary in order to understand the situation I am addressing. I will stop here with this particular life cycle diagram since my only purpose was to introduce the technique.

Now, it is worthwhile to revisit the elevator problem I discussed earlier.

The elevators revisited
I have summarized the elevator problem in Figure 4. For simplicity, I am only diagramming the arrival of employees to work. A similar diagram would apply when they go home.

Fig. 4 Elevators **Life Cycle**

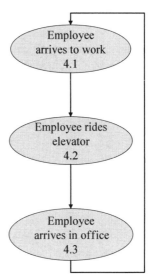

Since the problem reported by the tenants occurred when they rode the elevators, "Employee rides elevator" (oval 4.2) is refined further in Figure 5.

Fig. 5 Employee Rides Elevator Life Cycle

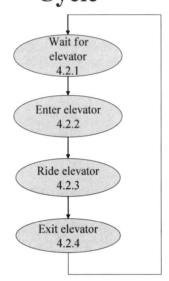

Consider each one of the ovals in Figure 5 in search of possible solutions to the elevator problem.

Wait for elevator (4.2.1). This is where the consultant found her elegant solution—the mirrors that increased the tolerance of the wait by the employees.

Enter elevator (4.2.2). I could also find a solution through this oval by creating a passage with entertainment through which employees must walk to reach the elevators. If the entertainment lasted long enough for the elevators to make a round trip, there would be no wait by the time the employees arrived at the elevator.

Ride elevator (4.2.3). This is the oval where most people would concentrate their efforts to find a solution. The obvious ones are to have more elevators, bigger elevators, or faster elevators. Another

possible solution would be to have some of the elevators provide express service to specific floors.

Exit elevator (4.2.4). I could consider a solution that has some "happy event" occurring as the employee exits the elevator in order to ameliorate the bad mood the employee experienced due to the wait.

What I am illustrating here is that the creation of the life cycle diagrams might prompt you to consider potential solutions that would not otherwise be apparent.

My own experience

A life cycle diagram of the software development process is shown in Figure 6.

Fig. 6 The Software Development Process Life Cycle

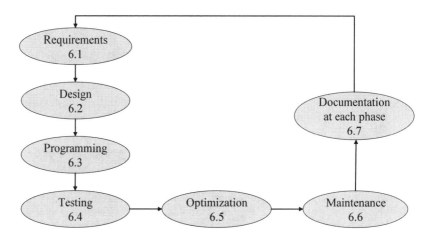

I mentioned earlier that I founded a software tools company. In essence, I came up with the idea when it became clear to me there was a dire need for facilitating and enforcing methodology in the software development, maintenance and management process. It was through the utilization of techniques such as life cycle diagrams that I was able to identify a number of products that were needed but not obvious.

For example, Figure 7 displays a detailed life cycle diagram for the testing phase of the software development process (oval 6.4) shown in Figure 6.

Fig. 7 The Software Testing Process Life Cycle

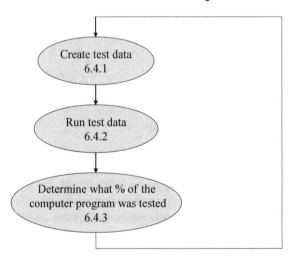

We realized we could create a software tool that automatically quantified what percentage of the computer program under test was actually being tested when specific test data was entered (oval

6.4.3). We designed such a tool, and it was a successful product. We also identified another potential tool (oval 6.4.1) to create test data automatically. We decided not to allocate our efforts to the creation of such a tool. Later on, other companies came out with tools to create test data.

For a more detailed understanding of the software development process, the diagram in Figure 6 would require further refinement; however, for our purposes, there is no need to go into such detail.

The salesman

Let me now create a practical example. Suppose your expertise and/or area of interest for your vision is in sales to corporations. You have not identified your specific area of business, and you wish to flush out a potential opportunity in the sales arena. I will show you next how the life cycle diagram approach could be of help.

Based on your experience and/or know-how, you diagram a sales life cycle as shown in Figure 8.

Fig. 8 Sales Life Cycle

In a professional and effective sales organization, each one of these ovals represents a substantial effort and expense. Each can be broken down into a series of ovals, which in turn can be subdivided into another series of ovals, and so on.

The prospecting phase could be divided into requests received from potential customers or unsolicited calls a salesperson makes. Figure 9 depicts the prospecting cycle.

Fig. 9 Prospecting Life Cycle

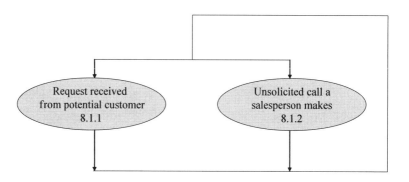

Requests received could come via the telephone, email, letter, fax, advertising response card, trade show, seminars, business partnerships, your website, etc. Figure 10 diagrams this process.

Fig. 10 Request Received from Potential Customer Life Cycle

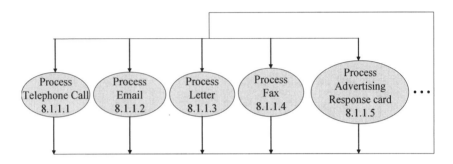

If you continue to refine the sales life cycle, you will end up with an elaborate series of diagrams.

The first issue that becomes apparent is that the top-down, divide-and-conquer approach described here helps you develop the detailed understanding of your problem you will need to make intelligent decisions. This is an iterative process. As you subdivide an oval, you often refine your understanding so you can go back and redo your ancestor diagram.

It is pertinent to note that when you try to describe a process in detail, as you need to do in a life cycle diagram, you realize how many pieces of the puzzle you really do not understand that well. **The diagramming technique is a catalyst to help you develop a sound understanding of the area you are considering as a potential business opportunity.**

At this time, let's return to evaluating the sales area in your search for a potential business opportunity. Assume you have completed a sales life cycle diagram in sufficient detail to be

satisfied that you have a good grasp of the issues. You can now list potential opportunities to evaluate.

To begin with, a sale is a complicated process that requires a number of administrative tools, particularly because of the large number of people involved in the sales process. It is so labor intensive and time sensitive that there are a number of companies who market software products for automating different activities in the sales process. You could systematically walk through your diagrams listing the kind of tools that might be useful to a potential client (i.e., a sales organization). You could pay particular attention to how these tools could be integrated and how they might be used to improve communications (e.g., the streamlining of inputting and extracting information from the sales process).

For example, referring to Figure 10, it may become apparent to you that tools to automate the handling and tracking of telephone calls, emails, letters, faxes, advertising response cards, etc. could indeed be quite useful and marketable. Next, you would have to examine the products available in the marketplace to decide whether or not there is an opportunity for you in this area.

Keep in mind that as technology and business practices evolve, new opportunities surface. For instance, outsourcing part or all of a company's sales was not that popular ten or fifteen years ago. Today, it is common to outsource parts of the sales process to foreign countries where labor is cheaper. Again, you could systematically walk through your diagrams, listing the kind of activities that could be outsourced by the selling organization. Next, you would gather information about which activities are being outsourced today, the costs involved, and the degree of client satisfaction with each outsourced activity. Then you can decide if outsourcing offers a good business opportunity for you.

Another approach you should use is to list your strengths. Then, using each one of your strengths as a criterion, make a pass through the diagrams looking for an opportunity match.

To summarize, what you have done is to use the life cycle diagrams to represent your knowledge of the area in which you would like to find a business opportunity. Then, using these

diagrams as a framework, you systematically try to identify a business opportunity that may work for you.

3. BINDING TIME

This is a powerful concept first introduced in 1972 [Pres 72]. The best way to explain the concept is through an example.

Many college students are not sure what field they want to study. Thus, they postpone declaring their major as long as they can. Let us examine the four years of college diagrammed in Figure 11. I have expanded the view of college life by adding ovals for admission and graduation. I have labeled the ovals T1 through T6. T1 denotes the time period the student spends in the admission process. T2 denotes the time period the student spends as a freshman, and so forth.

Fig. 11 College Life Cycle Revisited

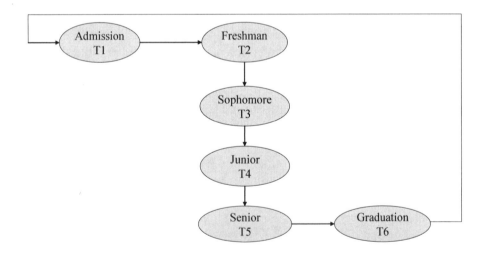

Depending on the college, students may be allowed to postpone declaring their major until their junior year. Assuming that is the case, we see that a student could declare his/her major during T1, T2, T3, or T4.

The earlier a student declares his/her major, the better the student will be able to prepare for that major, and the fewer courses the student may take that would not apply to graduating with that major. Thus, the student would minimize the cost and duration of his/her education. On the other hand, the later a student declares a major, the more time the student will have to learn about possible majors; however, the student may pay for this flexibility by taking longer to graduate and by spending more for his/her college education.

I call the time when a student decides on a major the *binding time* for that decision.

This leads me to another basic principle that allows me to discuss a simple and powerful technique for problem solving and opportunity identification.

The earlier you bind, the simpler and most cost effective the solution. The later you bind, the more flexibility you have, but the more complex and more expensive the solution.

Thus, if you are able to identify key decisions to be made in the solution of a problem and evaluate the possible different binding times for those decisions, you may discover some interesting business opportunities.

The writer

Let me now create what could be a real-life example. Suppose your expertise and/or area of interest is in writing articles for newspapers and magazines. Since you have not identified your specific business vision, you want to analyze this area in an attempt to flush out a potential opportunity. I will show you how the binding time approach could be of help.

As I have mentioned before, technological developments continually affect established businesses, creating opportunities for new ones. So, suppose you zero in on the much-discussed issue of

online publications taking business away from established print publications (i.e., conventional newspapers and magazines). Can you find your vision in this general area?

First, let me describe how I currently use these publications. I will limit the discussion to newspapers, and I will concentrate on my own habits.

I subscribe to two different daily print newspapers: my local newspaper and *The Wall Street Journal*. Through my Internet service I have access to online news services.

When I hear about some breaking news (typically through radio, TV, online news summary, or a friend) of interest to me, I go online to get the immediate details. The next day I read further about it in my local paper.

I read *The Wall Street Journal* for two reasons. First, it has good financial coverage. Second, it contains excellent in-depth articles on news stories of interest to me. Often, I have already read something about a *Wall Street Journal* story in the online service and in my local newspaper. The fact that the story runs in *The Wall Street Journal* days or weeks later does not bother me because it is typically so well-researched and informative.

So, from a content point of view, the online service has my attention because of the immediacy of its reporting, *The Wall Street Journal* because of its extensive research and completeness, and the local newspaper because of its ability to provide an intermediate solution to my needs.

I can think of many important differences between a print publication business and an online one, running the gamut from capital requirements to staffing to printing and distribution costs. For my purposes here, I will only focus on the issue of the timing of the news delivery and on the quality of the coverage.

A daily morning print newspaper has to finalize the decision of what stories to run the night before. An online publication, on the other hand, can make that decision on a minute-by-minute basis. In our terminology, the *binding time* decision for content is the night before for print and almost instantaneously for online news. Quality

and thorough coverage of a story requires a much longer binding time.

With this framework in mind, binding time analysis could lead you to explore the following business opportunity for implementing your vision.

Utilizing your experience and strength, your business could be the creation of thorough, well-researched stories on news issues a la *The Wall Street Journal*; however, your potential clients would be daily newspapers and online publications. You would need to do your homework to determine your appropriate binding time.

It is worth noting that on January 2, 2007, *The Wall Street Journal* came out with a new strategy and format for both its print and its online editions. Their goal is to have the two editions be part of an integrated design where they complement each other. The online edition to provide immediate coverage; the print edition to offer well-researched coverage. This strategy represents an excellent business example of a company intertwining 'old' and 'new' technology. However, this combination of print and online editions alone may not be enough to rescue the decaying situation of most other print newspapers. These newspapers have to find novel ways to increase traffic to their online editions to in turn maintain and increase the readership of their print editions. In 2007, a consortium of newspaper companies entered into a business arrangement with Yahoo for this very purpose [Stec 07, Stei 07].

My objective here has been to illustrate that **the technique of identifying and evaluating binding times can serve as a lever to help you pinpoint your particular business opportunity.** Again, I emphasize that you first need a good idea of the general area for your vision; these techniques only serve as catalysts to help you reach your goal.

Next I address our last problem-solving technique.

4. DATA STRUCTURES

The basic idea here is that **one of the most powerful ways to understand a problem is to represent the data manipulated in that problem in different ways.** As you do that, you gain valuable insights into the problem and potential solutions. Again, this may help you isolate your business opportunity.

A good example to illustrate this technique is to assume your task is to send and receive messages in Morse Code.

Morse Code is a method for transmitting information in which each letter is represented by dots and/or dashes. Each letter is preceded by a new letter indicator. Although it is no longer in much use, I employ it here because it offers a simple way to illustrate the technique being discussed.

Figure 12 displays the Morse Code.

Fig. 12 Morse Code

A .-	H	O ---	V ...-
B -...	I ..	P .--.	W .--
C -.-.	J .---	Q --.-	X -..-
D -..	K -.-	R .-.	Y -.--
E .	L .-..	S ...	Z --..
F ..-.	M --	T -	
G --.	N -.	U ..-	

This is an excellent way to represent the data (i.e., the Morse Code) for the sender who is sending messages one letter at a time. When the sender needs to find the code corresponding to a given letter, he/she simply looks for it alphabetically and retrieves and sends the appropriate code. Because the letters are arranged in alphabetical order, the sender can find the corresponding code very quickly.

Now consider the receiver who gets a series of dots and dashes. The receiver has to check the code he/she just received against the letters, one by one, until he/she finds a match. This is a very slow process.

Is there a better way to streamline the task of the receiver?

Suppose you restructure the Morse Code as shown in Figure 13.

Fig. 13 Morse Code for Receiver

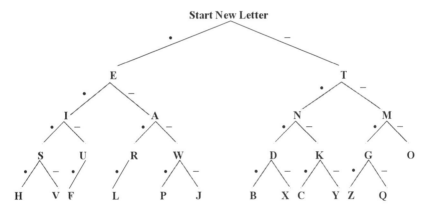

The Morse Code is displayed in Figure 13 as a tree diagram. When the receiver receives the code for a letter, the receiver simply follows the tree diagram to reach the desired letter. This is a much more efficient way to decode arriving messages.

For example, suppose the receiver is being sent the code for the letter *K*: - . -

After realizing that he/she is being sent a new letter, the receiver examines the first symbol received which in this case is "-". Starting from the top of Figure 13, the receiver moves to the right and one level down. The next symbol to arrive is ".". Thus the receiver moves to the left and another level down. The next incoming symbol is "-" so the receiver moves to the right and another level down. Now, the receiver detects that the complete letter has been received since the next symbol would indicate the beginning of a new letter. The receiver then retrieves the letter associated with its location in the tree diagram: the letter *K*.

The lesson here is that by analyzing the process that you wish to carry out simultaneously with the format of the data you need to access or manipulate, you may come up with more effective ways of accomplishing your desired task. Using this technique of analyzing the structure of data can serve as a catalyst to help you pinpoint your business vision.

SUMMARY

I discussed some powerful problem-solving techniques and showed how they can be employed to help develop and/or fine-tune your vision.

These problem-solving tools will not identify your vision for you. However, if you have identified a potential area and need to pinpoint the particular business opportunity that will serve as the building block for your vision, these problem-solving techniques may indeed be of assistance.

KEY POINTS COVERED

- Problem-solving techniques are not automated formulas to create your vision. They represent tools that can be of assistance in identifying a business opportunity if you have an initial general area under consideration.
- The four problem-solving techniques covered were:
 1. **Variables vs. constants**
 When faced with a problem, list as many variables as you can. Then examine each variable and ask yourself if adjusting that variable could help you solve your problem.
 2. **Life cycle diagrams**
 Use life cycle diagrams to represent your knowledge of the area in which you would like to find a business opportunity. Then, using the diagrams as a framework, you can systematically try to identify a business opportunity that may work for you.
 3. **Binding time**
 Analyze the binding times of the problem you are considering. The earlier you bind, the simpler and more cost effective the solution. The later you bind, the more flexibility you will have but the more complex and more expensive the solution will be.
 4. **Data structures**
 Analyze the data structures manipulated in the problem you are considering. One of the most powerful ways to understand a problem is to represent the data manipulated in that problem in different ways.

CHAPTER 6

SELLING

AN OVERVIEW

Whether or not your business succeeds will depend on how well and how quickly you sell your products.

The purpose of this chapter is to provide you with a pragmatic overview of what is involved in organizing and managing the marketing and sales activities of a business.

Particular attention is given in this chapter to large sales you can generate yourself. These large sales can be immensely helpful to you in achieving your goals.

A well thought-out marketing and sales plan is crucial for the success of your business.

BACKGROUND

When you start a business, there are many necessary and critical components that must be created and/or implemented properly if you are to succeed as an entrepreneur. You must exercise sound common sense, have the right vision, have a realistic understanding of your market, obtain the required funding, recruit competent staff, build your products on time, and much more.

A fundamental activity that will determine whether your business goes forward or fails is selling your products at a profit. This fact must be ingrained in your mind.

Sales and the implicit revenue represent the bloodstream that will keep your business alive and sustain its evolution and growth.

In order to grow your business you need to grow your sales. Notwithstanding exceptional cases, a firm with no revenues has limited or zero value, unless it owns valuable intellectual property. Other exceptions were during the days of the Internet bubble in the 1990s, when companies with no current sales were being sold at amazing valuations based on the promise of their future sales.

Therefore, the question, "How am I going to sell my products?" should be in your mind from the very first day that you decide to create an enterprise. Moreover, if you cannot put together a realistic plan for sales, you do not have a viable business.

MARKETING VS. SELLING

Marketing and selling are intertwined terms. Discussion abounds as to what is marketing and what is selling and where the boundaries are. For our purposes, that is of little importance. In general, "marketing" refers to the aggregate of functions involved in moving products from producer to consumer. Within marketing, we shall employ the term "selling" to refer to those activities more directly associated with the process of obtaining a purchase order.

OVERVIEW OF MARKETING

In what follows I touch upon key elements of marketing.

MARKETING RESEARCH

You need to delineate your target market and understand its needs. You should convince yourself that the products you are planning to produce represent a solution to the needs of your target market. You should also identify potential changes and threats to your proposed target market and take these factors into consideration when you design your products and marketing plan. Most importantly, you must convince yourself that the target market you are going after will accommodate your revenue and profit goals.

These activities could require large expenditures of money, staff, and time. I am not going to discuss here the techniques conventionally used by large corporations and marketing professionals to carry out these tasks. Suffice it to say that a start-up company typically does not have the resources to accomplish these tasks to the level recommended by marketing gurus. However, you should at a minimum carry out some research, even if it is simply performing some basic market sizing, understanding your competition, and identifying and talking to potential clients.

73

You should be aware that a substantial portion of the information you will need is available from sources that do not charge for it. For example, competitor's websites, company annual reports, government filings, U.S. Department of Commerce and U.S. Census Bureau publications, and professional organizations.

COMPETITIVE ANALYSIS

An important part of your marketing research is the identification and analysis of your competition.

Relevant questions include: Who are your competitors? What are their strengths? What are their weaknesses? How are their products positioned, priced and sold? What is their financial situation? What are their profit margins? What are your competitive advantages? What are your competitive weaknesses?

The answers to these questions will be of invaluable help to position your company and products in the marketplace.

PRICING

Pricing your products just right is a challenge with important consequences. The information gathered in your marketing research will be of much help.

How should you price your products? Many articles have been written on pricing theory. How much effort are you going to dedicate to reading such articles vs. basing your prices on the information you have collected, your goals, costs, experience and common sense, while monitoring the results to adjust accordingly?

MARKETING COMMUNICATIONS

An important marketing function is the promotion of your company and its products and services. Marketing communications typically includes the creation of brochures, advertising, press releases, a website, direct mailings, email campaigns, and seminars, as well as direct customer contacts, press or trade journal relations, attendance at trade shows, and other related activities. All of these activities are quite expensive.

Writing, designing, and printing brochures will be costly and time-consuming. Advertising in publications or online search engines is expensive.

Creating and maintaining a well-designed website will also incur expenses, as will direct mailings and email campaigns. Seminars to present your products to potential customers necessitate preparation, staffing and travel expenses.

Direct customer contacts require sending people on the road with the associated costs.

Maintaining press relationships and issuing press releases necessitate at least one person dedicated to working on these tasks.

Attendance at trade shows requires designing and creating a booth (a serious expense), as well as transporting and staffing the booth during a show. Also, trade shows tend to impose a stiff charge for booth space. And do not forget the costs of the staff traveling to the show and staying at a hotel for its duration.

The point is that all of these activities involve significant personnel and financial commitments.

SELLING STRATEGY

What sales channel(s) should you use? Should you employ distributors? Should you utilize the Internet? Should you have a telesales staff? Should you try to have your own direct sales force? Should you have some combination of these different channels?

Your answer to these questions will make the difference between success and failure.

OVERVIEW OF SELLING

Successful selling requires a well thought-out methodology. To make the point, consider anew the sales life cycle presented in Figure 8.

Fig. 8 Sales Life Cycle

As we discussed previously, the prospecting phase could be first divided into requests received from potential customers or unsolicited calls a person makes.

Requests received could come via the telephone, email, letter, fax, advertising response cards, trade shows, seminars, business partnerships, your website, etc.

In the case of unsolicited calls, there is the issue of identifying the list of people to call and their telephone numbers as well as the list of people to email and their email addresses. Techniques to get through on the telephone or to get through email filters come into play, as well as many other related issues.

Once a prospect is identified, a determination has to be made as to who is to make the contact and how that potential customer is contacted. For example, should contact be made through a dedicated group in the corporate office, from a field office, or through face-to-

face contact? The answers to these questions depend on the type of product being sold, the type of marketing and sales organization that exists, the average dollar amount of a sale, the politics of the selling organization, and a number of other factors. It is also critical to keep in mind that all of these activities are controlled by the available budgets.

There is a boundary between prospecting and qualification. At what point is this transition to occur and how is it managed effectively?

The qualification phase could be divided into financial, business and technical, if appropriate. That is, does the potential customer have the means to buy, does his/her business justify a purchase and, if pertinent, does the customer have the technical equipment and training to utilize your products? Furthermore, are you talking to the right individuals?

The selling organization must answer some key questions. Can we play? More importantly, can we win?

It is relevant to point out that in my experience, regardless of whether you are a one-person sales operation or a member of a large sales organization, it is important that you clearly understand your sales life cycle if you wish to succeed. **In a start-up situation where you wear multiple hats, you must understand the timing and purpose of each hat**.

Returning to the sales life cycle, it should be clear that it is a sophisticated process not easily carried in one person's mind. It needs to be automated and monitored.

After some experience in your sales environment, you should establish some metrics concerning the number of potential sales needed at each phase or sub-phase of your sales cycle to meet your revenue goals. For example, you may find out that you need two hundred prospects (i.e., candidates entering the prospecting phase) to have one sale exiting the procurement phase. You may also find out that, on average, it takes six months for the prospect who becomes a sale to travel the length of your sales life cycle diagram. These types of numbers are critical for realistic sales management and forecasting. Remember, your sales are your revenues!

At this point you may feel that the aggregate of the issues listed and their costs are so overwhelming that perhaps you should forget about starting a company. It is not my intention to discourage you. Rather, it is to make you well aware that if you follow the advice of the gurus of each discipline, you will never get off the ground. The cumulative tasks are too immense. Further, the dynamics of the marketplace are continually changing. Even if you manage to perform all the tasks recommended by the experts, by the time you finish, many of your conclusions will already be obsolete.

So what do you do?

What you do is what you will need to do, not just in marketing and selling, but in every other facet of your effort to start a company. You list and understand what the experts recommend you do. This collection of recommendations assumes you have all the money and time in the world, but if you did, you would not be trying to start a business. So you create a shorter list with the activities you believe you must do, and you list and understand the resources you have. If you don't have enough resources to do everything on your short list, you eliminate some items or you reduce the scale of others. You keep working on your short list until the resources you have available and the cost of the activities you have designated as priorities balance each other. We will come back to this process later on, after we cover topics such as funding and lawyers.

MARKETING AND SELLING: THE PLAYERS

Another view of marketing is that it is the collection of activities that identifies qualified prospects for your products. Selling is the process of getting those prospects to issue a purchase order for your products and to issue this purchase order as rapidly as possible and as large as possible.

Marketing and selling are major psychological challenges. In marketing, your objective is to do all that is necessary to identify qualified prospects who will view your company, your staff, and your products as a potential solution to their problems. In fact, marketing efforts may even have to educate the prospect on the

existence of a problem they didn't realize they had. To illustrate this last point, I recently watched an advertisement on television warning viewers about "restless leg syndrome" and presenting a medication to cure this problem. Frankly, it never occurred to me that my legs could be acting independently and that to prevent the potential rebellion of my lower limbs there was a medication I could buy.

You should read a basic marketing book to obtain an overview of the issues. Your bookstore or library will have books on this subject. For a discussion of specific marketing strategies, I also recommend you read Ries and Trout's books [Ries 86 and Ries 90] as well as Moore's book [Moor 91].

Successful selling requires the effective handling of numerous issues. For example, if you are selling to large corporations, the better you understand such issues as their organizational charts, their political environment, their decision processes, the perceived decision makers, the real decision makers, their problems, and many other appropriate issues, the more successful you will be. There are a couple of excellent books you should read to obtain a better overview of all the basic issues involved [Mill 85 and Hold 89]. In addition, each of these books presents in detail a different selling methodology.

Later in this chapter I will discuss how you can take advantage of the Internet in your marketing and sales activities, and I will provide you with appropriate references if you wish to carry out further reading.

THE PLAYERS IN MARKETING

Before I continue, let us pause and face reality. When you are starting your company, you are the marketing strategist and you are also the marketing staff. However, at some point, you will begin to expand your organization. I now address some of the challenges you will face at that time.

In my experience, finding a good marketing person to include on your team is a challenge. If you advertise for one, you will receive a large number of applications. Lots of students graduate with a degree in something that includes the term marketing, and they

believe that they are marketers. Regrettably, very few are. What you need is a bright and energetic individual with basic marketing training and experience, who is affordable and hungry for success. Whether or not that person has a degree in anything is not of much importance. You want an individual capable of independent thinking who will design and execute a great marketing plan for your new company.

What you want is someone who understands the limitations of your tight budget and who will work within those constraints, a person who will be highly creative in utilizing conventional as well as unconventional resources to get the job done. You seek an individual who will take over whatever marketing work you have done thus far and build on it and evolve it. You need a person who will interact well with you and who has the ability to convince others on your team that his/her plan is a good one. Of course you should expect such an individual to lobby for additional budget, but everyone on your team will be doing that, and it is your management challenge to deal with those requests.

Now, the reality is that the probability of your finding this marketing person early in your entrepreneurial trek is very low. So what do you do? Once you are ready to start delegating your marketing hat, you look for the ideal individual and settle for the best person you can find who meets your minimum standards of qualifications. Your common sense and your ability to evaluate people will be of much importance in deciding when and who to hire.

After hiring that person, you do not just hand over the marketing function and move on to other activities. What you do is delegate tasks incrementally with regular evaluations of his/her performance. At some point, and you cannot afford to wait long, you must decide if this person is the right one for the job and act accordingly. The answer will become clear within a short time. If you made a hiring mistake and this is not the right person, you need to terminate this individual and start recruiting afresh. If you are fortunate enough to have hired wisely, you can begin delegating more and more of the marketing activities. More often than not, your evaluation of your

new marketing hire leads you to mixed conclusions. In that case, in order to make a decision you have to rely again on your common sense, your "gut feelings," and your grasp of everything else going on in your entrepreneurial efforts at the time. Remember that this is your company and you need to keep a close eye on marketing.

Sometimes someone you never considered as a marketing person may turn out to be your marketing star, which solves your problem. The way your discovery comes about is that in team meetings on key company issues or in one-to-one discussions, you realize that this person has innate marketing talents. That marketing star-in-the-making has had other duties on your team. You will need to find someone else to take over those duties before you have him/her make the transition to the marketing position.

Your organization could also evolve more conservatively. You may not be able to find a marketing manager you can afford who meets your criteria, or you simply may decide that it is too risky to hire someone new and place such critical responsibilities on an unknown. So you decide to continue wearing the hat yourself. You hire one or more members of a marketing staff, typically to carry out marketing communication functions. With time it is your hope that one of these staffers could be the marketing manager you seek. This is not a bad way to proceed if you feel comfortable with the marketing plan you have initially put in place.

To illustrate the point that innate marketing savvy sometimes resides where you least expect it, consider the following short story extracted from a news item published in *The Wall Street Journal* [Vara 07].

The head priest

In India, Lord Balaji is one of the most-worshiped local incarnations of the Hindu Lord Vishnu. His adherents flock to his many temples to pray for such things like happiness, prosperity and fertility.

In the late 1990s the small Chilkur Balaji temple in the outskirts of the city of Hyderabad—the capital of the southern state of Andhra Pradesh—drew just two or three visitors a week.

C.S. Gopala Krishna, the 63-year-old head priest of the Chilkur Balaji Temple, wanted more people to come. Earlier in his life Mr. Gopala Krishna had studied commerce in college and had worked for a consumer products giant.

Mr. Gopala Krishna realized that there was much frustration among many Indians, particularly educated Indians, who wanted to travel or move to the United States and other Western countries. The problem is that it is very difficult to obtain a visa, especially to work in the United States. He also realized that the number of such visa seekers was quite large.

Well, here is what Mr. Gopala Krishna did. He gave Lord Balaji a new identity. He named Lord Balaji the Visa God. He told visitors that if they walked around his temple 11 times they would get their wish of obtaining a visa.

The temple is currently drawing 100,000 visitors a week, many of whom come to pray to Lord Balaji, the Visa God, for visas. Billboards now stand on the dirt road to the temple advertising English-language schools and visa advisers. Next to the temple parking lot, vendors hawk souvenirs and fruit. Mr. Gopala Krishna has also launched a website and a newsletter called Voice of Temples, which offers a primer of sample prayers for help in visa interviews.

THE PLAYERS IN SALES

Creating your sales organization and hiring salespeople is much more challenging and failure-prone than finding a marketing manager and marketing staff. Moreover, mistakes in hiring salespeople have an impact on your revenue stream in the immediate and near future. This can be fatal to your plans for success as an entrepreneur. At the very least, such hiring mistakes will delay and curtail your progress.

The decision as to what type of sales channels you are going to employ is an absolutely critical one. In the case of some products, specific sales channels are necessary. For example, if your average sale is $200,000 it is likely you are going to require face-to-face

contact with your prospects to close your sales, although some would say it is possible to sell a $200,000 product over the Internet.

Once you decide on your sales channels, you need to staff accordingly. For example, a telesales channel (whether through the telephone or through the Internet) has different staffing requirements than a direct sales channel where the salespeople have face-to-face contact with potential clients.

As in the case of marketing, you can follow different hiring strategies. You can hire a sales manager and incrementally pass on to him/her more and more responsibilities. Or, depending on your confidence level and your available funding, you can give this sales manager quite a bit of latitude to start a sales organization. In either case, you need to monitor closely what is happening; sales is your bloodstream. Alternatively, you can continue to wear the sales management hat and hire sales staff while you develop or find the appropriate sales manager. In any case, a sales manager is a key player in your organization, and you need to do everything in your power to find the right person for the job, despite the fact that it is a difficult and challenging problem.

You must set sales quotas for salespeople. There are different thoughts by successful sales professionals as to whether sales quotas should be set at a realistic and achievable number, or above or below this number. Regardless of how you set the sales quota for a salesperson, a sales channel, or an entire sales organization, these are your metrics for sales management. The majority of salespeople are by nature highly optimistic. Therefore, they promise sales performance way above what most can achieve.

Keep in mind that if you have a well-defined sales methodology in place, you can monitor the flow of prospects through the sales life cycle. You should have a good idea of how many prospects there need to be at different points in the sales cycle to achieve a desired number of sales. You should be regularly monitoring these numbers and their quality to avoid surprises.

You should make contact with sales prospects at various points in their trip through the sales cycle. It is important to determine the

credibility and reliability of the sales forecasts you are receiving from the salesperson and your sales manager.

It is a fact that frequently salespeople and sales managers will fail to meet their expected sales quotas. In each case, you will hear excuses ranging from faults in your products to poor product pricing to a lack of resources, as well as many others. You are faced with the decisions necessary to fix the problem. You have to be focused on meeting your revenue goals. You will often wonder whether or not your revenue goals are realistic and/or attainable in a given time frame.

You will also face the problem that replacing a salesperson has an impact on his/her sales pipeline, which was costly to develop. This pipeline will now be placed in jeopardy, unless you discover that it was unrealistic or made out of smoke.

LEVERAGED SALES

Let us pause and face reality one more time. When you are starting your company, you are the head of sales, and you are also the sales staff; therefore, before you start thinking about creating a sales organization, you should ask yourself how you can leverage your sales efforts to bring in substantial revenues. If you succeed in such an effort, in addition to having revenues to run your company, you will have more credibility when trying to hire salespeople.

The way to realize leveraged sales is for you to make some large sales and/or to make deals with large organizations to resell your products or incorporate your products into their products. This is no small challenge. It will test your creativity to be unconventional, it will test your sales abilities, it will test your perseverance, and it will test the acceptability of your firm and its products.

In searching for these leveraged deals you also have to be careful not to give the store away. What that means is that you have to be extremely careful in signing any exclusive deals that would prohibit your company from selling to others or prevent your company from selling directly in certain areas. Larger companies will try to use their weight to extract such exclusivity deals.

Now, let's turn to the basic question of how to find and close such leveraged deals.

There is no formula or textbook that will give you the answer. You have to use your intellect and common sense. The following stories illustrate what is required.

The minicomputer opportunity

When I started my software tools company, I was the sales force. I concentrated on the challenge of finding leveraged deals and making large sales.

Of my initial products, there were two that were particularly simple to understand, install and use. One was for testing computer programs and the other was for optimizing the running time of computer programs. We called them the Testing Instrumenters and the Optimization Instrumenters. These products were geared to the scientific marketplace (e.g., engineering and research companies) rather than the commercial marketplace (e.g., banks and insurance companies). They were pioneering products automating tasks not previously automated.

At this point in the computer industry (the late 1970s), there was a major market segment that bought "minicomputers." Simply stated, these were computers much smaller in power and cost than the large mainframe computers. They typically sold for less than a hundred thousand dollars rather than a million dollars or so for a mainframe computer. Low-cost personal computers did not have a serious market presence at that time.

There were quite a number of minicomputer companies, some with yearly sales in the billion dollar range and many with yearly sales in the hundred million dollar range. The smaller companies did not have the resources to produce much supporting software. Thus, they tended to specialize in specific market segments. These facts led me to conclude that they represented an opportunity for a pure software company like ours. At the time, minicomputers were a fast-growing market.

I needed to find a leveraged deal with my Instrumenters, so I asked myself, "Who are the customers who buy minicomputers and

then need to have their programs run as fast and as reliably as possible?"

After some homework I discovered that those people doing scientific simulations were always in need of making their programs run faster, since speed was a limiting factor in their ability to carry out more complex simulations. I also discovered that this was a substantial market spending several hundred million dollars a year in minicomputers for their simulations. Then, I went on to identify the minicomputer companies that specialized in selling to the simulations marketplace.

For several reasons the one most appealing to me and the leader in this segment of the market was a company called Systems Engineering Laboratories (SEL) based in Fort Lauderdale, Florida. As I recall, their yearly sales at that time were about $70 million. As I suspected, all they offered their clients was a basic set of software to run their computers, with no software tools of any kind. It looked like a made-to-order opportunity for a leveraged deal. It was time to start my sales process.

After some effort I contacted one of the company's three regional sales managers, a young and knowledgeable man who was well-respected within SEL. He recognized that we offered the potential for a competitive advantage and became our champion within SEL. He talked to the other sales managers and to his boss, the vice president of sales. I had successfully created a positive swell for my forthcoming sales proposal to SEL. Of much value was the fact that this swell was originating within their sales force.

When I called to meet with the executive vice president of SEL who ran their day-to-day operations, he had already been "softened" by his own sales organization. My proposal was that SEL provide us with a computer, and we would take responsibility for making the Instrumenters work in their computers. Further, we would deliver a finished Instrumenters package that they could sell to their clients. We would jointly agree on the selling price and maintenance fees for the Instrumenters, and we would share the revenues 50/50. He assigned their software product manager to evaluate our proposal.

They had no software products at the time. This man had recently been hired to find software products for SEL.

After several visits to my company, the software product manager produced a report in which he concluded that SEL should not enter into any agreement with Softool. Based on his analysis of the business relationship I was proposing, he projected total yearly revenues for SEL of about $70,000 and yearly expenses well above that. Thus, his conclusion was that this was a losing proposition for SEL.

I learned about the contents of this report and got on an airplane for Fort Lauderdale to meet with the executive vice president. I was logical in my argument that this report did not make sense and that there was a great opportunity for both of our companies. Furthermore, they had little to lose by trying it. I managed to convince him to proceed and enter into an agreement with us. The agreement was to include both the Testing and the Optimization Instrumenters.

I thought I had a done deal. Well, I had much to learn. The executive vice president assigned the business and contracts vice president to negotiate a deal with me. He had the perspective that SEL was a $70 million computer company (a respectable number in those days) and we were a small start-up with little revenues. So, he came back with a proposal that we split the revenues obtained through sales of the Instrumenters 90/10. The 90% was for them. He also insisted that we provide them exclusivity in the minicomputer marketplace so that no one else could sell our Instrumenters on any other minicomputer brand. They stood firm on their offer.

Although we were hungry for business, after much thought, I decided to reject their offer and stick to my original proposal.

I had several reasons for doing so: (1) if we provided exclusivity, our growth plans would be killed; (2) we would become dependent on SEL; (3) we represented a great market differentiator for them, giving them increased computer sales; (4) any revenues they obtained by selling the Instrumenters would represent profits going directly to their profit line; (5) I had learned that their sales

organization was putting a lot of pressure on the executive vice president to make this deal; and (6) it was abusive on their part.

They invited me to come to Fort Lauderdale for another meeting. When I walked into the meeting room and saw the executive vice president, the business and contracts vice president, and their president, I realized they were there to do business. On my side, it was just me. It was a bit overwhelming.

After a couple of hours of discussion, they dropped their request for exclusivity and offered a split of 75/25. Of course the 75% was for them. They told me that was their last offer and that I was to take it or leave it. To be honest, my stomach was churning. Nevertheless, for the reasons listed above, I stuck with my original proposal. As a result, the meeting ended, and we said our polite good-byes. As I was getting in my car with a feeling of emptiness, the business and contracts vice president ran out and called to me, "Come back! We accept your deal!"

In the first year of our agreement, the Instrumenters revenues reached $2 million. In the second year they were $4 million. It was a very successful relationship for both companies that lasted for several years.

Postscript to the story. I developed a lasting personal friendship with the executive vice president, the business and contracts vice president, the regional sales manager, and several others at SEL. The relationships continued after several of them moved on to other companies.

The Rolodex roulette

For young readers who may have never seen a Rolodex, it is a pre-computer era gadget that sat on your desk, a small rotatable cylinder with removable cards. You recorded contact information on each card, with one contact per card.

In an excellent presentation that is as applicable today as when it was delivered, Ed Bersoff, a successful entrepreneur, discussed the trials and tribulations of the early years of his company [Bers 94]. His company was to be an engineering and software development firm. He had run a small company in the same general area for

someone else before he embarked on the creation of his own enterprise. He had a reputation as someone who was competent and got things done. When he began, however, he was a one-man operation. In his presentation, he described how he negotiated his first leveraged deal.

He referred to his approach as the Rolodex roulette. He started calling the contacts on his Rolodex, one at a time.

He received a call back from a large company named System Development Corporation (SDC), which later became part of an even larger corporation named Unisys.

When he met with the SDC people, they told him, "We want you to become a consultant for us." Bersoff refers to that meeting as a key turning point in his entrepreneurial life. He did not want to be a consultant. He wanted to build a company. He said he gulped and said, "I cannot do that, but I'll tell you what. Why don't you give me a $250,000 contract for the next six months? I'll bring a couple of people over to do work for you because I think we can help you. But I won't take a consulting contract, and by the way, I'm not going to work on it full-time, either. I'll work on it half-time, because I need some time to go out and sell."

Bersoff states that he left that meeting wondering what kind of a fool he was. However, he felt that if he did not stay on track towards his goal, he would never achieve it. SDC eventually took his deal.

The moral of these stories is that it is indeed possible to create leveraged sales deals. As the above stories make clear, however, it is not a task for the faint of heart.

INTERNATIONAL SALES

Another area that you must explore is the international marketplace. You may be surprised at the opportunities you may find for the sale of your products. Address the market on a country-by-country basis, doing some homework and prioritizing the countries you should explore. Once you have such a list, you need to be creative in finding ways to reach those markets. Using distributors or agents who are not on your payroll but share in the

revenues is the only reasonable way to start. Approach the distributors that sell other products to your customer base. Find out who is distributing your competitors' products, and approach the competitors of those distributors.

Developing a successful sales organization and a predictable revenue stream is a formidable challenge. You need to move with caution, in incremental steps, and with much common sense.

THE INTERNET IN MARKETING AND SALES
The Internet is a rapidly growing and dynamic force in marketing and sales. You will need to consider it carefully and decide how and to what extent you base your marketing and selling efforts on the Internet. There should be no question in your mind that the Internet needs to be an important part of your marketing and selling efforts.

In what follows, I will summarize some key concepts that will help you make effective use of the Internet.

1. You must be clear on the differences between marketing and selling items that are expected to be *hits* (i.e., items that account for a large number of sales) and *niche* items (i.e., items that appeal to specific niche markets and sell in limited numbers.)

For an excellent discussion of this topic read the book by Anderson [And1 06]. Anderson introduces the concept of 'the long tail' brought to the surface by the Internet. The implication of the long tail is that the aggregate value of the sales of a sufficiently large number of niche items can equal or surpass the value of the sales of hit items. With the Internet, the long tail can be reached economically (e.g., vast reach, no constraints of physical shelf space, manufacture on demand). Thus, the Internet truly opens a new dimension for the marketing and sale of products. In particular, Anderson's book will help you understand the core strategies employed by such successful Internet-based companies as Amazon, Netflix, eBay and Google.

2. **The Internet is a platform of cooperation**.

This represents another dimension to the power of the Internet. The more successful you are in having your potential clients add value to your Internet offerings the more successful your marketing and sales efforts will be. A good example is Amazon where user reviews of books add value to the site. Social websites (networks) like Myspace, Facebook, and Bebo are prime examples of what can be accomplished through the cooperative power supported by the Internet.

Another fascinating example is offered by Wikipedia, the most popular encyclopedia ever, which has been created and is maintained by anonymous people around the world. Consequently, the venerable Encyclopaedia Britannica recently announced a program for letting people contribute to entries, with a formal process for professional oversight [Cro1 09].

You should try to forge a two-way relationship with your consumers and potential clients covering such issues as product development, customer service and product promotion. For an excellent discussion of these topics see the articles by O'Reilly [O'Re 05] and Parise, et al. [Pari 08].

3. **The Internet is a continually growing collection of communities [Haye 08].**

Consumers are increasingly organizing themselves into communities dedicated to specific areas of interest such as photography, fishing, video games, and infinitely many more. Such communities embody golden business opportunities where the dollars spent in marketing and sales efforts can lead to serious market penetration and highly lucrative results. The challenge is to devise successful viral techniques that indeed propagate your message like a virus throughout the targeted community.

Compared with efforts to focus on pertinent Internet communities, conventional broad advertising campaigns may indeed represent a very inefficient use of marketing resources.

Corporations such as IBM and Toyota are establishing their own affiliated social networks in order to bind their customers closer to

their offerings. Such networks can be viewed as bringing the old user's groups associated with a company's products into the Internet age.

To succeed in leveraging the power offered by these user communities you must overcome some key challenges. For example, you have to navigate your way into the community and devise ways to capture and reward consumer attention without antagonizing its members. Also, these communities are often self-governing, and you must find acceptable ways to work with its leadership.

4. **Your Internet strategy must support your business model**.
The best way for me to drive this point home is through a simple example. Consider Google. Google's revenues are created by sending potential clients to the websites of those companies that advertise through Google. Google gets a fee for every potential client they send to an advertiser. Thus, they want to maximize and expedite traffic to their advertiser's sites. When you go to Google's website all you are presented with is a simple box to key in what you are searching for. The rest of the page is blank; there is little to distract and delay you. Compare this to Yahoo's website.

5. **Websites are becoming more and more dynamic**.
Early website designs presented static information to visitors. Now, websites can be designed to change dynamically and to notify users that a change of interest to that user has occurred. For example, I can subscribe to a financial website and request that when certain stocks of interest to me reach specific values that I be immediately notified. Again, this represents another dimension to the power of the Internet.

From the discussion thus far it follows that effective utilization of the Internet in your marketing and sales efforts requires the creation of a well thought-out strategy.

You will also need to consider such issues as the proper design for your website, taking steps that optimize the results of search

engine indexing programs so that your site is brought to the attention of searchers as often as possible, search engine selection for your advertisements, blogging, customer reviews and recommendations, email campaigns, and many others.

A well-designed website should convey the image of a larger company, one that understands the potential client's needs and that has the products and services to solve these problems.

In addition, if your products are such that you can process sales orders directly on your website, you will need to put in place the mechanisms to accept credit cards, create inventories based on demand, and package and ship products on a timely basis.

To illustrate the possibilities, let me discuss one powerful channel for Internet sales.

Affiliate marketing (also known by other names such as Associate Programs, Partner Marketing, Pay-For-Performance Programs, or Referral Programs) is an arrangement in which you recruit partners (i.e., affiliates) who agree to display your advertisement on their website, with links to your website. In exchange, you agree to pay the affiliates a commission on any leads or sales that result from those advertisements.

In essence, what you are doing is creating a network of selected websites that will refer potential clients to your site.

To implement this approach, you not only have to identify and recruit appropriate affiliates, but you also have to provide the material to be easily incorporated in the affiliates' websites, design an appropriate "landing page" on your website to optimize the number of leads that convert to sales, track referrals, make timely payments to affiliates, and monitor and analyze the cost effectiveness of this marketing channel. Furthermore, affiliate marketing requires continual management of these activities. If you do not produce income for an affiliate, you will probably be dropped from their website. You can manage these monitoring activities, or you can outsource the implementation and management of an affiliate marketing program to another company.

Affiliate marketing is a strategy that exemplifies how technological developments can offer new business opportunities in established business areas.

Another couple of examples of technology opening new business opportunities for the astute entrepreneur are Law School Expert (www.LawSchoolExpert.com), a website dedicated to assisting law school applicants, and Insider Medical Admissions (www.InsiderMedicalAdmissions.com), a website dedicated to assisting applicants to medical school.

The Internet is a formidable technology offering many possibilities and opportunities. It is up to you to take advantage of them.

It is important to emphasize at this point that the marketing and selling activities discussed in this chapter will need to be carried out not only at the onset of your company, but throughout its life cycle. For instance, the fact that you have a competitive advantage at the beginning of your business does not guarantee you this advantage forever. You will need to continually do your homework to try to maintain this competitive advantage as long as possible.

SUMMARY

In order to succeed, you need to sell your products at a profit, and you need to sell them as soon as possible.

This chapter provided you with a pragmatic overview of what is involved in organizing and managing the marketing and sales activities.

In particular, I called your attention to large sales that you can generate yourself. These large sales can be of immense help in achieving your goals.

KEY POINTS COVERED

- The fundamental activity that will determine whether your business goes forward or fails is selling your products at a profit. This fact must be ingrained in your mind.
- The question of how you are going to sell your products should be in your mind from the very first day that you decide to create an enterprise.
- Marketing is the collection of activities that identifies qualified prospects for your products. Selling is the process of getting those prospects to issue a large purchase order for your products and to issue this purchase order as rapidly as possible.
- You must develop an explicit strategy for the creation and growth of your marketing and sales organization.
- Explore the use of the Internet as a component of your marketing and sales strategy.
- You should give personal attention to making large sales as soon as it makes sense to do so.
- Closing large sales early in the life of your company requires conviction and confidence in your business plan.
- Use leveraged sales as a way of bringing in substantial revenues.
- Investigate the international marketplace.

CHAPTER 7

FUNDING

AN OVERVIEW

Without money there is no business.

In this chapter I am not going to discuss how much money you need for your new company. I will do that later on.

What I am going to cover is: Where can you go for money?

In discussing the main alternatives in procuring funding, I will examine the advantages and disadvantages of each alternative.

I will view the issues from your perspective as well as from the perspective of your potential lender or investor.

This is precisely the kind of knowledge you must have before you decide to select and approach a potential lender or investor.

BACKGROUND

When you obtain money, there are strings attached. Most of the time, these strings can be quite dangerous.

Before I proceed, you need to understand clearly the difference between obtaining money by borrowing and obtaining money by providing equity.

Equity is the term commonly used to denote percentage of ownership. When you sell equity in your company, the provider of the money becomes your partner.

When you borrow, the lender will charge you interest for the debt; however, the lender will have no ownership in your company unless you default on the payments.

SOURCES OF MONEY

There are a number of different ways to obtain the money to fund your start-up. They include:

1. Your personal savings

2. Borrowing
 - On your credit cards
 - From family and friends
 - On a bank line of credit
 - Other sources
3. Creative financing
 - Leverage
 - Bartering
 - Suppliers
4. Venture capital
5. Angel investor
6. Government

1. YOUR PERSONAL SAVINGS

I assume you are committed to your entrepreneurial challenge. The question is, how much money do you have in savings or can you generate in another way, including selling assets you may own?

You will have to plan not only for the money necessary to launch your new company, but also for the money required to maintain your personal life. You will not draw a salary until your company can afford it. If you put all the money in your company and then pay yourself a salary, your available money will be reduced by the payroll taxes the company needs to pay.

Whatever amount you are able to put together is what you have to start your business. Then, whether it is on day one because you have no money or one year into your company's life because you had enough money to carry it to that point, you will need to find other sources of money.

2. BORROWING
Borrowing on your credit cards

If you have one or more credit cards, you could borrow from your credit card companies. There are two major problems with this approach:

1. The **interest** you are charged on money you borrow is **very high** and builds up quickly.
2. You must have a plan to pay back the loan. Typically, you do not have sales revenue coming in when you are starting your business. **Thus, think it through carefully before you borrow on your credit cards.**

Later on, after you have a revenue stream, you can borrow on your credit cards to bridge temporary cash flow problems.

Borrowing from family and friends

Your family and your friends are the people who know you best and who trust you. They are emotionally linked to you and want you to succeed. Because of their personal attachments, however, they will probably make the decision whether or not to lend to you on an emotional basis rather than on a business one.

Borrowing from family and friends places on you a very serious moral burden. You should consider carefully how you would pay the money back if your enterprise fails. Otherwise, how are you going to face Uncle Mike who lent you the $100,000 he had saved for his retirement?

Let us next consider going to the bank for a loan.

Borrowing on a bank line of credit

For a start-up without assets or revenues, obtaining a bank line of credit guaranteed by the company alone is extremely unlikely. A bank may give you a line of credit but only if you have the supporting assets to guarantee repayment personally.

Be aware that even though you may be guaranteeing the loan with an asset such as your home, the bank may not give you the loan when they learn that you are going to be unemployed and risking all the money in a start-up.

If you own a home and have equity in the home, you may obtain a mortgage. During periods of loose lending practices, such as 2005-2007, banks will lend you 80% to 100% of the appraised value of your home [Valu 08]. In difficult economic times, such as 2009,

lending criteria are much stricter, and banks will lend you a much lower percentage of the appraised value of your home.

There is a difference between a line of credit and a mortgage. In both instances, you will be required to use your home to guarantee repayment of the money you are borrowing. With a line of credit, you have the ability to borrow as needed up to a preset limit. You may or may not, at your discretion, draw money on this line of credit. With a mortgage, you are borrowing a lump sum of money up front.

Accounts receivable line of credit

Once you have a revenue stream, you can approach the bank for a line of credit based on your accounts receivable (i.e., the money owed to you by customers).

In this case, you are guaranteeing any monies you borrow with your accounts receivable. After the bank eliminates any accounts receivable that are not acceptable to them, they will give you a line of credit of 70% to 85% of what is left. In difficult economic times the bank will be much more selective in the accounts that it accepts, and the line of credit will be at a lower percentage of the accounts receivable. You have to provide the bank with an updated list of your accounts receivable at agreed intervals of time, such as at the end of every month or every quarter.

You must be aware of the following potential problem with this type of credit line. Suppose your current credit line is for $400,000, and you have borrowed $400,000. You deliver to the bank your updated accounts receivable showing the total amount of receivables as less than in the previous period. The bank will recalculate your new maximum credit line. If they determine your maximum is now $300,000, they will demand immediate payment of the extra $100,000 you have already borrowed.

It is very likely the reason your accounts receivable are down is that you have hit a period of low sales. By the time you update your accounts receivable, you may have identified the problem and begun to fix it or you may have already fixed it; however, it takes time for the accounts receivable to build up again.

This is precisely when you need your credit line, and the bank is asking for repayment of $100,000! Such a situation can keep you awake at night, so plan carefully before you draw on all of your available credit.

Here's a word of caution about using your accounts receivable as collateral. It is important that your customers feel confident you are a growing firm that is going to survive over the long term. In order to gain business, your bigger competitors will say you are a small company with weak financials and that you will not be around long. If the bank starts contacting customers in your accounts receivable list, they will in fact be providing ammunition to your competitors. You should discuss this problem with the bank. A reasonable bank officer will understand the issue and work with you. If that is not the case, look for another banker.

When you initially set up your accounts receivable line of credit, it is almost a certainty that the bank will also ask you for a personal guarantee. If your company defaults on its debt, the bank will be able to come after you personally. When you begin your relationship with the bank, try to negotiate a written agreement that defines at what point the personal guarantee will be eliminated as your company grows.

Also be aware that your loan agreement with the bank will probably have an "annual clean-up" clause in it. This means that once a year you must pay off any money you have borrowed and refrain from borrowing for a specified time period, usually thirty days. If your agreement with the bank incorporates such a clause, you need to plan accordingly.

Once you have a revenue stream and a revenue history, it is an excellent time to prepare for the eventuality that you may need to borrow money.

Banks are hierarchical organizations in which lower level staff members typically have impressive titles but little power. You need to make certain that you are dealing with someone who has the authority to make a decision on the loan you are seeking. For example, if you are seeking a $400,000 line of credit, you will be wasting your time talking to a bank officer who has an approval

limit of $100,000. Do not hesitate to ask a bank officer to tell you his/her approval limit. In my experience, you have to persist to get this question answered.

Banks like to lend you money when you have tangible assets to offer as collateral (e.g., real estate). They take very little risk and will lend you less than the appraised value of your property. Bank loan officers do not have the understanding or the discretion to lend on other types of assets. The following story makes this point quite clear.

I cannot feel your software

My company had already developed and was successfully selling several software products. I had received a written offer from a larger reputable company wanting to buy the rights to one of our software products for $5 million. At the time I had no intention of selling the rights to any of our products.

However, I thought that I could use this software product as collateral for a bank loan. After all, this offer quantified its current market value.

I went to see a couple of bankers. I explained the situation to them and showed them the written offer I had received with documentation indicating that the offer was from a financially solid company. I said I wanted a line of credit of $400,000 and offered this software product as collateral for the line of credit I was requesting. I emphasized to them that $400,000 represented only 8% of the market value of the collateral I was offering.

I was told that the bank is not a venture capital organization. They could not see or "feel" my software. They turned down my request for a loan.

I made the statement earlier that banks take very little risk when they make loans, especially smaller loans. This has been generally the case. However, there have been instances where banks have stepped outside their traditional realm and made serious investments errors. A case in point came to light in 2008 when many banks that had invested large amounts in speculative homeowner's mortgages

packaged into securities incurred devastating losses, leading to the failure of a number of banks. As a consequence, in 2008, banks became very cautious when approving loans, making it more difficult for entrepreneurs to borrow from them.

When I cover accounting issues, I will provide you with additional information that will be helpful in dealing with the bank.

Borrowing from other sources [Wilm 06, Cove 09]

Credit unions and insurance companies can also be a potential source of funds.

Credit unions offer personal loans to members, which is an option definitely worth exploring.

If you have live insurance, often the insurance company will lend you money against your life insurance policy; however, until the loan is repaid, your coverage will be reduced by the amount of the loan. In many instances the interest rates you are charged by credit unions or insurance companies are lower than those charged by commercial banks.

Factoring is the name applied to another possible way you can proceed to obtain cash. There are companies referred to as factors that will buy your accounts receivables in the amount of the receivables minus a fee. The monies paid by your customers go directly to the factor. A factor fee could be as high as 30% to 40% annually. Thus, you must be making an annualized profit of at least 30% to 40% just to cover the factoring costs!

I never used factoring, and I do not recommend it.

3. CREATIVE FINANCING

The ideal solution to your financial requirements would be for your business to generate sufficient revenues from day one to maintain and grow the business. As impossible as this may sound, it has been done. I know of several cases. In fact, the second company I formed, Compass Corporation, was self-sufficient from day one.

The key is to postpone or eliminate expenses and to obtain the revenues ahead of time.

Leverage

In the previous chapter when I discussed selling, I described two stories—the minicomputer opportunity and the Rolodex roulette. These stories are excellent examples of creative financing through an approach I refer to as leverage.

What follows are two other stories illustrating creative financing through leverage.

The developer

Consider a real estate developer who wants to build a thirty-unit condominium complex in a very desirable area. Let's say she enters into an agreement with the owner of the land to exchange the land for five units of the building to be constructed, a very appealing arrangement for the landowner. Because of the building's location, the developer would be able to presell enough units to raise the capital necessary for construction. This would not be a bad arrangement.

I know of several developers who, during good times in the real estate market, managed to minimize their cash requirements by employing variations of the approach I just described.

The Japanese arrangement

This story concerns Softool Corporation at a point in our business when we had sales and support offices throughout the United States and in Great Britain, France, Germany and Italy—but not Japan. We had made a few sales there, and we were convinced that it represented an excellent market for our products.

After some homework, we concluded that it was too costly and too risky for us to open our own sales offices in Japan at that time. We also decided that what we wanted was a partnership with a large company in Japan to represent and sell our products. We made a number of attempts to identify a potential partner and failed. In the process, we learned quite a bit about the way business is conducted in Japan. We concluded that if we were to succeed, we needed to make contact at the top management levels of the potential partners.

I went back to my list of contacts. About a year earlier, I had met a man at a social event who had told me he had a company specializing in the energy field. He had said his company was doing a fair amount of business serving as an intermediary between American and Japanese companies. He had also told me that he visited Japan every month. After doing some checking on this man and his company, I called him and arranged a meeting.

After explaining our business and our desire to market our products in Japan, I made the following proposal to this gentleman. If he had interest in expanding the areas of business for his company, the software arena had great potential. If he would help us find the right partner, we would agree on a compensation arrangement based on the revenues we received from Japan for a certain period of time. This would motivate him to obtain as much money up front as possible.

He loved the proposal and said that he had interest in expanding his company's activities. He felt comfortable asking his Japanese high-level contacts for introductions, and since he was traveling to Japan every month, the extra cost for him was minimal. We entered into an agreement. As part of this agreement, we would not pay a penny to his company until we received revenues from Japan. He, in turn, had checked us out and was impressed with our reputation.

After a few months, we had several large Japanese companies competing to do business with us. Ultimately, we entered into a partnership with a large Japanese concern that agreed to pay a substantial advance in royalties to us.

Whenever we received a payment from Japan, we immediately sent this man's company its percentage. Our Japanese revenues were substantial and helped to fuel the continued growth of both of our companies.

This story illustrates some important points. First, it is a good example of creative financing. Second, it shows that living up to your agreements is critical to your long-term success. When you and your company develop an image of ethical behavior, professionalism and trust, it will help you to open doors that would otherwise not open. Third, this was a win/win/win situation for the

three parties involved. **Successful and lasting agreements are those in which all the parties in the agreement win.**

Next, I describe another approach that comes under the umbrella of creative financing.

Bartering

To buy supplies or services for your business costs money. If that money comes from company revenues, as you hope it would, you incur costs in obtaining those revenues (for example, sales commissions). Thus, if you need $5,000 for supplies, you must bring in revenues larger than $5,000 by some cost factor in order to end up with the $5,000 you actually need. If you could barter for those supplies, you are in essence eliminating or reducing expenses, depending on what you are providing in exchange. Let me illustrate.

Computer equipment

When I started Softool, our strategy was to have our software run on a number of different computers. To do that effectively, we needed access to the various target computers. In our case, they were computers manufactured by Digital Equipment Corporation (DEC), Data General Corporation (DG), Systems Engineering Laboratories (SEL) and International Business Machines (IBM). At the time, we did not have the money to buy these computers. I needed to do some creative financing. Here is how I went about it in each case.

DEC: I knew the President of a small local company who owned a DEC computer that they used only part of the time. In the past I had done a number of personal favors for him. I went to his office and asked if we could buy some time on his computer. The only problem was that I could not pay for that computer time right away. He agreed that I could pay for it at a future date, as soon as my company had sufficient revenues.

DG: I attended a computer conference where one of the speakers was a senior vice president of DG. A very sharp fellow, he was in

charge of all of their research and development, including software. At that time, DG was one of the top minicomputer companies in the marketplace and a substantial corporation. In his presentation, he focused on software issues as the biggest obstacle for the proliferation of computers. After his presentation I introduced myself. I quickly told him what we were doing and that we wanted to have our products running on DG equipment but could not justify buying a DG computer at this time. He gave me his business card and told me to call him the following week.

When I called, he arranged to have a DG computer system delivered to our office on an indefinite loan.

SEL: In the previous chapter on sales, I told of entering into a contract with SEL. As part of the agreement, we also received a computer.

IBM: Because of the cost, there were very few IBM mainframes in my area, but I knew the local university had one. I tried to obtain computer time on their computer and failed. Next, I went to the manager of the computer operation of a large company in town and asked if we could obtain computer time on their IBM. He knew we were a software company. He responded with the following proposal. He told me he had taken a risk and had bought a large number of graphics terminals for his company's staff. His people were having a difficult time interfacing the software of the graphics terminals with the IBM computer software. His company's management was becoming unhappy, which was not good for him. If we could solve his problem, he would solve ours.

We only had a few people in our company at the time; however, one of our people had come to us from a graphics software company. After he analyzed the problem, he told me he could solve it in a couple of days. I called the manager at the local company and told him we would have his problem solved within a week, and we proceeded to do just that. He in turn gave us access to his computer. The arrangement lasted for about a year until we purchased our own IBM mainframe.

There are a number of Websites promoting bartering by businesses [Spor 06].

Be aware that bartering needs to be treated appropriately for tax purposes. Before entering into a bartering arrangement, be sure to consult with your accountant.

Suppliers

Your suppliers represent another potential source of funding. First, you might be able to negotiate extended payment terms if you have short-term cash flow problems. Second, remember that your suppliers know your industry and have had an opportunity to develop knowledge of your company. If you decide to seek investors, many of your suppliers are successful and astute businesspeople who may be willing to make an investment in your company with terms that are fair to you. They may be amenable to providing you a loan at an interest rate that is attractive to both of you. Also, you may gain a valuable adviser [Turn 04]. On the other hand, be careful in how you approach your suppliers. You do not want them to become concerned that you are a collection problem in the making.

For further relevant discussions on creative financing, you may want to read Gianforte and Gibson's book [Gian 05].

4. VENTURE CAPITAL

As previously pointed out, banks are businesses that lend money when there is little risk that they will not get back their money. All they ask of you is that you pay interest on your loan and that you eventually pay the loan back.

Venture capital (VC) firms, on the other hand, will typically lend or invest money when there is a high risk that they will not receive their money back. The money they provide is referred to as venture capital money. Venture capitalists expect a very large return on their money and will not invest unless they are convinced that this will be the case. Such large returns are necessary for venture capital firms

since it is generally believed that only 1 in 10 [Brow 06] of their investments are really successful; that is, 10% of their investments (some people believe this number is closer to 5 %).

The return on the successful investment has to help cover the cost of all the failures plus contribute to a respectable profit. Therefore, venture capitalists employ investment agreements that are quite biased in their favor to secure the potential return on their investment as much as possible. What venture capitalists ask from you in exchange for their investment is substantial enough that it could leave you with a small return on your investment or even cost you your company.

In what follows, I will provide you with information on what will be asked of you, the dangers involved, and the benefits of accepting money from a VC firm.

For purposes of our discussion, I display in Figure 14 a typical life cycle of a company and employ some of the definitions presented in a book by D. Gladstone [Glad 88]. The different phases have been numbered for ease of reference.

Fig. 14 Life Cycle of a Company

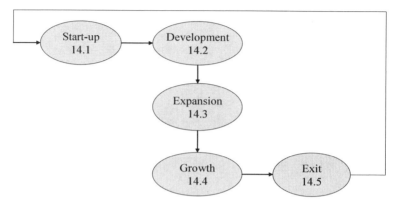

At the start-up phase, all you have is an idea and a business plan. Any money you raise at this stage is often referred to as seed money.

At the development phase, you have managed to prove that your idea can work, typically through development of a prototype or some other means that validates your idea.

At the expansion phase, your company has already created a product or service. You are marketing it with some degree of success, but you need capital for further expansion.

At the growth stage, your company is running well and is generating a profit but needs additional capital in order to continue its strong growth. Typically, your objective at this stage is to reach 'critical mass;' that is the point where your company can be sold, merged, or taken public.

At the exit phase, you have capitalized on your company (e.g., sold, merged, or gone public).

Based on common sense, a few observations can be made.

Observation 1. The earlier you are in the life cycle, the higher the risk for the venture capitalist that invests in you. Thus, it is going to be more difficult to get funding. I display this relationship graphically in Figure 15.

Fig. 15 Stage vs. VC Risk

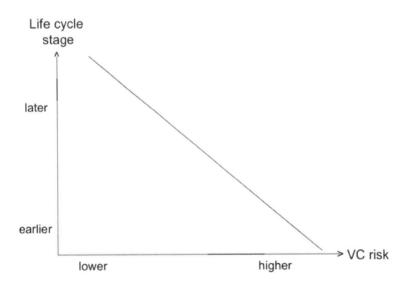

Observation 2. The earlier you are in the life cycle, the more it will cost you to raise a given amount of money. I display this relationship graphically in Figure 16.

Fig. 16 Stage vs. Equity Cost

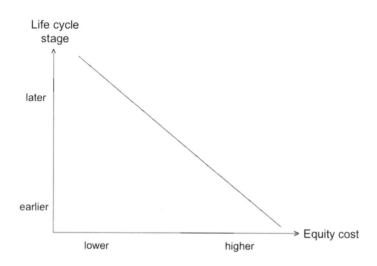

Observation 3. The larger the amounts of funding you seek, the more it will cost you. I display this relationship graphically in Figure 17.

Fig. 17 Funding vs. Equity Cost

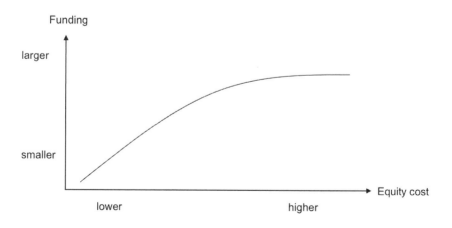

Note that if you obtain funding in increments, as you progress to the later stages of your company's life cycle, you will minimize your equity costs as long as the valuation of your company is increasing. On the other hand, if the valuation of your company is decreasing, funding may become quite expensive or it may not be available at all.

Typically, the VC firm does not want to own 100% of your company. They want you and the rest of the management team to have enough equity to remain incentivized.

Many venture capital firms have large amounts of money to invest and limited staff to manage their investments. Accordingly, they prefer to make minimum investments that are often measured in millions of dollars rather than in thousands of dollars [Buck 07]. Thus, the new entrepreneur seeking smaller amounts of funding is generally not attractive to venture capitalists.

If you ask for money from a small VC fund vs. a large fund, you are likely to give up as much equity to the small fund as you would to the larger fund if you asked for a larger amount of money from the larger fund. As stated previously, the larger fund would probably not consider investing the smaller amount for lesser equity as it is not cost effective for them. Therefore:

Identify the amount of money you need to reach the milestone you have targeted in your plan; then, approach VC funds whose preferred investment size (called by some their 'sweet spot') matches the amount you seek.

Other important criteria to consider when selecting which VC funds to approach include the fund's industry focus, their geographic area of interest, and whether they prefer early or late-stage investments.

Pre-money vs. post-money

In the terminology of venture capital funding, the term "pre-money valuation" refers to the valuation given to your company immediately before the money invested by a VC is taken into account. The term "post-money valuation" refers to the valuation

given to your company when the money invested by the VC is taken into account. The relationship can be formulated as follows:

Post-money valuation = Pre-money valuation + Investment

Evaluating the cost of venture capital money

I have been discussing what raising money at the various stages of your company life cycle will cost you—that is, what the venture capitalist(s) will be requesting from you.

The financial arrangements of obtaining funding from a venture capitalist will be detailed in the various legal documents you will be required to sign. Your bottom line question is what these financial arrangements will cost you as measured in terms of the following equally important parameters:

1. How will the company be valued by the venture capitalist?
2. How much equity will you have to give up?
3. How much additional equity will you have to give up to the venture capitalist in any future financing if there is a decrease in the valuation of the company?
4. How much will you have to pay in interest payments and other fees and expenses?
5. When the company has sufficient monies to start paying such items as loans and dividends, where will you be on the priority list?
6. If the company is sold or liquidated how much money will be left for you?
7. Under what terms can the company be forced to repurchase the venture capitalist's shares and at what cost?
8. Will the venture capitalist have the right to elect a certain number of directors to the company's Board of Directors?
9. Will the venture capitalist be able to force you to sell, go public or liquidate the company?
10. Will the venture capitalist require that your shares, and the shares of other managers, be subject to future vesting so that shares are forfeited by anyone leaving the employment of the company before the vesting period expires? (Vesting

denotes the process where a person gradually acquires their shares based on their length of service at the company).

11. How much control over the day-to-day and future business decisions will you have to agree to relinquish? Examples of restrictive clauses include limiting your ability to borrow additional monies, to hire and fire senior management staff, to enter into a development or distribution agreement, or to increase your salary without approval from the venture capitalist.

12. What are the chances that you may lose control of the company and be forced to leave the company?

13. How much effort and time will be consumed in dealing with the venture capitalist?

There are a number of other questions that are also appropriate, but the above list gives you a feeling for the criticality of your decision when you seek VC funding. There are serious risks.

Evaluating the benefits of venture capital money
What I have discussed so far are the potential disadvantages of receiving VC funding. Let me now go over the benefits you may realize.

1. *Money.* The VC firm will be providing capital that will help you execute your vision.

2. *Contacts.* The VC firm could open doors for you. For example, they could help you implement leveraged sales agreements. These in turn would allow you to meet your goals more quickly.

3. *Advice.* The VC firm probably has experience in business issues and in your particular industry that could be of assistance to you.

4. *Recruiting.* The VC firm could help you in hiring senior people.

5. *Additional funding.* Assuming everyone is ultimately happy with the arrangement, you will have established a source of additional funding should you require it.

Although the potential contacts could be as important as the money itself, you have no assurances that such contacts will be forthcoming. There are, however, other benefits that could accrue if you are fortunate to enter into an agreement with the right VC firm. For example, the VC firm could be very helpful if a decision is made to sell the company.

Other considerations when evaluating a VC relationship

The effort and time required for you to prepare, identify and negotiate with a VC firm is substantial and will consume you, with no guarantee you will succeed. Only a small percentage of start-ups seeking VC funding actually obtain it.

If you go through several rounds of financing, by the time the VC decides to sell, merge, or go public with your company (yes, they will make that decision), your ownership will be small. It could be less than 20%, and less than 5% is not unusual. For instance, albeit the founders of Google where in an exceptionally strong position when raising funding, in 2004 when Google did its Initial Public Offering, each of the two founders, Sergey Brin and Larry Page, owned about 15% of the company [Buch 07].

The point is that as your ownership percentage diminishes, in order to meet your original personal financial objectives, the valuation of your company will have to reach a much higher number than you may have anticipated. It also implies that along the way, you will be vulnerable to being cast aside if your investors believe that they can replace you with someone who would do a better job.

On the other hand, the VC money may allow you to create a much more successful company in a shorter time period. Again, using Google as an example, the 15% ownership of each of the Google founders represented well over $22 billion by the end of 2007, and both of them remained in top positions with the company.

Common goals and conflicting goals

You and the VC will have some common goals, but you also will have some conflicting ones. Some of the key issues are as follows:

1. The VC objective is a straightforward one. They want to make money with your company—lots of money. The reason is clear. VC firms operate with money they have borrowed or received from their own investors (e.g., wealthy individuals, pension funds, insurance companies, university endowments), and their compensation, reputation, and future depends on producing high returns for these investors.

 You also want to make money, but as we discussed in an earlier chapter, there are other motivating factors also driving you, such as making a difference and contributing to your community.

2. Although by definition VC firms are risk investors, they want to keep that risk to a minimum. So, for example, they want your company to have a well-staffed management team and strong second-level management to minimize risk if someone in the first level leaves or is asked to leave. They will use your equity to entice these hires.

 You also want to have a well-staffed management team in place. You have a good sense of which hats you can wear and how long you can wear them. You want to proceed with caution before you give away your equity.

3. Sometimes the VC will want you to spend heavily and quickly to expedite growth. This will burn your cash faster and will very likely force you to secure additional rounds of financing, resulting in a further dilution of your equity. The VC, on the other hand, could obtain additional equity at very favorable terms in any additional financing.

 You also want to expedite growth but you want to balance the speed of that growth against further personal equity costs.

4. VC funds are typically structured to provide returns over 10

years; thus, they have pressure to cash out of their investments as this time line approaches. Historically, they obtain their profits when the company they invested in does a public stock offering or the company is sold or merged with a public company. If your company cannot do a public stock offering or is not sold or merged, the VC wishing to cash out may pressure you to buy out their shares or they may sell all or part of their stake in your company to others who specialize in buying assets from the venture community [Tam 07].

You also want to have the option to cash out within 10 years, however, you do not want to be placed in a precarious financial position if you have to buy the shares from the VC. You also do not want to end up with a new partner that is not of your liking.

You must make the decision as to whether or not you will commit the time and effort it takes to seek venture capital. Some entrepreneurs have been very successful following the venture capital funding path, while others have had bitter experiences. Personally, every time I considered obtaining VC funding, I decided against it.

In an interesting article on October 31, 2005, *The Wall Street Journal* reported that many Internet start-ups were refusing VC money [Buck 05]. The reasons for this include the fact that new companies can get off the ground with less capital than in earlier years and that entrepreneurs desire to maintain their independence. On the other hand, in the same article, a partner in a VC firm expresses his opinion that some of these companies could have been bigger successes if they had taken advantage of VC money.

You must be keenly aware that during rough financial times, such as the recession that commenced in 2008, it becomes quite difficult to obtain VC funding.

My objective was to provide you with an overview that will help you decide if you want to explore this route. It should be clear to

you that if you decide to seek and negotiate a VC deal, you will need competent legal help. That is the subject of the next chapter.

Before leaving the discussion on VC funding, there is a short story that is appropriate.

Whose feet are on my desk?

After Softool had established itself as a profitable company with a bright future and much potential for greater profit, we became the target of a number of VC firms. Frankly, this is a great position to be in for an entrepreneur.

One junior partner from a VC firm was particularly persistent and articulate in discussing the merits of his firm. I made him aware that one of my main concerns in considering VC money was the extent to which a VC firm might interfere with the running of my company. He strongly assured me that they would never do that.

One day this junior partner brought one of the senior partners from his firm to my office to meet with me. After we spent about thirty minutes chatting, the senior partner said he had a couple of important calls to make and asked if there was a telephone he could use in private. As a gesture of politeness, I offered the telephone in my office. I invited the junior partner to come with me to another part of the company while his boss made his calls. After about twenty minutes, I figured the senior partner must be done with his calls, and we returned to my office. As I entered my office, I was amazed by what I saw.

The senior partner had shoved aside some of the items on top of my desk and was sitting in my chair with his feet on my desk. Not only that, he also had commandeered my secretary and given her a number of tasks to do. He was acting as if he were in charge of the place. Remember, the junior partner had emphasized how sensitive their firm was and how they would not interfere with my business.

As politely as I could, I promptly terminated his use of my office and secretary, and I bid them good-bye.

Postscript to this story. My office was located in a visible place in my company. Several employees had walked by while this senior partner was giving the appearance of being in control. As a result, a

rumor spread rapidly that the company had been sold. It took some effort to dispel this rumor.

Statistics

According to published reports [Vent 07, Vent 08, Vent 09], venture capitalists invested $22.7 billion in the United States in 2005, $25.5 billion in 2006, $29.4 billion in 2007, and $28.2 billion in 2008 (see Table 1). The reports provided the following breakdown:

- Funding for start-up and early-stage companies was $4.4 billion for 1,018 deals in 2005, $5 billion for 1,176 deals in 2006, $6.4 billion for 1,410 deals in 2007, and $6.8 billion for 1,453 deals in 2008.
- Funding for middle-stage (i.e., expansion stage in Figure 14) was $8.6 billion for 1,092 deals in 2005, $11.2 billion for 1,283 deals in 2006, $10.8 billion for 1,235 deals in 2007, and $10.6 billion for 1,178 deals in 2008.
- Funding for later-stage companies was $9.7 billion for 990 deals in 2005, $9.3 billion for 957 deals in 2006, $12.2 billion for 1,168 deals in 2007, and $10.8 billion for 1,177 deals in 2008.

Thus, of the total amount venture capitalists invested in 2005, approximately 19% was in start-up and early-stage companies, approximately 38% was in middle-stage companies, and approximately 43% was in later-stage companies.

In 2006, approximately 20% was in start-up and early-stage companies, approximately 44% was in middle-stage companies, and approximately 36% was in later- stage companies.

In 2007, approximately 22% was in start-up and early-stage companies, approximately 37% was in middle-stage companies, and approximately 41% was in later-stage companies.

In 2008, approximately 24% was in start-up and early-stage companies, approximately 38% was in middle-stage companies, and

Table 1 Venture Capital Investments

Year	Total $ in billions	Start-up Stage			Expansion (Middle) Stage			Later Stage		
		Invest. $ in billions	No. of deals	% of total invest.	Invest. $ in billions	No. of deals	% of total invest.	Invest. $ in billions	No. of deals	% of total invest.
2005	22.7	4.4	1,018	19	8.6	1,092	38	9.7	990	43
2006	25.5	5	1,176	20	11.2	1,283	44	9.3	957	36
2007	29.4	6.4	1,410	22	10.8	1,235	37	12.2	1,168	41
2008	28.2	6.8	1,453	24	10.6	1,178	38	10.8	1,177	38

approximately 38% was in later-stage companies. Table 1 summarizes all of this data.

As previously mentioned, note that the typical venture capital investment is measured in millions of dollars. For example, as reported above, in 2007 venture capitalists invested $6.4 billion in 1,410 start-up and early-stage companies or approximately $4.539 million per deal. Also, realize that often several venture capitalists invest in the same deal.

According to a 2006 report by the Kauffman Foundation [Kauf 06] covering the period from 1996 to 2004, an estimated average of 550,000 new businesses per month were being created at the individual owner level in the United States by 2004. This number includes new businesses with employees as well as those without employees other than the founder. This corresponds to an average of approximately 0.36% of the adult population creating a new business each month; that is, 360 out of every 100,000 adults. The number of new businesses being created in the United States per year then totaled 6,600,000 (i.e., 550,000 x 12). In 2008, an updated report [Kau1 08] extending the coverage period to 2007 was published. These reports indicate that the rate of entrepreneurship activity remained relatively constant over the twelve year period. For simplicity, we shall use the approximate figure of 6,600,000 as representative of the number of new businesses created in the United States each year during the period from 1996 to 2007. Please note that in fact this number may well be substantially lower due to double counting and other inaccuracies in the estimation process. However, for our purposes here the 6,600,000 number will serve our needs; employing a lower number will not change our conclusions.

The United States Small Business Administration Office of Advocacy [SBA 08] reports that two-thirds of new employer establishments survive at least two years, 44 percent survive at least 4 years, and 31 percent survive at least seven years. Further, a *Forbes* 2006 magazine article [Brow 06] states that 90% of venture capital-backed firms fail.

Combining the numbers from the above reports [Vent 07, Vent 08, Vent 09, Kauf 06, Kau1 08, Brow 06] leads us to some interesting conclusions:

- Venture capitalists funded 1,018, 1,176, 1,410, and 1,453 start-up and early-stage companies in 2005, 2006, 2007, and 2008 respectively.
- Assuming that in 2008 the average total number of new businesses created per year was the same as that reported for 1996 through 2007, that is 6,600,000, then less than 0.03% of new or early-stage businesses in 2005, 2006, 2007, and 2008 were funded by venture capitalists (e.g., for 2007: (1,410/6,600,000) (100) < 0.03%). (Of course, not everyone that started a new business asked for VC funding, and many of those who failed in their quest for VC money never started a new business).
 Wooldridge [Wool 09] offers pertinent numbers for a specific venture capital firm. He reports that Highland Capital Partners receives about 10,000 plausible business plans a year, conducts about 1,000 meetings followed by 400 company visits and ends up making 10-20 investments a year. This represents a funding of 0.1% to 0.2% of the plausible business plans received!
- Of the 1,018 start-up and early-stage companies funded by venture capitalists in 2005, approximately 916 will fail. Of the 1,176 start-up and early-stage companies funded by venture capitalists in 2006, approximately 1,058 will fail. Of the 1,410 start-up and early-stage companies funded by venture capitalists in 2007, approximately 1,269 will fail. Of the 1,453 start-up and early-stage companies funded by venture capitalist in 2008, approximately 1,308 will fail. Table 2 summarizes the expected successes.

Table 2 Expected Successes

Year	No. of start-up/early stage companies funded by VCs	No. of companies expected to succeed
2005	1,018	102
2006	1,176	118
2007	1,410	141
2008	1,453	145

5. ANGEL INVESTORS

Wealthy individuals, quite often successful entrepreneurs who have sold their companies, are an important source of funding. They are referred to as angel investors. They tend to be flexible, and you can often negotiate whether their funding will be debt financing or equity financing or some combination. They also tend to be more lax in their restrictions. Typically, angel investors invest smaller amounts than venture capitalists. Their investments are generally measured in thousands of dollars per deal rather than in millions of dollars. Thus, they represent an alternative for the new entrepreneur seeking smaller amounts of money.

Angel investors tend to invest in start-up ventures in the areas in which they have knowledge, experience and contacts. They typically like to get involved in giving advice and opening doors and have little interest in the day-to-day operations of the company. Angel investors often prefer local entrepreneurs who are good listeners and who can be coached.

If you are fortunate enough to associate yourself with the right angel investor, your chances of success could improve substantially. On the other hand, if you get involved with the wrong angel investor, you may suffer serious consequences.

You must be aware that during rough economic times angel investors become very careful with their cash, thus their investments are fewer and much more selective.

Statistics

According to reports in *The Wall Street Journal* [Carm 06], angel investors put $22.5 billion in companies in the United States in 2004 and $23.1 billion in 2005 [Tam 06]. The Center for Venture Research [Wrig 07, Wrig 08, Sohl 09] reports that angel investors invested $25.6 billion in the United States in 2006, $26 billion in 2007 and $19.2 billion in 2008. Further, one of the reports states that 85% of angel investors invest in businesses within half a day's travel from their homes.

According to the Center for Venture Research [Wrig 06, Wrig 07, Wrig 08, Sohl 09] (the main source for *The Wall Street Journal* articles on angel investors mentioned above), the estimated number of active angel investors in the United States in 2005 was 227,000, in 2006 it was 234,000, in 2007 it was 258,200, and in 2008 it was 260,500. They also report that a total of 49,500 entrepreneurial ventures received angel funding in 2005, 51,000 in 2006, 57,120 in 2007, and 55,480 in 2008.

Table 3 summarizes this data.

Table 3 Angel Investments

Year	Total $ invest. in billions	No. of active angel investors	No. of deals
2005	23.1	227,000	49,500
2006	25.6	234,000	51,000
2007	26	258,200	57,120
2008	19.2	260,500	55,480

As previously mentioned, note that the typical angel investment is measured in thousands of dollars. For example, as reported above, in 2007 angel investors invested $26 billion, and there were 258,200

active angel investors that year. Thus, the average amount invested by an angel investor was approximately $101,000. Since it was also reported that in 2007 a total of 57,120 companies received angel funding, the average angel invested in 4.52 deals (i.e., 258,200/57,120). Consequently, the average investment per angel investor per deal was approximately $22,345 (i.e., $101,000/4.52). Note that in 2008 as the economic environment worsened the average investment per angel investor went down to approximately $15,698.

It is also reported [Wrig 08] that in 2007, 39% of the total investment of $26 billion for that year went into start-ups, that is $10.14 billion. Now, if 6,600,000 new businesses were created in 2007, we find that less than 0.4% of new businesses in 2007 were funded by angel investors (i.e., for 2007: [39%(57,120)/6,600,000)] (100) < 0.4%). (Of course, not everyone that started a new business asked for angel funding, and many of those who failed in their quest for angel money never started a new business).

It is worth noting that it has been reported [Sohl 09] that in 2008 the amount of angel capital that went into start-ups was 45%.

Note on the statistics provided for VC and angel investors

For our purposes it is less important how accurate the data is from the various sources than the clear message that is being conveyed.

The new entrepreneur without a track record has a very small chance of obtaining funding from either venture capitalists or angel investors.

Informal discussions with others corroborate the point that this message holds true, even though not every business seeks funding from VC and/or angel investors.

6. GOVERNMENT

Contrary to the belief of many, the government of the United States does not hand you money to start a company. However, **the United States government, through its Small Business**

Administration (SBA), does provide a number of guaranteed loan programs that can be of great assistance to entrepreneurs.

If you qualify, the SBA will guarantee up to 50% to 90% of the repayment of a loan from a commercial bank participating in their programs, depending on the type of loan. If you have any assets, the SBA (and the participating bank) requires that you utilize them to guarantee the loan. Although the SBA does not deny approval of a SBA Guarantee Loan solely due to lack of collateral, it is a factor in the loan approval process. All owners of 20% or more of the business are required to personally guarantee SBA loans. To apply for a SBA guaranteed loan you request a loan from a commercial bank participating in the SBA program. If the banker believes that you will qualify for the loan, he/she will guide you through the application process.

Also, you should know that the SBA has a number of special loan programs for specific business areas such as small general contractors, international trade, pollution control, and others.

In 2007, the SBA announced the Patriot Express Pilot Loan Initiative for veterans, reservists, National Guard members and their current spouses who need a loan to establish or expand a small business. The program is offered through a network of participating lenders and makes loans of up to $500,000 with the SBA guaranteeing up to 85% of the loan. The interest charged for these loans ranged between 2.25 percent to 4.75 percent over the prime rate depending upon the size and maturity of the loan. The prime rate is the interest rate charged by banks to their most credit-worthy borrowers. You can determine the current prime rate by referring to any of a number of financial sources of information such as *The Wall Street Journal*. The prime rate is discussed in the next section.

For current and detailed information on SBA loan programs visit their website at www.sba.gov.

Other programs exist at the state and local levels. Often, the banker you are dealing with can help you identify such programs.

In any case, the paperwork and effort required to identify and pursue government sponsored programs is time-consuming. Before

you go down this path, you should carefully evaluate spending your efforts in other potentially more rewarding activities.

I should also make you aware of the existence of the Small Business Investment Company (SBIC).

In 1958, the government of the United States established the SBIC program to encourage private equity funds (e.g., venture capital firms) to focus on small businesses that normally would not be of interest to venture capital funds [Enri 06].

In essence, SBICs are venture capital funds that use private capital as well as money borrowed from the government at favorable rates. The SBA typically provides a 2-to-1 match on funds raised privately by an SBIC. However, the fund must raise at least $5 million in private capital to qualify for the program.

SBICs are required to invest in companies with after-tax annual revenues of $6 million or less for the preceding two years and tangible net worth of less than $18 million.

From 2001 to 2005, the average SBIC investment ranged from $511,000 to $1.04 million, according to a report in *The Wall Street Journal* [Sing 06].

According to this report, there were approximately 407 active SBICs. Of these, most are either Participating Security SBICs, which provide equity capital, or Debenture SBICs, which provide subordinated debt financing; that is, other lenders would have priority in case of default.

The same article, quoting the Association of Small Business Investment Companies, states that SBICs invested a total of $2.9 billion in fiscal year 2005. The article also points out that since 2004, the Participating Security Program has been closed to new licensees and will gradually cease to exist unless Congress acts to extend it. On the other hand, the Debenture Program enjoys stability and government support.

INTEREST RATES

Whenever you borrow money you pay a rate of interest on the monies you borrow. Different lenders may employ different benchmarks upon which they base the interest rate that they wish to

charge you for your loan, or you may simply be asked to pay a fixed interest rate. You should have an understanding of the key benchmarks that are typically utilized.

Prime rate [Wiki 07, Wik1 08, Wik2 08]

After a history of banking crises, the United States created the Federal Reserve System in 1913 as the central banking system of the country. As part of its responsibilities, the Federal Reserve System supervises and regulates banking institutions. In the United States banks are required by law to maintain certain levels of cash reserves. If for any reason the bank's cash reserves are reduced so that it goes below the required legal level, it can borrow money for a short term from other banks. The Federal Reserve System sets the 'federal funds rate,' which is the interest rate at which banks can lend to other banks. This federal funds rate is set by a committee that meets eight times per year. At each meeting the committee decides whether to increase, decrease or leave as it is the then current federal funds rate.

In the United States, the interest rate charged by banks to their most credit-worthy customers is called the prime rate. Typically, the prime rate runs approximately 3 percent above the federal funds rate. Note that a bank's prime rate does not change on a regular basis; rather, it changes as a consequence of changes to the federal funds rate.

The prime rate is used as a reference line when lending to consumers. For example, your bank may offer you a loan with an interest rate of 'prime plus 1.' This means you will be charged one percent above the prevailing prime rate. Thus, if the current prime rate is 5%, you will pay 6% interest.

The Wall Street Journal publishes on a regular basis a prime rate that represents a composite of the prime rate charged by 75% of the 30 largest banks in the United States. This prime rate index is the one used in many contracts. During 2008, the prime rate ranged from a historical low of 3.25% to a high of 7.5%.

LIBOR [Wik3 08]

The London Interbank Offered Rate (LIBOR) originated in London, England, around the year 1985. This rate is fixed by the British Bankers Association each day at 11 a. m. London time. The rate is an average derived from the quotations provided by a group of 16 banks determined by the British Bankers' Association.

LIBOR is the rate at which banks lend to each other in certain London money markets. Note that LIBOR is a floating rate: it fluctuates continually.

LIBOR is a benchmark interest rate used as a reference in lending and borrowing transactions around the globe. In particular, many corporate loans are indexed to LIBOR, as well as many adjustable rate mortgages. For example, you may be offered a loan with an interest rate of 'LIBOR plus 1.' This means you will be charged one percent above the daily LIBOR rate. Generally, the higher the LIBOR rate, the tighter the credit markets.

Prime rate versus LIBOR

The prime rate is fixed for extended periods of time while LIBOR is set daily. The prime rate is tied to the federal funds rate, which is targeted by the United States government. LIBOR is determined by market quotations in London.

Generally in normal markets LIBOR runs slightly above the federal funds rate, typically 0.15% to 0.20%. A wider spread between these two benchmarks indicates uncertainties in the world credit market. For example, in the midst of the financial crisis of 2008, a wide spread developed between these two rates with LIBOR at times running well over three percentage points above the federal funds rate.

When discussing interest rates another common term used is 'basis points.' One hundred basis points constitute one percent. So, for example, if your lender says that he/she will charge you prime plus 125 basis points for a loan that means you will be charged prime plus 1.25%.

To check on the prime rate, LIBOR, and other rates you can go to www.bloomberg.com or to *The Wall Street Journal*.

SUMMARY

Without money there is no business.

I discussed the principal alternatives that you have in procuring funding. I examined the advantages and disadvantages of each of these alternatives.

I viewed the issues from your perspective as well as from the perspective of your potential lender or investor.

The information in this chapter is precisely what you must know before you decide to select and approach a potential lender or investor.

I encouraged you to pay particular attention to creative financing opportunities that can have a significant positive impact in your search for funding.

KEY POINTS COVERED

- The principal alternatives to obtain monies to fund your business include:
 1. Your own savings
 2. Borrowing
 a. On your credit cards
 b. From family and friends
 c. On a bank line of credit
 3. Creative financing
 a. Leverage
 b. Bartering
 c. Suppliers
 4. Venture capital
 5. Angel investor
 6. Government
- A start-up without assets or revenues is unlikely to obtain a bank line of credit guaranteed by the company alone.
- Once you have a revenue stream, you can approach the bank for a line of credit based on your accounts receivable.
- Do your best to identify creative financing opportunities.
- Successful and lasting agreements are those in which all the parties in the agreement win.
- The earlier you are in the life cycle of your company, the higher the risk for the venture capitalist or any other investor who invests in your company and thus, the more difficult it will be to raise funding.
- The earlier you are in the life cycle of your company, the more it will cost you to raise a given amount of money.
- The larger the amounts of funding you seek, the more it will cost you.
- There are a number of financial provisions embodied in the various legal documents that the venture capitalist, or any other lender, will require you to sign. You need to understand them.

CHAPTER 8

THE LEGAL FRAMEWORK

AN OVERVIEW

We live in a very litigious environment. You must operate within a framework of laws, or it can cost you dearly. You need to prevent legal headaches before you are immersed in one. Ignorance of the law is not a defense.

In this chapter I address the various legal structures that are available to you to create a business. I outline the advantages and disadvantages of each of these legal structures, including many associated tax issues.

I also cover how to protect yourself, your company, and your intellectual property, and I list the various contracts you will need.

In addition, I discuss how to select and interact with lawyers. I provide you with tips to keep your legal costs down.

This chapter is not intended as a substitute for legal or accounting advice. On the contrary, the objective is to help prepare you for discussions with your attorney and your accountant.

BACKGROUND

The United States has been a haven and a magnet for entrepreneurs. American culture promotes a viable path to success for those who have vision and talent, who are not afraid of hard work, and who are not risk averse.

Our culture is implemented through our laws. Our laws protect the basic rights of both employees and business owners. To a large degree our laws provide a level playing field for those with new ideas and entrepreneurial talents to compete against the established corporations. In recent years, however, the cumulative effects of laws promulgated by lawmakers with little understanding of business have created many obstacles for entrepreneurs [Mal2 08].

The result is that we now live in a society that is spending much of its precious resources overcoming impediments and either preventing or engaging in litigation.

As a consequence, the threshold for success for entrepreneurs has been raised substantially.

It is the purpose of this chapter to highlight some of the more important legal issues you will face. Since legal decisions and tax considerations are intertwined, we will also touch on a number of tax issues.

COMPANY LEGAL STRUCTURE

One of the first legal decisions you have to make is how you are going to operate as a business. This decision has legal, tax, and operational implications.

Of primary concern to you in making this decision should be the personal liability protections and the tax consequences of a given legal structure. Equally important is to select a legal structure that allows you to implement your business goals. For example, you may want the option to issue shares to use as incentives for employees, and thus the structure you choose must accommodate this need.

Currently, there are six principal alternatives:

1. Sole proprietorship
2. General partnership
3. Limited partnership (LP)
4. C corporation
5. S corporation
6. Limited liability company (LLC)

There are a multitude of books [e.g., Leso 04] and websites with much discussion on these legal structures. Here I am simply going to summarize their characteristics as well as their advantages and disadvantages. I will do this in a concise manner that allows you to reach some conclusions without getting lost in the midst of too many secondary details.

1. SOLE PROPRIETORSHIP

This is a simple structure. You and your business are considered one and the same, with no legal distinction.

For tax purposes, all income received by the business and all expenses incurred by the business are included on your personal income tax return. That is, any business income (loss) you have *passes through* the sole proprietorship without any tax consequences to the sole proprietorship. Any business earnings you have are taxed only once at individual tax rates on your personal income tax.

Concerning liabilities, you will have unlimited personal liability for all obligations and debts of the business. Any assets that you own outside of the business could be seized to satisfy a claim filed against you or the business.

In addition to the onerous unlimited liability problem, this type of structure does not lend itself well for high growth operations that may need to raise money and motivate employees. The reasons will become clearer when I discuss corporations in the next few pages.

2. GENERAL PARTNERSHIP

In a partnership, two or more people operate a business as partners and divide the profits and/or losses.

The two key characteristics of general partnerships are that they involve unlimited liability of the partners and that they can be structured as pass-through entities for tax purposes as explained below.

Partners typically draft a partnership agreement that covers a collection of pertinent issues, such as how business decisions are made, how disputes among the partners are resolved, how profits and losses are to be divided among the partners, how the death of a partner is to be handled, how a separation of the partners is to be managed, and much more.

In a general partnership, any partner can bind all other partners for actions they take within the scope of the partnership agreement. Management rights and liability may be divided equally or allocated unevenly per agreement by the partners.

When profits/losses are recognized by the partnership, they are "passed through" to the individual partners in the proportions agreed to in the partnership agreement. The individual partners then report such profits/losses on their personal income tax returns. The partnership does not pay taxes on its income. Thus, business earnings are taxed only once at individual tax rates.

This type of structure is generally not acceptable to potential investors for reasons that we will mention below when we discuss corporations and thus does not lend itself well for high-growth operations that may need to raise money and motivate employees.

3. LIMITED PARTNERSHIP (LP)

In an LP there are two types of partners: limited, or passive, partners and general, or active, partners.

The limited partners have no say in day-to-day management; however, limited partners can have voting rights with respect to such matters as the election and removal of general partners and the sale of the partnership, unless the limited partnership agreement states otherwise.

The liability of the limited partners is limited to their investment in the partnership. Limited partners need to be aware that their participation in the management of the partnership could jeopardize their limited liability protection.

The general partners run the partnership and have unlimited personal liability for partnership obligations, as in a general partnership. Typically, an unpaid creditor goes after the partnership assets first and then after the assets of the general partners. It is possible for a corporation to be a general partner; the corporation stockholders are then shielded from the partnership creditors. This will become clearer as we discuss corporations below.

Tax treatment of an LP is similar to that of a general partnership, that is, as a pass-through entity.

An LP does not lend itself well for high-growth operations that may need to raise money and motivate employees. We explain the reasons in the next section.

4. C CORPORATION

A C corporation is a corporation so-named because it elects to be taxed under Subchapter C of the Internal Revenue Code. A corporation is an independent legal entity, separate from its owners. The shareholders are the owners of the corporation. The shareholders elect a Board of Directors to run the corporation, and the Board of Directors appoints the officers to manage the corporation's day-to-day business. The Board of Directors must also carry out such activities as making timely notifications of meetings to shareholders, holding regular meetings, and maintaining minutes of these meetings. These activities protect the corporate status and preserve the corporate shield intended to protect shareholders from personal liability.

Since a corporation is a separate entity from its owners, the shareholders are not responsible for any liabilities incurred by the corporation. That is, the shareholders' liability is limited to the investment they made in their shares (i.e., the cost of their stock).

It is common in a start-up for the entrepreneur to be a shareholder, a board member and an officer (and an underpaid laborer). **Such an entrepreneur must ensure that proper procedures are followed to preserve the corporate shield.**

A corporation pays income tax on its income at the prevalent corporate rate. The Board of Directors decides on whether or not dividends are paid, and if they are paid, the Board decides the amount and the timing. The shareholders pay income tax on any corporate dividends they receive at the individual tax rate on their personal income. **This is referred to as double taxation. That is, the earnings of the business are first taxed at the corporate level and then at the individual level.**

When a shareholder sells his/her shares, that shareholder will pay taxes on gains or claim losses as the case may be on his/her personal income tax return. As I will discuss in a subsequent chapter, holding your shares for more than a year before selling them may result in significant tax savings.

The C corporation is well-suited for raising funds and for creating incentive plans for employees. It provides the Board of

Directors with quite a bit of flexibility. **The key is the availability of shares, particularly because a C corporation can issue different classes of shares with different rights.**

For example, a C corporation can issue standard common shares. It can also issue preferred shares that will have certain preferences over the common stock. Preferred shares are a favorite instrument of investors.

Here is another important point. A share has two components—voting power and economic value. You can indeed separate these two components. For example, the Board of Directors can create a class of shares—let's say they are called B shares—that have economic value but no voting power. B shares represent an excellent instrument to provide incentives to employees while you preserve your control of the corporation.

If you are planning on raising venture capital money and/or doing a public offering, the C corporation is the legal structure commonly used for these purposes.

The principal reasons are that C corporations represent favorable investment structures for venture capitalists, tax-exempt institutions, angel investors, and non-United States citizens. In addition, C corporations are generally the most advantageous type of legal entity for carrying out a public offering. Also, a corporation facilitates future liquidity for an investor.

You will need to choose a state in which to incorporate. That state does not need to be the one in which your company is located. Different states offer certain advantages over other states. You should consult with your attorney to select the best state in which to incorporate based on the objectives you are trying to meet.

Your Board of Directors represents your company and your image. You want to have directors with good reputations who can open doors for your company and who can provide experienced advice. Recruiting such directors has become difficult because of the flurry of lawsuits which name not only the corporation, but also its directors. A number of law firms specialize in filing such lawsuits.

One way to ameliorate this problem is for the corporation to procure and pay for Board of Directors liability insurance, formally

referred to as Directors and Officers Liability Insurance. This type of insurance is so expensive that, in most cases, only large established corporations can afford to pay for it.

5. S CORPORATION

An S corporation is a corporation so-named because it elects to be taxed under Subchapter S of the Internal Revenue Code. With an S corporation you have the same liability protection as with a C corporation. The most important difference between a C and an S corporation is the tax treatment. An S corporation is treated essentially in the same manner as a partnership for tax purposes. Corporate profits/losses will pass through to the individual shareholders who will include them on their personal income tax returns. Double taxation is eliminated.

In an S corporation, the shareholders elect a Board of Directors, just as they do in a C corporation.

An S corporation can be of much help during the initial life of your company when you are funding it with your own money and you want to offset any personal income with the corporation's initial losses.

One disadvantage of an S corporation is that it must comply with specific restrictions. For example, an S corporation can have only one class of outstanding shares (although voting and non-voting shares are allowed), and the number of shareholders cannot exceed one hundred. Shareholders must be U.S. resident individuals or trusts (partnerships or corporations are not allowed). These rules curtail some of the flexibility enjoyed with a C corporation. However, you can begin as an S corporation and later convert to a C corporation. If this is your intention, you should plan the conversion with care to minimize its cost.

Corporations, both C and S, may be subject to state tax in the state in which they are incorporated. Depending on the state, they are taxed differently. However, they typically both pay a minimum yearly state tax (e.g., $800 in California, $150 in Florida).

6. LIMITED LIABILITY COMPANY (LLC)

With an LLC you have the same liability protection as with a C corporation. The most important differences between an LLC and a C corporation are tax treatment, flexibility in raising money, and the ability to do a public offering.

An LLC operates just like a C corporation except that it is treated in the same manner as a partnership for tax purposes. Company profits/losses will pass through to the individual shareholders who will include them on their personal income tax returns. Double taxation is eliminated.

The shareholders of an LLC are referred to as members. The members are the owners of the LLC.

An LLC does not have a Board of Directors as a C or S corporation. In an LLC the members can manage the LLC or they can appoint one or more managers (who can be members or non-members) to manage the LLC. Also, note that a single member LLC can be a relatively uncomplicated entity.

An LLC could also be thought of as a limited partnership without the requirement of a general partner.

Many of the restrictions on S corporations do not apply to an LLC. For example, an LLC may have any number of classes of members. Each class may have its own unique economic and other rights. Thus, the LLC offers some flexibility for raising funds and creating incentive plans.

It is possible to convert an LLC to a C corporation. If the conversion is planned at the time the LLC is organized and proper language is included in its operating agreement, it could be a relatively contained effort. Otherwise, a conversion could result in substantial legal and financial implications.

You should be aware that LLCs can be formed in all 50 states of the United States. However, states impose different tax rules and yearly taxes on LLCs. You will need to choose a state in which to organize your LLC. It need not be the same state in which your company is located. You should consult with your attorney when selecting the best state in which to organize the LLC.

Generally, LLCs cannot be publicly traded.

LLCs typically pay a yearly minimum state tax in the state in which they are incorporated (e.g., $800 in California, $200 in North Carolina, $139 in Florida).

More comparative comments between S corporations and LLCs

Given the apparent similarities between an S corporation and an LLC, some additional comments are appropriate to differentiate the two types of entities.

An important advantage of an LLC is the flexibility in allocating income and loss to its members. An S corporation must allocate income and loss based on each shareholder's ownership percentage. On the other hand, an LLC may have special allocations and guaranteed payments. Furthermore, an LLC member may have greater ability to deduct losses than an S corporation shareholder. S corporation shareholders may only recognize losses up to their stock basis (i.e., original cost) and their loans to the S corporation. LLC members may recognize losses up to their stock basis, their loans to the LLC, and their proportionate share of certain liabilities.

An LLC also offers potential tax advantages in the tax treatment of contributions and distributions of properties. An LLC distribution of property is generally tax-free while an S corporation's distribution of property may trigger taxable gains which flow through to the shareholders.

LLCs offer more flexibility with respect to internal governance than S corporations.

The shareholders of S corporations are able to sell their interest without obtaining the approval of the other shareholders. In contrast, depending on the terms of the operating agreement, members of LLCs may need the approval of the other members in order to sell their interest.

Often in an S corporation the shareholders enter into a "right of first refusal agreement" concerning the selling of their stock in the S corporation. This means that if a shareholder decides to sell stock, this shareholder must first offer the shares he/she is selling to the other shareholders, typically on a prorated basis, on the same terms

the selling shareholder is planning to offer to outsiders. The operating agreement of an LLC may also include a right of first refusal clause.

With respect to business expenses, S corporations may be advantageous in terms of self-employment taxes in comparison to LLCs. In an LLC a member who is also a manager may be required to treat his share of the income as self-employment income subject to additional taxes to fund social security and Medicare.

You should evaluate and compare overall tax consequences when deciding between an S corporation and an LLC. If your business will have little or no profit after deductions for perks for the owners, deductibility of benefits should be an important consideration[Jask 08], often favoring the selection of an S corporation over an LLC.

To emphasize the importance of analyzing the taxing consequences of an S versus an LLC selection of legal entity for your business, consider the situation in the state of California [Goli 03]. In the case of an LLC, this state imposes a minimum state tax of $800 as well as a gross income tax that is capped at $11,790. On the other hand, in California an S corporation is subject to a state tax that is 1.5 percent of net income or $800, whichever is greater. For instance, it is reported [Goli 03] that Steven Spielberg's DreamWorks chose to be an LLC, saving money in state taxes that were capped at $11,790 plus the $800 minimum fee.

You should be clear on the following. When a state (e.g., California) imposes a tax on the income of an S corporation or an LLC, in addition to paying this tax, that income will pass through to the individual shareholders (members) who will include it in their individual tax returns and be subject to pertinent personal taxes.

More comparative comments between C corporations and LLCs

LLCs generally are more flexible than C corporations with respect to issues of internal governance and the financial relationships among equity holders.

In an LLC, you can allocate the way you want the profits to be distributed, and it does not have to be based upon the percentage of ownership as in a C corporation.

The amount of liability and the basis in an LLC may be larger than in a C corporation.

In an LLC, depending on the terms of the operating agreement, members may need the approval of other members in order to sell their interest, while in a C corporation shareholders are able to sell their interest without the approval of the other shareholders.

 LLCs cannot engage in certain businesses such as banking and insurance.

While C corporations can be publicly traded companies, LLCs taxed as partnerships generally cannot be publicly traded entities.

Typically, C corporations are less expensive to set up than LLCs, principally because the articles of incorporation and bylaws required for a C corporation are more standardized and easier to create than the agreements required by LLCs.

More comparative comments between S corporations, LLCs, and C corporations

Most entrepreneurs creating a start-up that will initially lose money will probably choose the S corporation or the LLC as their company legal structure because they can pass through the losses on their personal tax returns.

Entrepreneurs who plan to extract money from their company on a regular schedule would probably select an S corporation or an LLC so that they pay taxes only once, avoiding the issue of double taxation.

Entrepreneurs who expect to start making profits early on, who are satisfied paying themselves a decent salary, and who plan to realize their long-term financial gain through retained earnings and an eventual sale of their company would probably be better off with a C corporation. This is because they will pay capital gains tax rates, not ordinary income tax rates, on the proceeds of the sale of the company. Of course, this strategy is appealing only as long as the

capital gains tax rate remains lower than the ordinary income tax rate.

Retained earnings are the accumulation of earnings, after all expenses and dividend payments, if any, are made; they represent the reinvestment of earnings into the firm.

If you decide to sell your company to a buyer who is a C corporation there are tax considerations (e.g., ability to defer taxes) that may make your company more appealing to the buyer if your company is a C corporation.

The purpose of these more detailed comparisons of C corporations, S corporations and LLCs was threefold. First, they were to help you better understand the differences among these three legal entities. Second, they illustrate the fact that most of your decisions, legal and otherwise, deal with icebergs. That is, there is a lot under the surface that only experience and time will help you uncover. Third, they emphasize that you need competent legal and accounting advice. Later on, I will discuss how to accomplish that.

A QUANTITATIVE LOOK AT SINGLE VS. DOUBLE TAXATION

To make certain you grasp the issue of double taxation, consider the following example.

For federal income tax purposes the following applied to the year 2008:

1. C corporations were taxed at a maximum tax rate of 35%.
2. Dividend distributions by C corporations to its shareholders were taxed at a maximum tax rate of 15%.
3. Individuals were taxed at a maximum tax rate of 35%.

If your earnings came through a C corporation, the effective tax rate on the earnings distributed to you personally was 44.75%. The tax rate was computed as follows: the income of the C corporation was taxed at 35%; the money remaining after the 35% tax was deducted then taxed again at 15% when it was distributed to you as

dividends; and the result is that you net approximately 55.25% (i.e., 100% – 44.75%) of the monies originally earned by the C corporation. That is double taxation!

Now, suppose that your earnings were coming through an S corporation or an LLC instead of a C corporation.

The earnings would pass through to you and be taxed as individual income at 35%. The result is that you would net 65% of the monies originally earned by the S corporation or the LLC. This is single taxation!

Note that with the S corporation or the LLC, you keep 9.75% more of the money originally earned (i.e., 44.75% - 35%).

Please realize that in this example I computed taxes based only on federal tax rates. In addition, you would have to pay applicable state and employment-related taxes. Thus, the tax bite is even larger.

The maximum 15% federal tax rate on the distribution of dividends is scheduled to expire in 2010. Before it expires, it might be extended by Congress or, on the other hand, it might be increased or decreased.

I have provided you with an overview of the various legal structures, their advantages and disadvantages. There are a number of other issues that need to be considered that I touched upon but did not discuss in detail. For example, as part of the mechanics required to create these legal entities, you will need articles of organization and operating agreements.

You will need to consult with a lawyer and an accountant before you make your final decisions.

Before I move on to the next topic, there is a short story that is pertinent here.

You have to understand what you are doing
Frankly, when I founded Softool Corporation I had a poor understanding of the various legal structures, their advantages and disadvantages, and the proper reasoning and timing for transitioning from one legal structure to another.

I started Softool as an S corporation because that was the advice I received from the accountant I used.

That turned out to be a good decision for two main reasons:

1. The company had no income for a while, and until we released some products, these initial losses were taken on my personal tax return.
2. After we established our sales, the company became very profitable, allowing me to take money out while avoiding double taxation.

After a while it became clear to me that due to competitive market forces and my planned exit strategy (discussed in a later chapter), every dollar of revenue that came in had to be reinvested in the company to maintain fast growth. That was the point—when I stopped taking profits out—that I should have switched to a C corporation.

I no longer had the problem of double taxation, and my exit plan was eventually to sell the company and realize capital gains on the sale.

I did switch to a C corporation, but following my accountant's advice, I made the transition a bit too early. I changed to a C corporation while I was still taking profits out, so I did pay double taxes unnecessarily for a while.

Looking back, I believe that the reason for this costly mistake was my poor understanding of the issues at the time, as well as the fact that I failed to communicate my plans effectively to the accountant providing the advice.

As stated earlier, as the entrepreneur, the big picture is my responsibility, and I erred.

COMPANY NAME

Some new entrepreneurs spend as much effort in selecting a name for their company as they do in selecting a name for their new baby. Having gone through that process with my first company, I understand it. The fact is that this new company is your "baby."

Choosing a name that is descriptive of your business and easy to pronounce, spell, remember and protect is a strong plus. On the other hand, let's review the names of some very successful companies.

Xerox, Apple, Sun, Oracle, Yahoo, Google, Pfizer, Starbucks. These names do not provide a hint of what business the company conducts. And how are you to pronounce the xs in Xerox? Some have error-prone spellings (e.g., Pfizer). Yet, these companies are incredible successes. The conclusion is that the name does not make the company; the company makes the name. Do not spend too much effort in creating a name. Pick one and move on.

Do a name search to make sure that no one else is using whatever name you select. A full trademark check is recommended (trademarks are discussed later in this chapter). Further, if you foresee your company going into foreign markets, you may want to do international name searches, with a separate search for each country. All of this can get expensive, which may not be the most effective way of spending your seed money. If possible, postpone name searches in foreign countries until the business opportunity justifies it. In any event, both the Internet and your lawyer can be your sources of assistance.

At the same time, you will need to obtain an Internet domain name for your business. A domain name is the name that will uniquely identify your website on the Internet. The Internet itself offers short tutorials on domain names and is a quick vehicle for registering one. To check on available domain names or to register a domain name you can go to websites such as www.register.com and www.GoDaddy.com.

Internet domain names can be quite valuable in generating Internet traffic and on-line-advertising revenue. You should take steps to protect your domain name [Dela 07]. You should also consider registering domain names that are similar to your chosen domain name to preclude others from using the similar name.

If you choose a company (or product or domain) name that might appeal to others, be prepared to defend it. In our own case, we continually had to threaten legal action to prevent others from using

the name of our company and our products. This resulted in additional legal expenditures.

OTHER LEGAL DOCUMENTS

As you start your business, there are various legal documents you will need to make sure you minimize your chances of becoming ensnarled in litigation. In what follows, I will discuss a number of these documents. The list is by no means exhaustive or prioritized. It is simply representative of the kinds of documents you should have, keeping in mind that some may not apply to your type of business.

You can obtain copies of many sample or template contracts from the Internet (e.g., www.docstoc.com), your local bookstore, your library, other companies, or your lawyer.

You should consult with a lawyer who specializes in employment law for the following type of documents:

Letter of employment

This is the letter used to make an offer of employment, carefully crafted with appropriate legal terminology. It should include an "at-will" provision, stating that employment may be terminated at any time. Every employee must accept employment by signing a copy of this letter. No exceptions. No negotiations.

Employment terms specific to a particular position or individual can be attached to this letter as an addendum.

Employment contract

This document defines in detail important terms and conditions of employment that apply to all employees. It covers such issues as (1) the requirement of the employer's written consent for employees to make commitments on behalf of the employer; (2) the consequences of negligence or misconduct by the employee; (3) restrictions on how employees are to treat trade secrets or any other confidential information of the employer; (4) the employee's treatment of the employer's property; and (5) the question of who has ownership of any work created by the employee. The contract

should also include a non-compete clause and a clause requiring work-place disputes to be arbitrated.

You should feel comfortable that the contract is a fair one.

Every employee must sign this contract the first day they report to work. No exceptions. No negotiations.

Employment contract (addendum) for salespeople

For employees involved in sales, you have to deal with such additional issues as travel and expense guidelines, expense reimbursement, and commission plans. These matters can be specified in a separate document or addendum to your standard employment contract.

You should feel comfortable that the contract is a fair one. Every employee involved in sales must sign this contract the first day they report to work. No exceptions. No negotiations.

Company policies and procedures

This is an easily updated binder that is handed out to every employee the first day they report to work.

This document is more than a repository of various company policies. It also includes a clear statement of the company's mission, goals, philosophy and ethical standards. In addition, it contains an organizational chart.

It provides complete coverage of company plans and policies regarding issues such as holidays, vacations, sick leave, any profit sharing plan, any health plan, security procedures, maternity leave, sexual harassment, drugs, alcohol, smoking, and many others. Employees should sign a form acknowledging receipt of this document.

Consultant agreement

If you are going to employ consultants, you need a contract to define the relationship. Every consultant signs one before they commence any work for your company.

You should consult with a lawyer that specializes in business law for the following types of documents:

Distributor agreement

If you are going to employ distributors as part of your marketing strategy, you need a contract to define the relationship. If any of these distributors are located in foreign countries, you will need country-specific agreements, and you may also need to consult with a lawyer in each appropriate country.

Every distributor signs one before they start distribution activities.

Product licensing agreement

If, for example, you are licensing a software product, the product licensing contract contains the agreement between your company and your customer. These types of agreements are ubiquitous. You see one whenever you buy a new software product for your personal computer.

Any customer who wishes to enter into a licensing arrangement with you either signs or accepts one.

Rental or lease agreement

Typically your landlord will provide you with a rental or lease agreement and request that you sign it on behalf of your company. The landlord may also require that you personally guarantee the agreement.

Agreements with financial backers

If you are raising money, you will need the assistance of a lawyer who specializes in that area. Often a lawyer with expertise in mergers and acquisitions is the right one, depending on the complexity of the financial transaction you may be considering.

Buy/sell agreement

If you have partners in your business, at a minimum, make sure you and your partner(s) have entered into a buy/sell

agreement. This agreement should be executed before you start the business and should detail what takes place if you and your partner(s) decide to part company. If you do not have such an agreement, you will probably regret it.

There are other general business agreements you may need (e.g., nondisclosure agreement, product evaluation agreement, outsourcing agreement), but this list should give you a good idea of the type of legal documents you will require.

ADDITIONAL COMMENTS ON CONTRACTS

Since we live in a highly litigious society, **it is necessary to have contracts supporting any business arrangement of value.**

There are a number of people in business—not many—whose word or handshake is a contract. Personally, I firmly believe that that is the way it ought to be, and I behave accordingly. When you encounter one of these honest and ethical individuals, protect that relationship. Doing business with such persons is much less stressful, has a better chance of success, and will minimize potential litigation expenses. The following story describes a rather exceptional business environment.

Diamonds are forever [Lowe 07]

Israel's Diamond Exchange consists of four inter-connected building complexes in the town of Ramat Gan. Affectionately known as the "bourse," it consists of 700,000 square feet of offices, banks, workshops, trading halls, two post offices, one synagogue, and much more. Every day, some 15,000 people pass through it, showing their multi-colored security badge to the guards and 'doing business.' Each year, an estimated $20 billion worth of diamonds are traded in the bourse.

Trading is typically carried out in transactions that are sealed with a handshake and by saying the Hebrew words "mazal uvracha" which mean "may this bring you good luck and a blessing."

In this business community, a trader's good name is everything. Anyone who violates the rules is banned from the business, and their

name is forwarded to the other 26 bourses, all of which are members of the World Federation of Diamond Bourses.

Returning to the topic of contracts, keep in mind that no matter how long and detailed any given contract is, events will arise that are not covered in the contract. **Entering into a win/win business arrangement is the key to resolving unforeseen events.** If it is in the best interest of both parties to make this business arrangement work, it will most likely survive.

A short story is pertinent here.

The telephone book

We completed the negotiations of a major business relationship with a large European concern. We agreed on a "term sheet" outlining the key business terms of the agreement. We then turned over the term sheet to our lawyer and asked him to create a formal legal contract. He did. I thought he had done an excellent and fair job. It consisted of approximately twenty pages of text.

I sent the finished draft over to the other company's headquarters in Europe expecting that they would have few issues with it. I received a call from the president of the European company to inform me that one of his vice presidents was coming to our Santa Barbara office with a few changes to the contract. He said this man had the authority to finalize the agreement.

The vice president arrived on schedule. He pulled out a document about an inch thick and pointed to it, stating that it contained their proposed modifications to the contract we had sent them. I was astounded.

For the next two days, I listened patiently as this man went over the changes they were requesting.

It became clear that this contract was his "baby," and I sensed that this was the first major agreement he had ever negotiated. Almost without exception, these vast changes were extensions to the contract my lawyer had drafted, specifying how the parties were to proceed in the event of an infinite list of eventualities. There were few substantive changes to the essence of the original agreement. I

agreed to most of his requested changes, and I thought we were ready to sign.

Well, I was wrong. We had provided this man with an office, and he kept returning to this office and emerging with more variables and more addenda to the contract.

I tried to convince him that you could not cover every possible eventuality in a contract, but it was to no avail. This was a large business transaction, and I decided it was best to let him continue with his process until he was ready to execute the agreement.

After a couple of days, I could not take it anymore.

I asked one of our vice presidents to continue working with this man until the logical conclusion of the process, which occurred some two weeks after the man had arrived from the European office.

I said we would give the new version of the agreement to our lawyer for review, which would probably take two to three days. The European vice president agreed to stay in Santa Barbara and wait.

Our lawyer got back to me and told me that in all his years in practice he had seldom seen such a waste of human effort. Our lawyer stated that this new contract, which was now some 150 pages long, did not alter the intent of the original agreement. Rather, it tried to account for what appeared to be an infinite number of potential eventualities.

I got back to the European vice president and after cleaning up a few details, we signed the agreement. It had the appearance of a big city telephone book. He returned to Europe happy and satisfied. I took a couple of days off because I was exhausted.

About a month later I received a telephone call from this European vice president. He was very humble. He informed me that they had encountered a business situation that was not covered in the contract and that we needed to discuss it.

We talked about it, and since this was a win/win agreement, we came to a satisfactory resolution in a short time.

After I hung up, I called into my office the person in our company who had worked on this agreement. After I told him about the telephone call, we both had a good laugh.

Of course, the moral of the story is that it is a foolish task and a waste of effort to try to account for every possible eventuality in a contract. Instead, concentrate in creating a win/win agreement.

Quite often after a business relationship begins, one of the parties to the agreement realizes that the current arrangement is not fair to him/her with respect to some issue. If you are that party, you should be able to sit down with the other party and show them why specific changes should be made to the contract. If you are the other party, you should be prepared to address any fair request for changes. On the other hand, unfair requests harm a relationship.

Finally, **avoid litigation if you can**. Litigation consumes valuable time and resources. Use your best efforts to settle any disagreement before it enters the legal pipeline. **There may be situations in which you have no choice but to take legal action. In these cases, go forth aggressively, and be prepared to go all the way to trial.**

PATENTS, COPYRIGHTS, TRADEMARKS AND TRADE SECRETS

The issue here is protecting your property.

Your company owns physical assets such as factory equipment, desks, computers and other furniture. You have certain procedures you use to protect those assets. For example, you make sure that someone is present during the day when the doors are unlocked, and you make sure that the doors are locked at night when no one is around.

Your company may also own intellectual assets such as inventions, methods, brands, and artistic creations. You need to protect these intellectual assets with great care. The reason is simple. Most likely, they represent a good part of the real value of your company. Furthermore, as your company matures and develops its products and penetrates the market, the value of your intellectual assets may increase dramatically.

According to an article in *The Wall Street Journal* [Timi 07] businesses in the United States currently invest as much in

intellectual property and other intangible assets, about $1 trillion, as they do in equipment, factories and other physical investments. The article states that intangible assets, including intellectual property, account for nearly one-third of the value of all United States stocks, about $5 trillion to $5.5 trillion, or 45% of the GDP of the United States.

Any entity interested in investing in your company or buying your company will want to know how well-protected your intellectual assets are. This will be an important factor in the valuation given to your business.

The first action you can take to protect your intellectual assets is to develop procedures to protect them. For example, you can make certain your employees are aware of the value of your intellectual property, and you can educate them on how to help protect these assets.

In addition, the legal system provides the following important mechanisms for protecting intellectual assets:

1. Patents
2. Copyrights
3. Trademarks
4. Trade secrets

There are a multitude of books, reports, and websites with much discussion on these forms of protection. Here I am simply going to summarize when they are employed, as well as their characteristics.

1. PATENTS
Patents are used to protect inventions.

In the United States, a patent grants to the inventor a monopoly over his/her invention for twenty years from the filing date of the application. The monopoly includes use, manufacture and sale of the invention. Further, in the United States, a patent prevents others from importing into the United States the patented invention.

To qualify for a patent, an invention must satisfy a number of legal criteria (e.g., "must be new, useful and non-obvious"), which

are beyond the scope of our discussion here. I should point out that an invention need not be a totally new idea to be patentable. You can obtain a patent on modest improvements in existing technology as long as the improvements are not obvious to ordinary practitioners of the art.

You should be aware that patents have also been issued for new ideas about how to carry out certain activities in areas such as finance, accounting and insurance [Cro2 09].

Patents are considered the strongest form of legal protection you can obtain for intellectual property.

Patents are time-consuming and costly to obtain. Procuring a patent in the United States can take three to four years and cost well over $15,000 when you seek the help of an intellectual property lawyer. To obtain foreign patent protection, you must file a patent application in each country in which you desire protection, since each country has its own patent laws.

Timing issues are important considerations. An invention will cease to be patentable in the United States if the inventor fails to file a patent application within one year after first publicly using, describing, or commercializing the invention. Some foreign countries do not offer this one-year grace period.

Patents are initially owned by their inventors. Thus, your company's employment contract must incorporate the assignment of any inventions made by your employees to your company.

Lawyers recommend that companies maintain documentary evidence establishing dates of conception and development of inventions. For example, some companies require their relevant staff to keep notebooks, with entries being signed, dated and witnessed on a regular basis [Fenw 05].

As part of your patent application the government requires applicants to provide a complete description of the invention. The United States Patent and Trademark Office will maintain patent applications in strict secrecy only if certain conditions are met. The patent offices of many other countries do not protect the secrecy of your application at all.

Patents are not enforceable until issued. Once a patent is issued, maintenance fees must be paid periodically to maintain the patent in force. Also, the owner of the patent should mark products incorporating the patented invention with the word "Patent" or "Pat." and the patent number. This marking notifies the public that the product is protected by a patent. This notification is helpful to be able to recover monetary damages from infringers.

If you are considering applying for a patent you should carry out a patent search to determine what related patents have been issued. Titles and abstracts of patents in the United States from 1976 to the present can be searched for free through the United States Patent and Trademark Office website (www.uspto.gov). Other websites that will assist you in your search are: the IBM Intellectual Property Network site (www.ibm.com/ibm/licensing) and the Delphion site (www.Delphion.com) which you have to pay a fee to access.

You can generate revenues with your patents not only by selling your invention directly but also by licensing it to others. For example, such companies as Procter & Gamble, International Business Machines, Dow Chemical, and Texas Instruments have generated substantial amounts of revenues by licensing their technology to others [Lich 07].

If you find that someone is infringing on your patent, you are generally entitled both to an injunction preventing future unauthorized use of your patent and to monetary damages. The following story illustrates the point.

BlackBerry

In a much publicized case [Hein 06], Research in Motion Ltd. (RIM) paid $612.5 million to NTP Inc. to settle a five-year legal battle concerning patent infringement.

RIM makes and markets a widely used wireless email device named BlackBerry with a fast growing user base estimated at four million users in the United States at the end of 2005. By 2009 the user base had grown to over 25 million users in over135 countries [Silv 08, Trac 09].

NTP, a very small company, sued RIM in 2001 claiming that BlackBerry infringed on its wireless email patents. RIM fought the case aggressively, but faced with the possibility of a shutdown, negative publicity that was affecting its sales and market share, and pressure from its major customers, RIM settled the case in March of 2006.

Patents can also be employed as a weapon against your competition. The following two stories illustrate the point.

Vonage [Fam 07, Sha1 07, Sha2 07, Chen 07, Sven 07, Yaho 07, Sha3 07]

Vonage Holding Corp., originally the largest Internet telephone start-up, has been hammered by Verizon, the second-biggest U.S. telecom operator, Sprint Nextel, a major wireless carrier, and AT & T, the largest telecommunications company in the U.S., through a series of patent-infringement suits filed in 2005, 2006 and 2007. Internet telephony represents a threat to Verizon's and Sprint Nextel's land-line and wireless phone businesses, as well as to AT & T businesses.

Vonage was found in March of 2007 to have infringed on three Verizon patents, and in September of 2007 to have violated six of Sprint Nextel's patents. Vonage was ordered by the courts to pay substantial damages to both Verizon and Sprint Nextel. In October of 2007, Vonage settled with Sprint Nextel. Vonage agreed to pay $80 million to Sprint Nextel to settle the matter. In October of 2007 Vonage also settled with Verizon. Vonage agreed to pay a maximum of $117.5 million to Verizon.

In October of 2007, AT & T sued Vonage for alleged patent infringement. In November of 2007, Vonage reached a tentative settlement agreement with AT & T. Vonage agreed to pay $39 million to AT & T.

Hewlett-Packard vs. Acer [Lawt 07, Eeta 07, Wsj1 07, Shuk 08]

Hewlett-Packard Co. was, as of 2007, the company shipping the largest number of personal computers worldwide. Acer Inc. of Taiwan was the fourth company worldwide in terms of personal computers shipments, but it was gaining ground at an impressive pace. Acer represented a threat to Hewlett-Packard's personal computer business.

In March of 2007, Hewlett-Packard filed suit against Acer alleging infringement of five patents owned by Hewlett-Packard and seeking treble damages and an injunction that would prevent Acer from selling infringing personal computers in the United States. In April of 2007, Hewlett-Packard filed another patent infringement lawsuit against Acer.

In July of 2007, Acer filed a patent infringement counterclaim against Hewlett-Packard. In October of 2007, Acer filed another patent infringement lawsuit against Hewlett-Packard alleging seven patent violations.

By 2008, Acer, after acquiring American computer maker Gateway, moved up to become the No. 3 vendor of personal computers.

In June of 2008, the two companies entered into a confidential settlement agreement resolving all ongoing patent litigation between the parties.

The Patent Office in the United States receives some 500 million applications a year. It is estimated that patent litigation costs exceed $10 billion a year! Furthermore, studies indicate that aside from the chemical and pharmaceutical industries, the cost of patent litigation now exceeds the profits companies generate from licensing patents [Cro2 09].

It is clear from the above discussion that owning a patent can be a major business advantage. Equally clear is the fact that applying for one is an expensive and time-consuming effort that will affect your business operation, particularly if you are a smaller company.

Also note that defending your rights in a patent infringement case can be quite expensive.

Before leaving this section it is appropriate to make you aware of a simplified approach to a patent application that is available to you in the United States.

Provisional patent application [Spo1 08, Know 08, Bell 08]

You can file a Provisional Application for Patent which will provide you intellectual property protection for up to a year. You must, however, file the full patent application (i.e., the non-provisional patent application) within one year or you may lose substantial rights. The filing fee for a provisional patent currently ranges between $130 and $260, and the documentation required is much simpler than the application for a non-provisional patent.

The advantages of filing a Provisional Application for Patent are:

1. It represents an inexpensive strategy that you can employ while you explore the marketplace before you invest the effort and the many thousand of dollars required to file for a full patent. In other words, it can buy you time to determine if filing a full patent application is the right allocation of your resources. In particular, it gives you legal protection while you talk to investors, potential customers, possible subcontractors and others.

2. As long as the full patent application is filed within twelve months of the filing of the provisional application, the filing date will be the date of the filing of the provisional application. This could be quite valuable if you are trying to beat a competitor by establishing an earlier filing date.

3. It provides you with up to a year of additional time to carry out research and prepare for the filing of a non-provisional patent application.

4. It allows you to claim 'patent pending' status which may result in a valuable marketing advantage.

You should be aware that current patent laws in the United States are the subject of much criticism [Cro1 08]. As a result, for a number of years, the Congress of the United States has been considering reforming the laws on how patents are awarded and litigated. It behooves you to keep abreast of any new legislation in this area.

2. COPYRIGHTS

In legal terminology, a patent provides protection for the embodiment of an inventor's concept. **A copyright, on the other hand, protects the expression of an author's concept.** Thus, for example, patents are utilized to protect gadgets such as a new mousetrap while copyrights are utilized to protect works such as books, music, motion pictures, sound recordings, art, websites and blogs. There are certain products that can be protected under either patent or copyright law (e.g., computer programs). If you have questions as to which may be applicable to your product, you should consult an attorney who specializes in intellectual property.

For a work to be considered original and therefore copyrightable, it cannot be substantially copied from another work and it must exhibit some intellectual labor. The requirement of originality does not have the same novelty or invention requirements that exist for patent protection [Fenw 93]. Copyright will not protect your work if someone creates a similar product without copying your work.

Copyright ownership automatically vests with the author upon creation of the original copyrighted work. Further, copyright ownership can only be transferred in writing.

The owner of a copyright possesses the exclusive right to control who can make copies or who can make works derived from the original work. The owner of a copyright can also sell or license this right.

Copyright protection lasts for the duration of the author's life plus 70 years after the author's death. In the case of a "work made for hire," protection lasts 95 years after publication or 120 years after creation, whichever expires first. "Work made for hire" is a

legal term that refers to a work prepared by an employee within the scope of his/her employment or to certain types of specially commissioned works.

In the case of a work made for hire, the employer or other person for whom the work was prepared is considered the owner; however, it is wise to have the company's employment contract incorporate the assignment of the ownership of any copyright work made by the employee to the employer.

The copyright of a work created by an independent contractor or a consultant will generally be owned by the contractor or consultant. Hence, you should incorporate appropriate assignment language in the contract you use to hire any contractors or consultants.

Albeit it is not necessary to have a notice of copyright attached to a product that you wish to protect under copyright law, it is strongly recommended that you do so in order to strengthen your legal situation in case someone violates your copyright. There are specific rules as to how you notify others that you own a copyright on a product. A proper notice of copyright should be placed on all publicly distributed copies of a work. This notice should consist of the following three elements:

- The word "Copyright" (The symbol "©" can be employed in lieu of the word "Copyright," but some people [Temp 04] do not recommend that you do so)
- The year of first publication of the work (which is not necessarily the year in which the work was created)
- The name of the owner of the copyright in the work

In addition, the phrase "All Rights Reserved" should be used since it may help [Temp 04] provide additional protection. An example of a proper copyright notice is

<div align="center">
Copyright 2009 XYZ Company

All Rights Reserved
</div>

There are also rules as to where these copyright notices are to be placed.

Although registration of a work with the United States Copyright Office is not required for copyright protection to exist, registration is strongly recommended. The reason is that registration is a prerequisite for filing a lawsuit for infringement and for protecting your copyrighted work (e.g., to stop the import of pirated copies of your work).

An application for copyright registration is a simple form that is easily prepared. Currently the registration application costs $45. The owner must also deposit with the Copyright Office one or two copies of the published work being copyrighted. Registration normally must take place within three months of the first customer shipment.

The scope and practicality of copyright protection you will receive outside of the United States varies widely from country to country.

In October of 1998 the Digital Millennium Copyright Act (DMCA) became law in the United States [UCLA 01, What 06, Wik4 08]. The intent of DMCA was to implement the treaties signed by over 50 countries in December 1996 at the World Intellectual Property Organization Geneva conference, and to update copyright law to deal with digital material and with new challenges brought about by the computer age. In particular, the DMCA addresses issues that include:

- Making it a crime to circumvent anti-piracy measures built into most commercial software
- Outlawing the manufacture, sale or distribution of code-cracking devices used to illegally copy software
- Limiting Internet service providers from copyright infringement liability for simply transmitting information over the Internet
- Expecting service providers to remove material from user's websites that appear to constitute copyright infringement

- Providing exemptions for a number of activities and institutions such as encryption research, testing of computer security systems, not-for-profit libraries, educational organizations, and other similar activities and entities

It is relevant to note that in the United States [McDo 08, Guth 08] open source software developers have the right to dictate the terms under which their copyrighted products can be used or modified (open source software refers to software whose source code is made available at no charge for use or modifications by others).

To avoid liability for copyright infringement by your employees on the copyright of others, you should incorporate written guidelines concerning any use of copyrighted materials in your company's Policies and Procedures Manual. The guidelines should make clear to employees that they can be held individually liable for infringing on the copyrights of others and that the company may be held liable for those acts as well.

There have been many highly publicized copyright infringement suits. The following case makes the point.

The Google Library [Cham 06]

In September of 2005, the Authors Guild filed a class suit against Google accusing Google of allowing copyrighted material to appear in its searchable book feature, known as Google Books, without permission. In October of 2005, a group of major book publishers led by the McGraw-Hill Companies also filed suit against Google for similar reasons. The complaints asked for damages and an injunction to halt further infringement. The cases were consolidated on October of 2006 by a United States District Judge.

After three years of litigation and negotiation a groundbreaking settlement was reached in November of 2008 [Ipwa 08]. Google agreed to pay $125 million. The money is to be used to create the Book Rights Registry, to resolve existing claims by authors and publishers and to cover legal fees. More importantly, the agreement establishes a framework that allows Google to continue to offer the

book search feature while addressing the rights and interests of copyright owners.

3. TRADEMARKS

For many companies, the marks by which that company and its products and services are known to the public become valuable assets. These assets are collectively referred to as trademarks.

Trademark law is the law protecting these marks.

In addition to providing protection against others using these assets, trademarks can be used to generate revenues through licensing arrangements.

The key to the creation of a strong trademark is to select a mark (e.g., word, name, picture, symbol, sound) that is as distinctive as possible—for example, the emblem of Exxon and the arches of McDonald's.

A descriptive mark commonly used in your industry will not be immediately associated with your product and will be difficult to protect against unauthorized use by others [Fenw 04]. For example, *Apple* is not protectable as a trademark for fruits, but it is protectable as a trademark for a brand of computers.

In the United States, trademark protection arises as a result of use in the marketplace, not registration. Once a company affixes a distinctive trademark to a product and ships that product in commerce in a genuine commercial transaction, the company begins to accrue rights in that trademark in connection with that product.

Although registration is not mandatory, it is strongly recommended since it provides documentary evidence of the ownership of the mark. It also serves as a deterrent to others considering unauthorized use of the mark.

It is important that any check on the availability of a trademark include a review of unregistered trademarks as well as those that have been registered. The check should also cover trademarks that may be pending for registration in the United States Patent and Trademark Office and in the trademark offices of the various states

[Fenw 04]. Also, such a search should take into account possible conflicts with Internet domain names.

To commence your search, go to the Trademark Electronic Search System (TESS) of the United States Patent and Trademark Office (www.uspto.gov).

The process of registering a trademark with the United States Patent and Trademark Office typically takes between six months and a year. The cost may range between $1,000 and $3,000 if you work through a conventional lawyer and much less if you work through the Internet, where you can file online for a $275 to $325 filing fee.

It is recommended [Wall 08] that you should generally refrain from registering any Web extension (e.g., .com, .net) when registering your trademark, the reason being that it will prevent others from registering the same name by just adding a different extension.

Trademark protection lasts for an initial period of ten years. Thereafter, if the trademark is used and maintained properly, the initial ten-year period can be renewed indefinitely for additional ten-year periods.

Once a mark is federally registered, prominent use of that mark should be followed by the trademark notice symbol: ®. This provides notice to the public that the mark is registered. Unregistered marks should be followed by the superscript: ™. This superscript need not appear every time the mark is used in printed materials as long as prominent uses of the mark are so noted.

There are both federal and state trademark laws; the use of federal registration minimizes geographic considerations within the United States and provides nationwide notice of the trademark owner's rights. This eliminates any infringement defense in which the offending party claims it was unaware of the trademark owner's prior use of the mark.

The United States Customs Service will assist the owner of a registered trademark by seizing goods entering the United States bearing infringing trademarks, but registration in the United States does not confer ownership rights abroad. In many foreign countries, trademark rights are established only by registration of the

trademark with the appropriate authorities. If you anticipate that your company will engage in international marketing, you may want to search in the countries of interest. This could be an expensive undertaking.

Almost all foreign countries award trademark rights to the first party to file a trademark application, not to the first party to use the mark in that country. The cost of registration in foreign countries may be in the $2,000 to $3,000 range if you work through a conventional lawyer and much less if you work through the Internet. Registration in a foreign country typically lasts for an initial defined number of years and can be renewed indefinitely if properly used and maintained as per the laws of that country.

If you do not register your mark in a given country and someone else registers that mark in their name (e.g., a former distributor) you may be prevented from distributing your product under that mark or from licensing your product in that country.

In recent years, the United States Patent and Trademark Office has been granting nontraditional trademarks for such items as product shapes, colors and scents that companies can claim are linked exclusively to the company's products in the consumer's mind [Oroz 08]. Currently, these nontraditional trademarks are difficult and costly to obtain. For example, on January 8, 2008, after a long and expensive effort, a trademark was granted to Apple, Inc. for the three-dimensional shape of its iPod media player.

If you discover that someone is infringing on your trademark, you can take legal action. Consider the following case.

Deckers vs. Steven Madden [Nels 06]

Deckers Outdoor Corporation, a footwear company known for its Ugg and Teva brands, settled a trademark lawsuit against national retailer Steven Madden Ltd. in 2006. The trademark and trade dress (i.e., visual appearance) infringement law suit alleged that Steven Madden, Ltd. was selling copies of Deckers' popular UGG Rock Star and Uptown sheepskin boots, complete with reproduction of Deckers' logo and unique design elements on the boots.

According to Deckers, Steven Madden acknowledged the infringement, agreed to pay a confidential amount in settlement, and agreed to an injunction prohibiting the use of the word *Ugg* or Deckers' logo in relation to its products. Steven Madden was also required to cease developing, reproducing, manufacturing, advertising, promoting, selling, offering to sell, importing or distributing any of the infringing products.

The following story describes an interesting example of the use of trademarks.

The Bacardi story [Cuti 05, Varg 08]

Bacardi is a rum manufacturing company originally established in Cuba in 1862 by a self-made entrepreneur. His name was Facundo Bacardi, and he emigrated from Spain to Cuba in the 1820s at age 15. He came from a poor background. His father was a bricklayer.

This family-owned company prospered, and by the 1950s, it was the largest supplier of rum in Cuba and controlled about 50% of the Cuban beer market.

At the time, the company was led by a man named Pepin Bosh, who had married into the Bacardi family. In 1956, Mr. Bosh, an astute businessman and a visionary, became uncomfortable with the political environment in Cuba. As a result, he formed a company in the Bahamas with the exclusive rights to distill and produce Bacardi rum outside Cuba, and transferred all of the Bacardi trademarks to the Bahamian company. A number of people at Bacardi thought that this was a waste of money.

In 1960, Fidel Castro confiscated all of the Bacardi properties in Cuba. This represented about 70% of all Bacardi assets. About 30% were outside of Cuba. It is of interest to note that Bacardi was one of the earliest multinational corporations. It had licensed a distillery in Spain in 1910, and it opened facilities in Mexico in 1933, and in Puerto Rico in 1935.

Bosh and his managers, most of whom had left Cuba, then set out to rebuild and expand Bacardi. By 1977, Bacardi had become

the largest seller of spirits in the world. To this day, it is still family-owned with worldwide sales approaching $6 billion a year. Bosh retired in 1976.

After Castro confiscated Bacardi's factories in Cuba, Castro tried to claim the trademarks. After many international legal battles the company prevailed everywhere. Castro lost.

Bosh and his successors believe that a key factor underlying their success after they left Cuba was that they owned the Bacardi trademarks in the international marketplace.

It is fascinating to note that the current chairman of the board, the founder's great-great-grandson, also named Facundo Bacardi, is a native of Chicago.

Copyrights and trademarks can also be employed as weapons against your competition. The following story illustrates the point.

Facebook Scrabulous [Char 08, Hata 08]

Brothers Rajat and Jayant Agarwalla built a clone of Scrabble, the popular word game owned by Hasbro Inc. and deployed it as a Facebook application named Scrabulous, which had been drawing half a million daily users.

In July of 2008, Hasbro Inc. filed a lawsuit against the Agarwalla brothers and their software company RJ Softwares claiming that Scrabulous violated its copyright and trademarks on Scrabble. Hasbro asked Facebook to block the game, and it was also seeking unspecified damages.

In response to the lawsuit, Facebook removed Scrabulous from its network. Then, the Agarwalla brothers returned to Facebook with a new application named Wordscraper. Although a new word game, Wordscraper retains certain similarities to the now defunct Scrabulous.

4. TRADE SECRETS

A trade secret is any information (such as a formula, program, device, method, technique, process, database) that is used in a business and that gives the business owner an

advantage over competitors who do not know it. A trade secret must also be the subject of reasonable efforts to maintain its secrecy.

Trade secret protection requires that you take consistent steps to treat the information you want to protect as a valuable secret, including steps such as obtaining signed nondisclosure agreements from those you give access to the secret.

You should include a provision in your employment contract requiring the employee to maintain the company's trade secrets in confidence, particularly after the employee leaves the company.

Trade secret protection will be lost when the information becomes generally available to the public. In particular, protection can be lost by disclosing a trade secret to someone who has not signed a written confidentiality agreement.

Trade secret protection requires no filings or registrations and may last indefinitely (e.g., the Coca-Cola formula, Google's search engine methodology [Brav 08], Col. Sanders' KFC recipe [Schr 08]).

Unlike patents, copyrights and trademarks, trade secrets are protected entirely by state law. Therefore, the scope of protection varies from state to state.

Individuals involved in the theft of trade secrets may be subject to prosecution. The following case is an example.

Yahoo vs. MForma, et al. [Spee 06, Tam1 07]

In a well-publicized event in February of 2006, Yahoo filed a lawsuit against a start-up mobile phone games company named MForma and seven of MForma's employees. The company changed its name to Hands-On Mobile in April of 2006. Yahoo charged MForma and the group of seven former Yahoo employees who went to work for MForma with theft of trade secrets. Within a week a California judge issued a temporary restraining order prohibiting the MForma employees from using or disclosing any proprietary Yahoo information in their work.

The lawsuit claimed that thousands of pages of Yahoo mobile business data were stolen, including market research, contact lists, and Power Point presentations.

The case was settled in January of 2007. The terms of the settlement are confidential.

The following three cases offer additional examples of trade secret and patent litigation. Furthermore, all of the cases presented here substantiate the point that litigation is ubiquitous in today's competitive business environment.

Nuance Communications vs. Yahoo [Spee 06, Oswa 05]

In September of 2005, Nuance Communications filed a lawsuit against Yahoo. Yahoo hired thirteen of Nuance's developers, which Nuance claimed was a conspiracy to take over their research and development efforts in speech recognition technology. Nuance also accused Yahoo of attempting to steal its intellectual property. The parties settled the lawsuit in February of 2006. Neither party admitted liability, and they agreed not to discuss the matter further.

VoiceSignal Technologies vs. Nuance Communications [Kawa 06]

In November of 2006, VoiceSignal Technologies filed a patent infringement lawsuit against Nuance Communications over VoiceSignal's voice recognition software. The lawsuit alleged that Nuance violated VoiceSignal's patent, which covers the methodology for correcting errors in dictation software. In May of 2007 Nuance Communications acquired VoiceSignal Technologies.

ScanSoft vs. VoiceSignal Technologies [Reut 04, Voic 07]

In February of 2004, ScanSoft filed a patent infringement and trade secret misappropriation lawsuit against VoiceSignal Technologies regarding voice-activated dialing for mobile phones. In August of 2007, after a report by a mutually agreed upon court-appointed neutral expert, the court dismissed all of the claims between ScanSoft and VoiceSignal Technologies.

Summarizing the above legal entanglements in chronological order we have:

ScanSoft sued VoiceSignal Technologies,
Nuance Communications sued Yahoo,
Yahoo sued MForma, and
VoiceSignal Technologies sued Nuance Communications.

The above lawsuits can also be viewed as:

ScanSoft sued VoiceSignal Technologies who sued Nuance Communications who sued Yahoo who sued MForma.

Regrettably, as the above cases exemplify, today's businesses are conducted in an environment where lawsuits are ubiquitous. **There is no question that you will need to deal with lawyers and potential lawsuits.** After some additional comments concerning trade secrets, and a short section on Internet issues, I will focus on lawyers.

It is important to take steps to avoid violating the trade secrets rights of others. **Your employment contract should include a clause requiring the new employee to verify that he/she will not bring or divulge to anyone in your company confidential information from any previous employer.**

Note that trade secret protection and patent protection present a conflicting situation. A patent is issued in exchange for a full public disclosure of the invention. United States patent law allows an inventor to retain trade secret protection under certain conditions while the patent application is being processed. If you are utilizing trade secret protection and you apply for a patent, you should consult your intellectual property attorney for advice.

INTELLECTUAL PROPERTY PROTECTION AND THE INTERNET

Previously, when discussing the new dimensions that the Internet brings forth, I mentioned that one of the most powerful

characteristics of the Internet is that it is a platform of cooperation. The more successful you are in having the visitors to your website add value explicitly or implicitly to your Internet offerings, the more successful your enterprise will be.

This need to facilitate cooperation on the Internet often conflicts with your desire for strong protection of your intellectual assets. For example, if I encourage users of my products to submit discussions of new ways to employ my products, who owns the rights to these descriptions of new applications to my offerings once they are made part of my website?

It is your responsibility to carefully evaluate what you need to do to encourage cooperation and selectively loosen your protection of the intellectual assets required to facilitate such cooperation. Your goal should be the creation of a win/win situation for you and for your users.

I have outlined in this chapter many of the legal issues you will face as an entrepreneur. There is no question that you should seek assistance and advice from lawyers in making your decisions. Next I discuss the challenge of interfacing with lawyers in a cost-effective manner.

LAWYERS
According to the American Bar Association there were over 1.1 million active lawyers in the United States at the end of 2006. Of these, over 147,000 were located in New York, over 145,000 were located in California, over 70,000 were located in Texas, and over 60,000 were located in Illinois. Thus, there is no shortage of lawyers. The challenge is finding the right lawyers.

Before I discuss how you may go about locating the right lawyers let me tell you a short story.

Legal encounter of the first kind
When I started my first company I needed a software product licensing agreement in order to start selling. Naive as I was at the time, I hired a lawyer specializing in business issues to create an

172

agreement for me. I did not check to see if this lawyer had any experience in drafting such agreements.

After some delays he sent me the agreement he had drafted for review. I read it, and I was shocked. Although my business experience was limited, it was clear to me that no potential customer in his/her right mind would sign this agreement. It was ridiculously one-sided in my company's favor. It made no business sense.

I immediately went to meet with this lawyer. I asked him to explain the agreement to me. His explanation made as much sense as the agreement itself. So I asked him, "If you were my potential customer, would you sign this agreement?"

His answer: "No."

My next question: "If you would not sign the agreement, how in the world can you justify giving me such an agreement to take to my clients?"

His answer (are you ready for this?): "You hired me to create an agreement for you that protects your company. This agreement certainly does that."

It is relevant to summarize my predicament at the time. I was ready to start sales, I was almost out of seed money, and now I did not have the product licensing agreement that I needed.

I got up, dropped the agreement in the lawyer's wastebasket, and left his office.

I did next what I should have done from the start.

I obtained copies of software product licensing agreements used by other established software companies. I sat down with a cup of coffee and listed the relevant issues that were important to me. Then, using the list I created and the agreements I had collected as models, I drafted an agreement for use by my company.

After doing some checking, I found another business lawyer in town. I gave him the agreement I had created and asked him to review it simply for proper legal terminology and content. I told him not to spend time on the business aspects of the agreement. I just wanted him to "bless" it as a proper legal document. He agreed to do that. His charge for this was very reasonable.

The end result was a software product licensing agreement that, with minor updates as time went on, lasted for the life of my company.

Back to the original lawyer. A few days after our meeting, I received a substantial invoice for his services. The amount was much larger than what I had anticipated for the creation of a usable agreement. I also noticed that one of the items in his invoice was time spent in research. In case you are wondering, I paid the bill. It goes without saying that I never used him again.

Postscript to the story. About a year later I arrived at my office early in the morning, and I found this lawyer sitting on the sidewalk waiting for me. He said humbly to me, "I was just hired by another software company to create a product licensing agreement, and I was wondering if I could get a copy of the one you are using."

This is what some people call "chutzpah."

I gave him a copy of my agreement and did not charge him a penny for it.

It is worthwhile to go over the lessons I learned from this experience. These lessons are not listed in any particular order, since they are equally important.

Lesson 1. Determine the area in which you need legal help. For example, does your problem concern employment law, contract law, intellectual property law, or real estate law? In any case, you need to hire a lawyer who specializes and has experience in that area. You want to get the best advice you can, and you want to minimize the lawyer's research expenses.

Lesson 2. Before you hire a lawyer, check him/her out. Identify two or three candidates. Ask around. If you do not receive solid recommendations, look for other lawyers. Meet with each candidate and follow your gut feeling. Do not compromise. If none of the lawyers makes you feel comfortable, keep looking.

The type of questions you want to ask others about a lawyer include:

- Is he/she competent?
- Is he/she easy to communicate with?
- Is he/she efficient and fair in his/her billing?
- Is he/she timely in dealing with clients' tasks?
- Is he/she respected by others in the legal community?
- Does he/she have many repeat clients?
- Do you know anyone who was not happy with this lawyer? (If you get a yes answer, follow this lead to its logical conclusion).

Martindale-Hubbell, a division of Reed Publishing, maintains a large directory on lawyers and law firms and provides profiles on them as well as some general evaluations. Their website is at www.martindale.com. It can serve as one of your resources in your search for a lawyer.

Also check with your State Bar Association to see if any disciplinary action has ever been taken against any attorney you are considering.

Questions you want to ask the lawyer when you meet him/her:

- What is your area of expertise?
- What is your actual experience in this area?
- Do you feel comfortable working on my particular problem?
- What is your time availability to deal with my problem?
- Who are other colleagues you can consult if necessary?
- How do you charge for your services?
- Will you be assigning an associate to this case? (If yes, meet and query the associate. "Associate" is the title given in law firms to junior lawyers).

It is important that when you ask these questions you do not come across as a difficult person. You want to convey that you are a decent person who is concerned with making the right decision.

Lesson 3. Lawyers typically charge by the hour. Presently most lawyers charge several hundred dollars per hour. Be prepared to describe to the lawyer what you need as clearly as you possibly can. Do your best to define your need as a well-contained request. Try not to give your lawyer an open-ended task.

Ask your lawyer to provide you with a written estimate of what the charges will be for working on this problem and for providing the answers or legal products you need. Lawyers refer to a letter describing what work they will do for you and how they will charge for their services as "an engagement letter."

You will need to be careful and fair. If you change the scope of the legal task you have given the lawyer, he/she will tell you that the original estimate no longer applies.

I recommend that once the lawyer has provided you with an acceptable estimate, you request that if at any time he/she realizes that the charges for this job will exceed the estimate, you are to be notified before the additional charges are incurred.

Finally, try to negotiate a "not-to-exceed" amount as long as you do not change your task in any major way.

Lesson 4. **There are two distinct and separate areas that you need to address as you prepare to retain the services of a lawyer for your business. First and foremost are the business issues. Second are the legal issues.**

The best way to convey to you the essence of these issues is through a sample scenario.

Suppose you are negotiating a licensing agreement with a distributor who will be reselling your products in a specific market. There are a multitude of business issues that need to be determined before you go to a lawyer to help turn this business deal into a contractual agreement. These issues include the reselling price, the

minimum quotas, any prepayments that the distributor may make, the length of the agreement, the conditions under which the agreement will be renewed, possible exclusivities, the party who is to pay the cost of training the distributor's personnel, and many other pertinent business issues.

Assume that you and the distributor have spent quite a bit of effort negotiating this deal before you and the distributor are ready to create a legal document to memorialize your agreement. At that point, assuming you want your lawyer to create the first version of the agreement, you go to your lawyer.

As surprising as this may sound to you, few lawyers have a good understanding of the realities of business life, not even those who specialize in business law. Yet most lawyers believe otherwise. The implication is that quite often the lawyers complicate matters in trying to address all sorts of potential eventualities that have minor relevance to the business deal at hand. What should have been a six-page agreement all of a sudden has become a fifty-page treatise. Much effort is spent on third-level and fourth-level issues. The deal begins to unravel.

I have seen this happen several times.

Your job is to separate the business and the legal issues. Stay in control of your business issues, and ask your lawyer to explain the legal issues to you in enough detail so you can determine their implication to the business deal under negotiation. Then, you decide the importance of any legal issue in question and instruct the lawyer accordingly.

Of course this problem can be minimized or eliminated if you have a lawyer who has a good understanding of business. It takes time working with a lawyer before you can decide how the lawyer performs in a business environment. When you find a competent lawyer with a good sense of business, you should do your best to hang on to that lawyer.

After being in business for a while, I was fortunate to find an outstanding lawyer who was very helpful to me. He would often bring to my attention business considerations that I had missed. We worked together until his retirement.

Lesson 5. Contracts are a critical part of your business. If you agree contractually to the wrong issue, you can lose your business and your entrepreneurial dream.

Moreover, there is no one better qualified than you to draft the business terms of a contract involving your company. Therefore, **"the contractual business hat" is one you should wear and not delegate for the life of your company.**

When you are in need of a contract for a transaction, you can proceed in one of two ways:

1. As I did in creating a draft of our original software product licensing agreement, you create the first draft of any contract required for your business to take to your lawyer to review and bless. Your contracts lawyer can be of much help if he/she provides you with an appropriate template for formulating the first draft of any required contract. Many lawyers are not amenable to this.
2. You create a list of the relevant business issues (often referred to as a "term sheet") and how they should be resolved. You provide this list to your attorney and ask him/her to draft a contract accordingly. You then review this draft to ensure that it satisfies your business issues and subsequently ask the lawyer to finalize the contract.

In my own case, after the creation of the software product licensing agreement, I employed the second approach listed above for creating most of my contracts.

This strategy has three important benefits:

1. It allows you to be involved and understand the details of any contract binding your company.
2. It helps to minimize your legal bills.
3. It allows you to allocate your time elsewhere.

Lesson 6. When communicating with your attorney, you do not want to be penny-wise and pound-foolish. You should meet with your attorney or use the telephone as necessary to get the job done. There are many times, however, when emails represent an efficient way to communicate. Using emails when appropriate are a way to help keep your costs down.

The preceding discussion provides you with an initial set of guidelines for selecting and working with an attorney. As you gain experience, you will develop your own guidelines.

SUMMARY

We live in a very litigious society. You need to prevent legal headaches before you are immersed in one. Litigation is costly and distractive.

I discussed the various legal structures that are available to you to create a business. I discussed the advantages and disadvantages of each of these legal structures, including many associated tax issues.

I covered how to protect yourself, your company, and your intellectual property. I also discussed the various contracts you will need.

I outlined how to select and interact with lawyers and provided you with tips to keep your legal costs down.

KEY POINTS COVERED

- Identify your operational needs and select the legal structure for your business that best meets those needs.
- The different legal structures include:
 1. Sole proprietorship
 2. General partnership
 3. Limited partnership (LP)
 4. C corporation
 5. S corporation
 6. Limited liability company (LLC)
- Entering into a win/win business arrangement is the key to successful contracts.
- Create a letter template to be used for all offers of employment.
- Create an employment contract to be signed by all employees.
- Create a company policy and procedures binder. Provide a copy to each employee.
- There are four important legal mechanisms for protecting your intellectual property:
 1. Patents
 2. Copyrights
 3. Trademarks
 4. Trade secrets
- Patents are employed to protect inventions. They are considered the strongest form of legal protection you can obtain.
- Copyrights are employed to protect the expression of an author's concept.
- Trademarks are employed to protect the symbols by which a company, its products and services are known to the public.
- Trade secret laws are employed to protect any device or information that is used in a business that gives the business owner an advantage over competitors who do not know it or use it.

KEY POINTS COVERED (CONT'D)

- When selecting and interacting with lawyers utilize the following guidelines:
 1. Determine the legal area in which you need help.
 2. Before you hire a lawyer, check him/her out.
 3. Define your legal need as a well-contained request.
 4. Obtain a written estimate of cost.
 5. Clearly differentiate business and legal issues.
 6. Stay in control of business issues.
 7. Decide on the importance of different legal issues.
 8. Stay fully involved in determining the terms of all contract negotiations.
 9. Use emails to communicate with your lawyer whenever it is appropriate.

CHAPTER 9

ACCOUNTING

AN OVERVIEW
In this chapter I will do the following:

- Explain some of the principal accounting issues you will need to face and understand to create and run your company
- Provide an overview of the financial statement that you will have to generate and maintain
- Describe how your potential lenders and investors employ this financial statement to decide whether to lend or invest in your company, and then to monitor your performance
- Introduce the additional financial reports you will need to manage your business effectively
- List the various taxes you must pay
- Discuss the different types of accountants and outline how to obtain accounting services in a cost-effective manner

This chapter is not intended as a substitute for legal or accounting advice. On the contrary, the objective is to help prepare you for discussions with your attorney and your accountant.

BACKGROUND
We live in a world of interconnected business people and businesses. A banker who may be evaluating a loan to your firm, a potential investor, or anyone considering buying shares of your company will want to know about the financial conditions of your business. Many large, potential customers who want to assess the long-term existence of your firm also want to know about your financial conditions. There is, therefore, a need to have a set of

conventions for summarizing the financial conditions of a business in a format that is understood by the business community.

Accountants are the professionals who map a company's financial status and business transactions into an agreed-upon format. They are also responsible for analyzing, verifying, and reporting the results. What they do is referred to as accounting.

ACCOUNTING STANDARDS

Accountants in the United States follow Generally Accepted Accounting Principles (GAAP), which is a set of conventions, rules, and procedures that define accepted accounting practice, including broad guidelines as well as detailed procedures. The basic doctrine was originally set forth by the Accounting Principles Board of the American Institute of Certified Public Accountants, which was superseded in 1973 by the Financial Accounting Standards Board (FASB), an independent, self-regulatory organization [Down 87].

The Securities and Exchange Commission (SEC) has the legal responsibility and authority to set accounting measurement and disclosure standards for public companies selling securities in the United States; however, a large number of accounting standards have been developed under private sector standard-setting bodies—currently the FASB—subject to the oversight of the SEC. In 2002, the Public Company Accounting Oversight Board (PCAOB) was created by Congress. The PCAOB is charged with overseeing the firms that audit public companies, registering and inspecting them, and crafting auditing standards. The SEC is responsible for overseeing the PCAOB.

Although the intent of GAAP is to produce a fair representation of the financial health of a company, there is sufficient room in the application of GAAP for misleading financial representations. Regrettably, there have been a number of high profile business debacles reported in the press in the last few years where this has been the case.

GAAP has been criticized [Wsj2 07] as being cumbersome and overwhelming and consequently opening the door for financial fraud. It consists of some 25,000 pages.

Most countries outside of the United States employ the International Financial Reporting Standards (IFRS) instead of GAAP. IFRS is currently required or permitted in over 100 countries, including all of Europe [Cox 08]. IFRS was developed by the International Accounting Standards Board (IASB) which is an independent privately funded accounting standard setter focusing on global accounting standards. The IASB is governed by a foundation called the International Accounting Standards Committee Foundation. The ultimate goal is to have IFRS function as the single standard for global accounting.

In the United States, companies listed on a United States stock exchange have been required to report their financials in GAAP. In August of 2008, the SEC announced that the United States will abandon GAAP in favor of IFRS according to a certain timetable. Voluntary adoption of IFRS will be permitted for some companies starting in 2009 with mandatory transition required by 2016 [Cro2 08, Pric 08].

A key difference between GAAP and IFRS is that GAAP is based on rules (a nine-inch, three-volume set), whereas IFRS is based on principles (a two-inch book) [Cro2 08]. As mentioned earlier, there have been fraudulent uses of GAAP, and there is sufficient room in the employment of IFRS for fraudulent use. Interestingly, it has been noted that the legal and regulatory system in the United States will have to evolve to accommodate financial statements that are produced by a system based on principles rather than rules [Cro2 08].

It has also been observed that transitioning to IFRS may impact such areas as how business is conducted with customers and vendors, internal business operations, taxes, and how some employees are compensated [Pric 08, Stei 08].

Certified Public Accountant

A Certified Public Accountant (CPA) is a person who has been licensed by his/her state of residence to practice accounting as a CPA. To obtain this license a person needs to have a college degree with emphasis in accounting, to pass the national uniform CPA

exam, and in most states, to have practical, on-the-job experience working for a CPA firm.

Public Accountants

Those who have not met all the requirements to obtain their CPA licenses can offer accounting and income tax services to the public. They are referred to as Public Accountants or Registered Accountants. The regulation of accountants who are not CPAs varies from state to state [Trac 94].

AUDITS

Individuals or entities that are considering loaning money to, investing in, or forming an association with a business will want to review the financial report on the condition of the business. They need to feel comfortable with the accuracy of the financial report. They will want someone to assure them that the financial report they are receiving can be trusted. The conventional way to respond to this need is to have the financial report audited by an independent CPA. After completing an audit, the CPA is expected to express an opinion on the financial report. This opinion is expressed in a standard format. The opinion takes one of three principal forms:

1. UNQUALIFIED OPINION (ALSO REFERRED TO AS A CLEAN OPINION)

This is the best audit opinion. The CPA states that he/she has no material disagreements with the financial report. A CPA who issues a clean opinion on a financial report that is later found to have been fraudulent or misleading, causing losses to those who relied on it, will often be sued.

2. QUALIFIED OPINION

In this case, although the auditor is satisfied that the financial report is not misleading, he/she raises flags. A typical caveat for an early-stage company might be the auditor's opinion expressing doubt about the company's ability to continue as a going concern.

3. ADVERSE OPINION

Here the auditor expresses the opinion that there are serious problems with this financial report.

It is also possible that the auditor simply writes a letter issuing no opinion.

Audits are very expensive, costing many thousands of dollars. The company issuing the financial report pays the bill.

Typically, the first time an entrepreneur receives a request for an audit is upon applying for a business loan from the bank.

REVIEWS

To my surprise, few entrepreneurs are aware of the existence and acceptability of reviews. A review is also conducted by an independent CPA, possibly the same one who would have conducted the audit if you had one done.

A review is basically a scaled-down audit. First, the CPA does not do as much verification work in carrying out a review as he/she may perform when doing an audit. Second, the review is much less costly than an audit.

When negotiating a loan, my bankers had no problem in accepting a review in lieu of an audit, as long as it was from a reputable CPA firm.

Should you actually need an audit at a later time, it is not a difficult process for the CPA to upgrade a review to an audit.

THE BIG FOUR

Most communities have some very competent and reputable local CPA firms. When the party requesting a review (or audit) from you is local, the chances are that any of a number of your local CPA firms would be acceptable to them. If the other party is not local, they may request that the review be carried out by one of the "Big Four" CPA firms. This is the term used to refer to the four largest CPA firms in the country. They also have a significant international presence.

The current Big Four are (in alphabetical order):
- Deloitte Touche Tohmatsu
- Ernst & Young
- KPMG
- PricewaterhouseCoopers

Recommendation: Before you commission a CPA firm to carry out a review or audit of your company, sit down with the individual from the CPA firm who will be responsible for the work and find out what he/she would require to issue an unqualified opinion.

For example, your financial report may indicate that your cash flow will not support the continued viability of your company. This would lead to a qualified opinion by the CPA, which typically is fatal in seeking outside financing, particularly from a bank. Yet, if you know that you are finalizing a deal that will show a totally different cash flow in three months, you might postpone the review and the loan from the bank, assuming this was the reason for the review. In the meantime, however, you will need to perform an entrepreneurial miracle and find the funds elsewhere.

The Xerox case [Reil 06, Shwi 08]

To illustrate the importance of professional audits and the consequences of accounting frauds not detected by CPAs, the Xerox Corporation story is an interesting one, as reported in *The Wall Street Journal*.

Between 1997 and 2000, Xerox allegedly concocted a scheme to manipulate accounting for leases of office equipment in a bid to meet Wall Street profit expectations. The SEC pursued the case, alleging that KPMG, the CPA firm that oversaw the audit, and its partners (i.e., accountants) involved in the Xerox audit knew or should have known about the improper adjustments made to Xerox's books. The SEC claimed the improper adjustments missed by KPMG accounted for $3 billion of $6.1 billion in revenue that Xerox eventually restated and $1.2 billion of $1.9 billion in restated earnings.

The SEC reported that it won $55.2 million in penalties from cases related to Xerox. Of this amount, KPMG paid $22.5 million. In addition, the four individual partners at KPMG involved in the audit personally paid $100,000 to $150,000 each in penalties.

In 2008, Xerox agreed to pay $670 million to settle a shareholder lawsuit over the alleged accounting misdeeds, while its former auditor KPMG agreed to pay $80 million.

As illustrated in the above story, **auditors are accountable for their work; however, it should be clear that the management of a company is responsible for providing honest financial information to the auditors.**

Acts by management found to be fraudulent or illegal can lead to costly business interruptions, financial penalties, adverse publicity, and possible criminal indictments.

The following story reported in *The Wall Street Journal* makes the point.

The Gemstar case [Spen 06]

A federal judge ordered the former chief executive officer of Gemstar-TV Guide International, Inc. to pay $22.3 million for his role in a fraud that led the company to overstate revenue by more than $225 million between 2000 and 2002.

The ruling came four years after the SEC launched its investigation of Gemstar, a once high-flying Hollywood company that publishes *TV Guide* and holds patents on technology used for cable and satellite television programming guides.

The former chief executive was found liable of perpetuating securities fraud, lying to auditors, and falsifying Gemstar's books.

Four other former Gemstar executives settled fraud charges with the SEC. Gemstar's former auditor, KPMG, and four of its employees also settled SEC charges that they failed to "exercise professional skepticism" by relying excessively on the "honesty of management." Gemstar also paid $10 million to settle the SEC charges.

News Corp., which owned 41% of Gemstar, was forced to write down $6 billion in losses.

Another more recent story detailed below as reported in *The Wall Street Journal* makes it very clear that both auditors and management are responsible for their actions.

The Cendant case [Reil 08]

Ernst & Young LLP settled for nearly $300 million a lawsuit brought against it by Cendant Corp. In its suit, Cendant alleged that Ernst & Young negligently failed to detect a massive fraud during its audit of a unit of the company. According to Cendant's lawsuit the fraud by senior managers of its subsidiary, CUC International Inc., started in 1986 and involved them inflating the unit's operating income. From 1995 to 1997 alone, Cendant alleged, CUC inflated its income by about $500 million.

Cendant's announcement in April 1998 that it had discovered accounting irregularities at CUC caused its stock to lose $14 billion in value in one day.

CUC's former chairman and chief executive was sentenced to twelve years and seven months in prison.

Ernst and Young had already, in 2000, paid out $335 million to Cendant shareholders as a result of the fraud. That is believed to be the largest-ever settlement by an auditor related to work for a single client. Cendant itself paid $2.85 billion to settle that shareholder litigation.

FINANCIAL STATEMENT

I have been employing the term "financial report" to refer to the document that describes the financial condition of a business. The standard name used in business is the "financial statement." A financial statement consists of three distinct parts:

1. The balance sheet
2. The income statement
3. The cash flow statement

There are many sources that contain detailed discussions about financial statements [e.g., Trac 94, Gian 05]. Also, the Internet is replete with tutorials on financial statements. Here I am simply going to summarize their contents.

1. THE BALANCE SHEET

The balance sheet is a listing of all the assets and liabilities of a business as of a particular date—for example, the last day of a quarter. It is divided into three sections: assets, liabilities, and stockholders' equity (or partners' capital if the entity happens to be a partnership).

In essence, the assets section lists everything you own and are owed, and the liabilities section lists everything you owe. You add each of these columns separately. The difference between the two totals is referred to as the "stockholders' equity," which is inserted as an item in the liability section so that the two totals are now the same. They balance.

The stockholders' equity represents, in essence, the net worth of the company. It is also known as the "book value" of the company.

The name "stockholders' equity" is commonly used for corporations in which stock has been issued and sold to shareholders as a means of funding. A partnership would have a partners' capital section.

If the stockholders' equity is a positive number, your assets exceed your liabilities, which is good. If the stockholders' equity is a negative number, your liabilities exceed your assets, and that is not good. Bankers do not like that.

It is common for companies in the early part of their life cycle to have a negative stockholders' equity. If this is true for your company, it will hurt your chances of getting a loan from the bank, and you will have to plan accordingly.

2. THE INCOME STATEMENT

The income statement consists of three sections: the revenues, the expenses, and the difference between the first two, which represents profits or losses. If the total of the revenues exceeds the

total of the expenses, you have a profit. If the total of the expenses exceeds the total of the revenues, you have a loss.

The income statement reports on a specific period of time such as a month, a quarter or a year.

The income statement is also referred to as "the profit and loss statement," or simply "the P&L statement."

The profit is typically referred to as "net income" or "net earnings." Because profits or losses are normally shown on the bottom line of the income statement, they are also referred to as "the bottom line" for the period being reported.

No one likes to see a loss for any period of time, but if your business is progressing according to plan and you are in the early part of your company's life cycle, a loss can be explained.

3. THE CASH FLOW STATEMENT

The cash flow statement is a summary of the cash received and the cash spent during a given period of time, such as a quarter.

This statement tells you if you consumed cash or accumulated cash during a given period and the overall net amount.

It is important to note that the cash flow statement will not detail the incremental changes in cash during a period of time. For example, a quarterly cash flow statement will not show cash flow at the end of the first or second month of the quarter. To illustrate the point consider the following situation.

Assume the quarterly cash flow indicates that your company generated $60,000 for the quarter. What could have happened was that at the end of the first month you were $20,000 to the negative, at the end of the second month you were cumulatively $40,000 to the negative but in the third month you generated $100,000 in positive cash. This would have resulted in an increase of $60,000 in cash for the quarter. Unless your cash reserves or borrowing ability were sufficient to cover the $40,000 deficit, you could have been in trouble during the first two months of the quarter.

Be aware that the three components of a financial statement are interconnected. For a more detailed discussion, you should read an introductory accounting book (e.g., [Trac 94]).

Note also that all three parts of a financial statement are historical. That is, they report on how you have performed, not on how you are going to perform. To succeed, you need not only a record of how you have done in the past but also a projection of what to expect in the future.

The challenge is for you to learn from past performance how to improve future performance and how to project future performance more accurately.

OTHER REPORTS

When you run a business, you need to record and summarize your financial performance (e.g., cash flow, expenditures, revenues, profits) in a form that is natural for you. You also require much detailed information. Records of your performance should allow you to analyze what is happening in your business and to make appropriate decisions in a timely manner. Further, based on what you learn from these records, you should be able to modify or fine-tune your original plans to optimize the future trajectory of your business.

The three standard components of a financial statement that I have described provide a summary of information expected by others to pass judgment on your financial performance. For the typical entrepreneur, however, they are difficult to use and incomplete. They are difficult to use because the entrepreneur does not easily relate to the detailed accounting terminology and conventions they use. They are incomplete because there is necessary information on the day-to-day operation of the business that does not appear in these statements. You need this information to detect and address problems in your business promptly. Further, a financial statement is based on historical information, and you also need projections about your future performance.

I strongly encourage you to list and design those reports *you* need to run your business effectively. Then create those reports as often as you need them.

In what follows, I will provide you with examples of such reports.

CASH FLOW PROJECTIONS

This is a spreadsheet of almost religious significance. It is the one that tells you whether or not you are going to have the funds to keep the business going. In a start-up, you need this report every month, and you need to look at it almost every day, often updating it several times within a given month. This report has several layers. Figure 18, on the following page, shows an example of the top layer.

FIG. 18 PROJECTED CASH FLOW FOR 20Y2 Prepared on Dec. 15, 20Y1

	Jan	Feb	Mar	Apr	May	Jun	Jul	Aug	Sep	Oct	Nov	Dec
Beginning Cash	32,000	5,000	-20,000	50,000	-13,000	-35,000	75,000	31,000	9,000	175,000	132,000	135,000
Collections	18,000	25,000	127,000	27,000	40,000	175,000	36,000	48,000	250,000	57,000	89,000	355,000
Disbursements	45,000	50,000	57,000	90,000	62,000	65,000	80,000	68,000	84,000	100,000	86,000	90,000
Ending Cash	5,000	-20,000	50,000	-13,000	-35,000	75,000	31,000	9,000	175,000	132,000	135,000	400,000

Let me make some observations on Figure 18 based on the sample numbers shown.

Observation 1
You will be short $20,000 in February, $13,000 in April, and $35,000 in May. This requires immediate attention.

Observation 2
Collections have a quarterly cycle. Looking at each quarter in turn, we see that collections increase as the quarter progresses, with the third month of each quarter being the strongest. As the year progresses, each new quarter is better than the previous one.

The year looks quite good. You start the year with $32,000 in cash and end the year with $400,000 in cash.

Observation 3
Disbursements are increasing steadily during the year. During the first month of each quarter there will be an increase in disbursements because sales commissions for the last month of the previous quarter are paid.

Observation 4
The disbursement in April is too large. You need to find out why.

Some other observations could be made, but the ones listed suffice to point out how you use this report. Now, zero in on the maximum amount of $35,000 you must find to solve the cash flow problem you will face if you do not do something about it now. You can either increase collections or decrease disbursements, or both.

Examine collections first. Another report that you should generate is one that details the expected collections each month showing the names of the customers, the amounts due, and the dates that they are due. Figure 19 presents a sample report.

FIG. 19 COLLECTION DETAILS FOR JAN 20Y2

Customer name	Amount due	Date due
AB Corporation	$5,000	Jan. 23
BC Corporation	$6,000	Jan. 5
CD Corporation	$8,000	Jan. 27
DE Corporation	$4,000	Jan.12
•	•	•
•	•	•
•	•	•
Total:	$29,000	

Referring to Figure 19, the first observation you make is that although for purposes of your projections you assumed $18,000 (see Figure 18) in collections for January, there is actually $29,000 due. You can now concentrate on each of these accounts to increase the collections and to expedite the receipt of the monies.

You will often find that the accounts payable departments of many large corporations include helpful staff members who understand the cash flow problems of small or growing firms. If you contact them and ask for help in expediting payment, you have a good chance of making it happen. Often, your check is a small one behind some large payments that need additional approvals, and they simply pull your check out of the queue and mail it to you.

Realize that if in January you end up collecting more than the $18,000 you assumed, you are going to affect collections in subsequent months since you will have already received a portion of the collections you projected.

You can always increase collections by selling more, keeping in mind the delay between sales and collections.

At Softool Corporation we had one person whose sole job was to expedite collections. Working from our central office, she did a wonderful job and even developed a manual on how to expedite collections. She received bonuses depending on the amount of monies she collected ahead of time.

Returning to your $35,000 cash shortfall, you can also look at disbursements. Another report you should generate is one that details the expected disbursements each month showing the names of the parties to whom the payments are due, the amounts due, and the dates they are due. Such a report would be similar to the one presented in Figure 19, except that this report would deal with disbursements.

You can analyze this disbursement report and try to postpone some payments. Again, note that you are not eliminating any payment you postpone; you are simply increasing your disbursements in a subsequent month.

This is an area you have to treat with care. Paying your bills on time is a wise strategy with many benefits. For example, your suppliers will work with you on discounts and expedite your orders if you pay promptly. Wouldn't you do the same thing for a good customer who always pays on time?

Of course, you can also solve your cash flow shortage of $35,000 by borrowing money if that option is available to you.

MANY MORE REPORTS

I used cash flow projections as an example of the type of report you should design and generate on a regular basis to monitor and run your company effectively. There are many other reports you should generate. I list a number of them below.

Revenue projections
By geographical area
By sales channel (e.g., direct sales force, telesales, Internet sales, distributors)
By salesperson
By product
By time period (e.g., month, quarter, year)
Per employee
By department
By product releases

-
-
-

Expense projections
By geographical area
By sales channel
By salesperson
By product
By time period
Per employee
By department
By product releases

-
-
-

Profits (Losses)
By geographical area
By sales channel
By salesperson
By product
By time period
Per employee
By department
By product releases

-
-
-

Comparative reports
By month
By year
By quarter
- •
- •
- •

Balance sheet projections
- •
- •
- •

Income statement projections
- •
- •
- •

Depending on your type of business, other reports you may need include unit order backlog reports, production reports, inventory reports, etc.

Of course, when you are trying to do everything as a one-person company or as a company with very few employees, it sounds overwhelming and even wasteful to allocate time and effort to create such reports. The point is that these are the reports you need to have continuously available to make smart decisions. The sooner you start generating them the better. As with everything else, you will face the challenge of juggling many needs with very limited resources.

By the time Softool was a reasonably mature company, I received a comparable collection of reports on a regular basis. Moreover, I had each department head or group head identify the reports they needed and had those reports prepared and delivered on a regular basis.

SELECTING AN ACCOUNTING METHOD

As I previously stated, accounting involves a set of conventions for summarizing the financial conditions of a business.

In accounting, "recognition" is when a financial activity is recorded and becomes part of the financial statement. The two principal accounting methods for recognition are cash basis and accrual basis accounting.

Next, I outline how each of these two accounting methods work.

1. CASH BASIS ACCOUNTING
Revenue and expenses are recorded when cash enters and leaves the business.

2. ACCRUAL BASIS ACCOUNTING
The financial effects of a business activity are recorded in the period in which the effect occurs.

The objective of accrual basis accounting is to match the recognition of revenue with the incurrence of the associated expenses, regardless of whether the revenue was collected or the expenses paid.

The desired result is to present the idealized business model of your company, without the vagaries of the ups and downs of actual cash payments and disbursements. It provides you with a cleaner picture of how well the business operates over increments of time (e.g., month-to-month).

A couple of simple examples will clarify the differences.

Example 1
Assume your company delivered a product to a client on December 5, 2008, and was paid on January 23, 2009. Under the cash method you would have recorded the payment on January 23, 2009. Under the accrual method you would have recorded the income in your books on December 5, 2008.

200

Example *2*

Assume your company purchased a new computer on credit on April 24, 2008, and paid for it on October 20, 2008. Under the cash method you would record the payment on October 20, 2008. Under the accrual method you would record the amount due for the computer on April 24, 2008, when you became obligated to pay for it.

The accrual method is the more commonly used method of accounting. Businesses are required by the IRS to use the accrual method in several instances, including

- if the business has inventory
- if the business is a C corporation
- if gross annual sales exceed $5 million (with certain exceptions as specified by the IRS)

Cash basis accounting is relatively easy to do. However, no attempt is made to match an expense with the revenue it generates. Accrual basis accounting is more complicated to implement, but it attempts to match an expense with the revenue it helps to generate.

Whichever method you use for your company, it is important to have a full picture when you monitor the financial conditions of your company. Neither of these methods alone will produce a financial statement that will give you that comprehensive information, which is why you need additional reports like the ones I listed previously.

For instance, the accrual method does not provide much information concerning cash flow. Your income statement may show tens of thousands of dollars in sales, while in reality your bank account may be empty because your clients have not paid you yet.

Realize that the accounting method you select will have an impact on your taxes and on your cash flow. For example, with the accrual method you can accelerate expenses by recording these expenses by year-end and actually paying them the following year.

Generally, you may change your accounting method but you may need permission from the IRS.

RATIO ANALYSIS

Financial analysts (i.e., those individuals whose job is to evaluate financial statements) often employ specific ratios between certain quantities in the financial statement of a business to pass judgment on the conditions of the business. In essence, these ratios represent metrics on the health of the business.

These ratios are typically used by these analysts in two major ways. First, they are utilized to compare the performance of the business under scrutiny to appropriate industry standards. Listings of such standards are commercially available (e.g., from Dun and Bradstreet). Second, these ratios for the company under evaluation are plotted over time to determine how the company has performed over a given time period.

W. Droms in his book on finance and accounting [Drom 90] summarizes the four major categories in which these ratios can be grouped as follows:

1. *Profitability*: "bottom line" ratios designed to measure the earning power and profitability of a business
2. *Liquidity*: ratios designed to measure the ability of the business to meet its short-term liabilities as they come due
3. *Operating efficiency*: ratios used to measure the efficiency with which business resources are employed to earn a profit
4. *Capital structure*: ratios used to measure the extent to which debt financing is employed by the business

Bankers and other investors like to use some of these ratios between specific quantities in the financial statement when deciding whether or not to make a loan or an investment.

Like the financial statement, these ratios are based on historical data. I will discuss next some of these indicators.

THE CURRENT RATIO

This is a measurement of liquidity. This ratio is intended to be an indicator of the short-term ability of the company to pay its debts. "Current" means collectibles and payables due within a year. This ratio is defined as follows:

Current ratio = total current assets / total current liabilities

For example, if your company's total current assets are $900,000 and its total current liabilities are $450,000, then:

Current ratio = $900,000 / $450,000 = 2

A current ratio of 2 is generally referred to as a ratio of 2 to 1.

Generally, your banker likes to see a current ratio of 2 or higher. A current ratio of 2 means that for every dollar of debt, you have two dollars of assets. Bankers also use this ratio as one of their guides in determining your maximum credit limit.

Companies in high technology—for instance, a software company—may not do well with this ratio. The assets as measured by accounting standards would not take into account the market value of a software product they have developed. So if they have a software product and another company is willing to pay $5 million for the rights to the product, but the product itself resides in a $5 computer diskette, its entry in the current assets is only $5.

THE ACID TEST RATIO

This is another measurement of liquidity. The *acid test ratio* is intended to be an indicator of the funds that your company could convert into cash quickly if it needed to do so. It is also known as the *quick ratio.* This ratio excludes from current assets anything that takes time to turn into cash, like inventory. This ratio is defined as follows:

Acid test ratio = (cash + securities + accounts receivable) / total current liabilities

For example, say your business has $50,000 in cash, it owns no marketable securities, it has accounts receivable of $400,000, and its total current liabilities are $450,000. Then:

Acid test ratio = ($50,000 + 0 + $400,000) / $450,000 = 1

Generally, your banker likes to see an acid test ratio of 1 or better. You can understand why. If your total debt is equal to or less than the amount of assets you could quickly convert into cash, the banker's risk in making a loan to your firm is minimal.

WORKING CAPITAL

This ratio relates to liquidity and to operating efficiency. This number is intended to quantify the amount of assets that a company has in the near term after subtracting the company's liabilities. It is defined as follows:

Working capital = total current assets – total current liabilities

For example, say that at a given point, your company's total current assets are $900,000 and its total current liabilities are $450,000. Then:

Working capital = $900,000 - $450,000 = $450,000

Your banker will often use this number as a guide to determine the actual amount of credit he/she is willing to provide you. It is an indicator of the value of the assets that could be converted to cash after debts are paid.

It is instructive to view working capital from two other perspectives:

1. Working capital may serve as an indicator of how efficiently a company is using its resources. For example, inventory is not included in total current assets. Thus, if a company stocks inventory and has allowed its inventory to grow too

large, the total current assets will be lower and its working capital will be lower.

2. Working capital represents the amount of cash your company has to generate each period to reinvest so it can continue. Working capital finances the "cash conversion cycle"—the time it takes to convert raw materials into finished goods, finished goods into sales, and accounts receivable into cash.

It should be noted that when you borrow money from a bank or other lender, the loan agreement typically stipulates that certain ratios must be maintained at or above certain levels, or your loan will be deemed to be in default. When a loan is in default, the lender can ask for immediate payment of all the monies it is owed. You need to understand any such covenants included in your loan agreement and plan accordingly.

If you have a loan with these types of covenants in place, you need to communicate clearly with your accountant. Your accounting needs to be consistent in the classification of different charges from one period to the next, or else the computation of financial ratios as described above could be affected negatively.

You should also be aware that lenders and investors will not necessarily use the same ratios. Lenders are primarily concerned with your ability to pay your debts, that is, your liquidity. Investors are principally concerned with the profitability of your business and its growth potential, as well as the quality of its management. For example, investors would be interested in the following ratios.

RETURN ON EQUITY

This ratio is a comprehensive indicator of the performance of a business. It provides a measurement of how well the management of the business is utilizing the funds invested in the firm to generate returns. It is defined as follows:

Return on equity (ROE) = net income / stockholders equity

For example, assume that at the end of last year the net income generated by your business for the year was $1,200,000 and the stockholders equity at that time was $2,400,000. Then:

Return on equity = $1,200,000 / $2,400,000 = 0.50

In this example, for every dollar of its net worth your business generated 50 cents in earnings. You have a good business!

The potential investor would compare the ROE (historical as well as projected) to the past and projected cost of equity capital to help him/her determine the quality of this investment.

NET PROFIT RATIO
This ratio indicates how well management has been able to turn revenues into earnings. It is defined as follows:

Net profit ratio = net income / sales revenue

For example, assume that at the end of last year the net income for the year was $1,200,000 and total sales for the year were $7,000,000. Then:

Net profit ratio = $1,200,000 / $7,000,000 = 0.17

In this case, for every dollar sold your business generated 17 cents in net profit.

There are a large number of other ratios used to interpret information found in financial statements. If you are interested in learning about other ratios, refer to an introductory accounting text for a more detailed discussion of these concepts [e.g., Drom 90].

TAXES
In previous discussions I have made references to tax issues and the tax consequences of your decisions. There is a lot you need to

know about taxes if you want to be effective in maximizing the use of your resources and in optimizing your profits. Moreover, tax laws change often. My objective in this book is to provide you with enough discussion of the subject so that you develop a general feeling for the issues and thus can plan appropriately.

In this section I am going to mention additional taxes that you will need to anticipate. This is not intended to be a complete list. You should seek the assistance of competent accountants and tax lawyers to address issues as you start your company and as your company evolves.

Note that in each case, these taxes must be paid in a timely manner, with penalties if you fail to do so.

Payroll taxes

If you hire any employees, each employee must complete tax forms (e.g., Form I-9 to verify eligibility to work in the United States; Form W-4 indicating withholding allowances) before you place them on your payroll. There are IRS tables specifying the amounts you are to withhold.

It is pertinent to mention here that current law in the United States makes hiring of aliens not authorized to work in the United States illegal, and places the responsibility for enforcement on the employer. Further, the law also prohibits an employer from using independent contractors who hire aliens not authorized to work in the United States.

Social Security and Medicare taxes

These are known as FICA (Federal Insurance Contributions Act) taxes. You must withhold these Social Security and Medicare taxes from the amount you pay your employees. In addition, you, as the employer, pay a matching amount.

Federal unemployment tax

These are known as FUTA (Federal Unemployment Tax Act) taxes, which in conjunction with state unemployment systems, are used to compensate workers who lose their jobs.

State and local taxes

Depending on your state and locality, there may be state and local taxes that you have to pay. In particular, if you are in the retail business, you will be responsible for collecting sales taxes and paying them to the state.

There are a number of other tax issues you must handle. For example, at the end of the year, you must furnish a copy of the Wage and Tax Statement Form W-2 to each employee who worked for you during that year. You must file a tax return on behalf of your company. If you hire independent contractors, there are specific tax guidelines that apply. For a good summary of tax issues refer to the booklet by Wilmott [Wilm 06] and to an article by Szabo [Leso 04, Chapter 41].

SOME BASIC TAX DEFINITIONS

CAPITAL GAIN VS. ORDINARY INCOME

Capital gain income is the difference between an asset's purchase price and its selling price, when the difference is positive. Typical assets are stocks, bonds and real estate.

Ordinary income is the income obtained from the normal activities of an individual or business (e.g., salaries, interest income).

Any capital gain from the sale of an asset held for a year or less is called a short-term capital gain. Any capital gain from the sale of an asset held for more than a year is called a long-term capital gain.

Currently the maximum federal tax rate on ordinary income for an individual is 35%, while the maximum federal tax rate on long-term capital gains is 15%. Both ordinary income and capital gains are also subject to any applicable state taxes.

The maximum 15% tax rate on long-term capital gains is scheduled to expire in 2010. Congress may choose to extend the rate before it expires, or on the other hand, they may increase it or decrease it.

Short-term capital gains are taxed at the same rates as ordinary income.

The lower tax rate for long-term capital gains represents a major incentive for entrepreneurs whose long-term financial benefits will come from long-term capital gains when they sell their shares in their company.

When the difference between an asset's purchase price and selling price is negative—that is, you have a loss—you refer to it as a capital loss. There are specific tax guidelines for offsetting capital losses and capital gains.

TAX CREDITS VS. TAX DEDUCTIONS

A tax credit is a direct dollar-for-dollar deduction in your tax liability. For example, if your tax bill is $50,000 and you are eligible for a tax credit of $10,000, taking advantage of this credit will reduce your tax bill to $40,000.

A tax deduction reduces your tax liability only by a percentage of your tax bracket. For example, if you are in the 25% tax bracket, you receive a $0.25 benefit for each $1 deduction. So if your tax bill is $50,000, you are in the 25% tax bracket, and you are eligible for a tax deduction of $10,000, your tax bill will be reduced by $2,500. Your total tax bill will be $47,500.

As you can see, although both tax credits and tax deductions are valuable, tax credits are much more valuable than tax deductions.

You should make sure you are not missing any legal opportunity to take advantage of any tax credits or tax deductions.

RELATIONSHIPS AMONG FOUR PRINCIPAL TAXES

In previous discussions I have mentioned four important types of taxes:

1. Ordinary income tax
2. Corporate tax
3. Capital gains tax
4. Dividends tax

Many of the legal and tax decisions that you make are influenced by the relationships among these four types of taxes. In particular, you are concerned with which tax is lower and which is higher.

In 2008, the maximum federal tax rates were as follows:

- Ordinary income tax rate for individuals: **35%**
- Corporate tax rate: **35%**
- Capital gains tax rate: **15%**
- Dividends tax rate: **15%**

You need to monitor changes in the tax laws that have an impact on these numbers and reevaluate relevant decisions when changes occur.

GETTING YOUR ACCOUNTING DONE

I have discussed Public Accountants and Certified Public Accountants (CPAs). I have also discussed CPA firms. Retaining the services of these professionals is costly, particularly for a start-up. So how do you meet your accounting needs in a cost-effective manner?

Let me identify another professional: the bookkeeper. This is an individual who has been trained as a bookkeeper or perhaps has not yet completed all of his/her accounting training. This individual should know how to use appropriate accounting and related software on the PC. This person is much less expensive to hire than an accountant.

When you start your business, you should hire a bookkeeper, preferably on a part-time basis. You could also retain a local accountant (preferably a CPA) to set up procedures for the accounting records that need to be kept, the taxes that need to be collected and paid, and any other relevant tasks. This is not a major undertaking for the CPA. You also want this CPA to come in periodically (perhaps quarterly) to finalize your financial statement and review how well you are executing the accounting tasks. I use the term "finalize" because you will want the CPA to have shown

the bookkeeper how to create and maintain your books so the CPA can finalize the financial statement at a minimal cost to you.

I recommend that you let your bookkeeper perform routine tasks, such as generating financial reports, which you define as your business evolves. This approach should be relatively inexpensive, and you must allocate your time and effort elsewhere. Nevertheless, you should understand what needs to be done and monitor that it is being done correctly. This is your responsibility.

As your business grows, your "accounting department" grows with it. At some point, the bookkeeper will become a full-time employee and at a later point, you may hire a full-time public accountant in addition to your bookkeeper. Throughout this time, you can use the CPA as a consultant at your discretion on any pertinent matters. Always ask well-defined questions and try not to give the CPA open-ended tasks.

Eventually, your business may justify adding a full-time CPA as an employee. You might even need to retain the services of one of the big four CPA firms if the need arises because of some national or international requirement.

You may want to involve one of the big four CPA firms on a consulting basis early in your business. The reasons are twofold. First, they have an extensive base of specialists in different areas, particularly where tax issues are concerned. Second, it allows you to start a relationship you may need at a later time.

When you are dealing with an individual public accountant or CPA, you want to identify one who is experienced in your business area. For example, I once dealt with an excellent accountant whose experience was in real estate and small retail businesses. My company was in the software business. This accountant was not aware of the research and development tax credit which represented major tax savings to a software company like mine.

You will have to develop an understanding of high level accounting issues in order to feel confident that your accounting needs and tax computations are in good hands.

SUMMARY

In this chapter I did the following:

- Explained some of the principal accounting issues you will need to face and understand in order to create and run your company
- Presented an overview of the financial statement you will have to generate and maintain
- Described how potential lenders and investors employ this financial statement to decide whether to lend or invest in your company, and then to monitor your company's performance
- Introduced the additional financial reports you will need to manage your business effectively
- Listed the various taxes you will have to pay
- Discussed the different types of accountants and outlined how to obtain accounting services in a cost-effective manner

KEY POINTS COVERED

- Audits are expensive; reviews often can be employed as a less costly alternative.
- Before you commission a CPA firm to conduct a review or audit of your firm, you should find out what they will require to issue an unqualified opinion.
- The standard financial statements consist of three distinct statements:
 1. The balance sheet
 2. The income statement
 3. The cash flow statement
- Cash flow projections are critical for the management and survival of your business.
- Define and generate on a regular schedule the reports you need to manage your business.
- There are two principal accounting methods: cash basis and accrual basis. Understand the implications of your selection.
- Understand how your banker and/or investor employ certain standard metrics such as current ratio, acid test ratio and working capital to decide whether or not to lend or invest in your company.
- There are a number of taxes you are responsible for collecting and paying.
- Understand the difference between capital gains and ordinary income.
- Understand the difference between tax credits and tax deductions.
- Understand the relationship between ordinary income, corporate income, capital gains, and dividend tax rates.
- Employ a bookkeeper in conjunction with a CPA to get your accounting done in a cost-effective manner.

CHAPTER 10

THE BUSINESS PLAN

AN OVERVIEW

In this chapter I describe a pragmatic procedure I have used successfully for generating a business plan.

The important point about the approach presented here is that it is based on monies you can get your hands on, not on monies you wish you could obtain. Thus, it drastically increases your chances of success.

I include a discussion of different funding strategies you may employ.

I also outline the financial reports you need to define and create in order to manage the execution of your business plan.

The end result is that you will create a business plan that quantifies the funding required to meet your goals and the time frame in which these funds are needed.

BACKGROUND

At this point I have covered most of the major areas you will need to address in order to get your company going. There are additional topics such as managing your employees, planning an exit strategy, and capitalizing on your work, which I will address in the remaining chapters.

I expect you to be overwhelmed and to question whether you can make your entrepreneurial dream happen. Well, if you have what it takes, it is doable. It has been done before; however, it will require careful planning and a well thought-out business plan.

THE MANY HATS YOU NEED TO WEAR

I have identified a great many activities that need to be addressed in starting your own business. These include securing the necessary funding, forming a legal structure, conducting market

research, planning your marketing, designing your products, fabricating your products, developing a selling strategy, creating selling channels, dealing with lawyers, dealing with accountants, collecting and reporting taxes, hiring and managing employees, negotiating with bankers, finding office or warehouse space for your company, procuring equipment and furnishings, and much more.

Each one of these activities represents a different hat you will need to wear at specific times and often many at once. There is only one of you, and there is much at stake. You are going to be juggling these hats for a long time. Figure 20 is intended to drive this point home.

Fig. 20 Juggling Priorities

GENERAL FORMAT OF A BUSINESS PLAN

When you talk to others and read books on the subject of business plans for entrepreneurs, you are typically told that you need a business plan for two reasons. One is so you will know where you

are going. The other is so you can present it to potential investors such as venture capitalists.

There are specific formats recommended for business plans. There are books on the subject as well as software programs and Internet sites that can provide you with a fill-in-the-blanks template.

The generally recommended sections for a business plan typically include the following:

- Executive summary
- Table of contents
- Business opportunity
- Competition
- Products
- Marketing plan
- Key personnel
- Operations plan
- Financial projections

WHAT YOU NEED TO KNOW ABOUT YOUR BUSINESS IDEA IN ORDER TO WRITE YOUR BUSINESS PLAN

In order to write your business plan, you should have an overall mental picture of what you want to do and good written notes on the various aspects of the business opportunity you want to address. This includes the following:

- The competition
- The products you plan to create
- The marketing and sales activities you plan to pursue
- The key management and staff that will be required
- The way you will operate your company
- The time frames involved
- A general feeling for the funding you are going to need
- Ideas about where you will find funding

Equally important, it should be clear in your mind which tasks you do well and will do yourself, which tasks you will do until you

can afford to hire employees to do them, and which tasks you cannot do and will need help from the beginning in order to accomplish them.

FOR WHOM ARE YOU WRITING THE BUSINESS PLAN?

Take a step back now and reevaluate your situation.

Who is going to be your most important investor? Who is going to be risking everything to make this effort a success? Who is going to stay awake at nights worrying about this business? Who is placing his/her professional career on the line to work on this new business? Who is going to be affecting his/her personal life in a major way? Who is going to be hurt the most if this effort does not succeed?

The answer to all of these questions is YOU.

So the one individual who has to be totally convinced, first and foremost, that this effort can succeed is YOU.

You need to write a business plan that first convinces you that your business will succeed. Once you are convinced, you can worry about convincing others if you need to.

This business plan should be written down for several reasons. The problem is much too large to keep in your head. When you attempt to write things down, you will realize all the details you need to resolve before you can complete your plan.

You will need to read your plan over and over.

The positive side for you as an investor when you read this plan is that you know the author. You know how well-grounded the data and conclusions employed in the business plan are.

It is important to summarize anew where you should be at this point. You have a reasonably good handle on all of the issues that go into a business plan as listed above. However, the necessary funding needs to be precisely identified and all of the issues brought together into an integrated whole.

Now you are ready to proceed to create your business plan.

THE AVAILABLE DOLLARS STRATEGY

Typically others recommend that you create each of the sections for your business plan more or less in the order listed in the general format presented above. That is, you start with your executive summary and finish with the financials required to implement the plan.

It follows then that when you finish writing your business plan, you would need to somehow raise the monies required by the plan.

There are several serious problems with this approach.

1. You have defined an ideal situation for your venture and consequently the amounts of money required to implement your plan are large.
2. You are a new entrepreneur with no track record of success.
3. As we discussed in a previous chapter, the chances of you obtaining funding, particularly VC or angel funding, are very small.

So common sense should tell you that if you follow this approach, your chances of success are very small.

What you need is an approach that gives you a fair opportunity to begin to implement your vision successfully.

The major roadblock in getting your business off the ground is having sufficient money, so **you should begin to create your business plan by working out your financials first and not last.** Further, your goal is to specify funding you can achieve without depending on a VC or angel investor.

Once you have your financial section written, you can complete the rest of the business plan.

Next I describe an approach that helps you write the financial section of your business plan.

THE MULTIDIMENSIONAL ATTACK

The approach I describe here for the creation of the financial section of a business plan is based on a multidimensional attack on the problem. The dimensions are:

- your ideal plan
- your funding framework
- your goals
- conservatism

I now discuss each of these dimensions in detail.

YOUR IDEAL PLAN

First, you create a version of your business plan financials by focusing only on your ideal plan. You make lists of all the activities and resources you will need to start your business and then to grow it. You will do this based on your current perception of the opportunity and what you believe needs to be done to take advantage of it on a timely basis. You are going to be generating a substantial collection of spreadsheets that will be interconnected. Let me go over some of them. I will focus on your first year.

Resources

You need to identify the resources you are going to need and when you are going to have to make expenditures for each of those resources. Figure 21 shows a sample spreadsheet. It is not intended to be complete by any means. It simply illustrates the format you might use to show your projections. Figure 21, on the following page, quantifies the amount of money you will require each month to meet your objectives for procuring resources. It also shows the totals for the year and the totals for each type of resource.

FIG. 21 PROJECTED RESOURCES FOR 20Y2 Prepared on Dec 15, 20Y1

	Jan	Feb	Mar	Apr	May	Jun	Jul	Aug	Sep	Oct	Nov	Dec	Total
Computers	3,000				1,500			1,500					6,000
Rent	4,000	2,000	2,000	2,000	2,000	2,000	2,000	2,000	2,000	2,000	2,000	2,000	26,000
Supplies	1,000	300	300	300	300	300	300	300	300	300	300	300	4,300
Telephones	2,000	200	200	200	230	230	230	260	260	260	260	260	4,590
Furniture	4,000				600			600					5,200
Electricity	600	300	300	300	300	300	300	300	300	300	300	300	3,900
Coffee	50	50	50	50	50	50	50	50	50	50	50	50	600
Copying	1,000	150	150	150	150	150	150	150	150	150	150	150	2,650
Cleaning	300	200	200	200	200	200	200	200	200	200	200	200	2,500
Total	15,950	3,200	3,200	3,200	5,330	3,230	3,230	5,360	3,260	3,260	3,260	3,260	55,740

Personnel

You need to identify the employees (full-time and part-time) you are going to need and when you need to have them on board. Figure 22, on the following page, shows a sample hiring schedule. I assume in this example that you are starting a software products company.

FIG. 22

PROJECTED HIRES FOR 20Y2

Prepared on Dec 15, 20Y1

	Jan	Feb	Mar	Apr	May	Jun	Jul	Aug	Sep	Oct	Nov	Dec
Programmer	1				1			1				
Secretary								1				
Salesperson												1
Bookkeeper	1											

Figure 23, on the following page, is a sample spreadsheet showing what the salary expenses are going to be during the year. When you hire an employee, the cost is not only the salary you pay that employee but also the associated expenses such as taxes, insurance, office space, telephone, and so on. The total cost of an employee is referred to as the "loaded cost." Assume that the numbers in Figure 23 represent loaded costs.

FIG. 23

PROJECTED COST OF HIRES FOR 20Y2

Prepared on Dec 15, 20Y1

	Jan	Feb	Mar	Apr	May	Jun	Jul	Aug	Sep	Oct	Nov	Dec	Total
Programmer	8,000	8,000	8,000	8,000	16,000	16,000	16,000	24,000	24,000	24,000	24,000	24,000	200,000
Secretary								4,000	4,000	4,000	4,000	4,000	20,000
Salesperson												10,000	10,000
Bookkeeper	1,000	1,000	1,000	1,000	1,000	1,000	1,000	1,000	1,000	1,000	1,000	1,000	12,000
Total	9,000	9,000	9,000	9,000	17,000	17,000	17,000	29,000	29,000	29,000	29,000	39,000	242,000

Marketing

You need to itemize each of the marketing tasks that you want to carry out and what you will need to spend on these marketing activities to meet your sales goals. That is, you need to identify enough prospects so that you can make the number of sales you want. Figure 24, on the following page, shows a sample spreadsheet.

FIG. 24 PROJECTED MARKETING ACTIVITIES FOR 20Y2 Prepared on Dec 15, 20Y1

	Jan	Feb	Mar	Apr	May	Jun	Jul	Aug	Sep	Oct	Nov	Dec	Total
Brochures			3,000										3,000
Advertising									2,000	2,000	2,000		6,000
Website			3,000										3,000
Trade shows											4,000		4,000
Mailings									1,500	2,000			3,500
Travel											1,000		1,000
Total			6,000						3,500	4,000	7,000		20,500

Product development

You need to create a schedule to ensure that your products, whatever they may be, are ready for the marketplace in synchronization with all your other activities. Otherwise, your sales and collections are not going to happen. Figure 25, on the following page, illustrates such a schedule.

In Figure 25 I assume that you are developing two software products that are moving through the stages of requirements, design, programming, testing, optimization and eventual release to the clients.

Figure 25 indicates, for example, that you will start specification of the requirements for Product 1 in January and will complete it by April when design commences.

FIG. 25 PRODUCT DEVELOPMENT SCHEDULE Prepared on Dec 15, 20Y1

	Jan	Feb	Mar	Apr	May	Jun	Jul	Aug	Sep	Oct	Nov	Dec
Product 1	Re-quire-ments			Design		Pro-gram-ming			Testing		Optimi-zation	Release
Product 2				Re-quire-ments			Design		Pro-gram-ming			Testing

228

Sales

You need to create a sales projections spreadsheet showing what sales you expect, the amount of each sale, and the dates you expect them to occur. Although according to Figure 25 the first product will not be released until December, assume you will manage to make some sales using a test version of the product starting in September, with delivery promised for December.

Collections

In synchronization with your sales projections spreadsheet, you need a spreadsheet showing how much you expect to collect each month. Assume that you will start collecting money after December, since you will not have a product for delivery until December. Thus, there will be no collections during your first year.

There are other spreadsheets you will need to create, but the ones I have illustrated above suffice for our purposes here.

Next, you combine all your spreadsheets into one master cash flow projection spread sheet as illustrated in Figure 26 on the following page. Since in this sample situation there will be no collections during the first year, Figure 26 is a summary of your expenses for the year.

FIG. 26

PROJECTED CASH FLOW FOR 20Y2

Prepared on Dec 15, 20Y1

	Jan	Feb	Mar	Apr	May	Jun	Jul	Aug	Sep	Oct	Nov	Dec	Total
Beginning Cash	0	-24,950	-37,150	-55,350	-67,550	-89,880	-110,110	-130,340	-164,700	-200,460	-236,720	-275,980	
Collections	0	0	0	0	0	0	0	0	0	0	0	0	0
Disbursements													
Resources	15,950	3,200	3,200	3,200	5,330	3,230	3,230	5,360	3,260	3,260	3,260	3,260	55,740
Employees	9,000	9,000	9,000	9,000	17,000	17,000	17,000	29,000	29,000	29,000	29,000	39,000	242,000
Marketing			6,000						3,500	4,000	7,000		20,500
Ending Cash	-24,950	-37,150	-55,350	-67,550	-89,880	-110,110	-130,340	-164,700	-200,460	-236,720	-275,980	-318,240	

Figure 26 represents a mapping of your plan into dollars and when these dollars are needed. It is the first version of your master cash flow projection.

Figure 26 indicates that you will need a total of $318,240 to fund your first year. This does not allow for any margin for errors. Also, it does not account for your own living expenses or for start-up expenses such as legal and accounting fees.

Now that you can see the magnitude of your financial needs for the first year, you can start reevaluating your plans and redoing your cash flow spreadsheet until you generate one that will work for you.

Quantify what you can do yourself or do without

You want to keep your expenses, and therefore the monies you will need, to a minimum. You need to understand clearly what you can do yourself, what you will need others to do for you, and what resources will be required to work effectively.

There are many tasks that you should be prepared to perform yourself and resources you will have to provide or eliminate until the business meets certain goals.

So make a pass through all the spreadsheets you have created in an effort to identify expenses you can eliminate. For example, referring to Figures 23 and 26, you can see that employee expenses tower over all other expenses. You need to ask yourself questions like:

- Can I do more programming myself, eliminate one programmer, or delay hiring one?
- Can I generate more sales myself initially and postpone the hiring of a salesperson?
- Can I postpone hiring a secretary?

Referring to Figure 24, which shows your marketing expenses, you may decide to postpone your advertising plans and reevaluate attendance to the trade show.

Referring to Figure 21, which shows projected expenditures for resources, you need to take a hard look at each of those expenses to determine what you can defer or do without.

Turning to the revenue side, the most blatant message generated by Figure 26 is that you have no collections. You need to ask yourself, *what can I do to start selling earlier?*

When you complete this pass, you generate a new version of Figure 26. In this new version you will require less money, and it is possible that some deadlines may be extended. This new tighter version of your cash flow represents what we will call the "*what-you-want-to-do*" version of your business plan.

THE FUNDING FRAMEWORK

You need to make a very important decision concerning funding. Your decision may span a spectrum of funding possibilities, including:

- You want your business to be totally self-funding. That is, you want to make the money before you spend it.
- You want the business to be funded by your savings until it is self-sufficient.
- You want your business to be funded by your savings and by an amount you will borrow until the business is self-sufficient.
- You want your business to be funded by your savings, by an amount you will borrow, and by some equity investment you are going to obtain from an angel investor.
- You want your business to be funded by equity investments from venture capitalists.
- You want your business to be funded by some combination of the above alternatives.

The decision that you make here superimposes a funding framework on the "what- you-want-to-do" version of your business plan. You will have some major conflicts between what you want to

do and the money you can or want to allocate to do it. You will have to negotiate with yourself, wearing two different hats, in an attempt to forge a satisfactory compromise.

As it currently stands, your vision may or may not lend itself to a viable compromise. It may require some revisions.

Before I continue, some historical comments are pertinent.

There are successful entrepreneurial stories that employed funding strategies that varied from one end of the spectrum to the other. For example:

- Bersoff [Bers 94] relates that his company, BTG, initially was essentially self-funded.
- Clark [Clar 01] says their company, The Baby Einstein Company, was started with $10,000 in savings he and his wife had, and from then on it was totally self-funded. He emphasizes that this approach was according to plan and not an accident.
- Softool, my own company, was funded with my savings, some family loans, and some bank loans. This was how I planned it.
- Wang [Wang 07] describes how he started his company, Vizio, with $600,000 he raised by mortgaging his home and borrowing from his parents and from a couple of friends. Later on he obtained venture capital financing and sold some equity to some of the manufacturers that he outsourced to. After all of this he still remained the majority holder of his company.
- Computer Associates, one of the largest software companies in existence, was funded in its early stages with monies from an angel investor.
- Apple Computer and Google received early backing from venture capital funds.

The funding strategy you select is a personal decision. The discussions we presented in the previous chapter on funding should provide you with insight to help you make a decision. At any rate,

your decision here needs to be married with your "what-you-want-to-do" version of your business plan, with the plan updated accordingly.

I never said this was going to be an easy process!

YOUR GOALS

This is another dimension to your planning process.

The reason you are considering starting a business and embarking on a journey of this magnitude is because there are certain goals you want to accomplish. We discussed some of these goals in earlier chapters. These goals may include financial independence within a certain time frame, sufficient personal fortune to take care of your children and grandchildren, sufficient personal fortune to create a foundation to support philanthropic causes, or simply the ability to retire in peace.

Your goals are also to reach these objectives by a given date.

So you have more negotiating to do with yourself. You have to superimpose on your "what-you-want-to-do" version of your business plan not only your funding framework but also your goals. The plan is updated again.

CONSERVATISM

I can assure you that regardless of how good you believe your business plan is, unpredictable events will occur. Moreover, these events are usually the bad news type of event rather than the good news kind.

If you want to be successful, you have to plan conservatively. You must have cash reserves or access to cash in case of a crisis to ensure survival.

Again, you must negotiate with yourself. You have to superimpose on your "what-you-want-to-do" version of your business plan not only your funding framework and your goals but also a strong dose of conservative planning. The plan is updated anew.

AN ITERATIVE PROCESS

In my experience the process is not as simple as generating the "what-you-want-to-do" version of your business plan, superimposing your funding framework, your goals, and your conservative margins, and—voila!—you have your desired business plan.

In practice, reaching your desired business plan is a process with multiple iterations and hard compromises. You may have to revise your vision, and many times you may feel that it is just not doable. Perhaps it is not. You are the only person who can make the final decision.

In order to proceed in your entrepreneurial journey, you must still be totally and firmly convinced that the financial plan that you have created will allow you to meet your goals within an acceptable time frame—and that you can make it happen!

COMPLETING YOUR BUSINESS PLAN

Once you have finalized your financial section, you need to clean up your notes and finalize all the other sections of your business plan, making certain that each section is in harmony with the financial section.

After having spent all the time and effort necessary to complete a business plan, it is easy to fall in love with it and to admire this great piece of work you have created. You should be proud of what you have accomplished but you cannot idolize it. The business plan is a dynamic entity subject to continual updates as you progress in your endeavors to establish and grow your company.

BUSINESS PLAN FOR THE OUTSIDE WORLD

Once you have completed your business plan for yourself and you are excited about it, you may decide to present your business plan to others, typically potential investors. You may choose to seek additional capital for various reasons. For example, you might wish to pursue a larger market at a faster pace.

You will need to edit your complete plan for clarity and proper English, and to make sure it presents you and your venture the way you want to be perceived.

A note of caution: **Your time is one of your most valuable assets. Evaluate with care how much of your time and effort you will spend trying to convince others to invest in you. Consider that alternatively, you could be allocating such time and effort to making sales or to identifying and obtaining some creative financing.**

How far out should you plan?

There is no question that when you create your business plan, in the back of your mind you have some idea as to where you want to be five or ten years into the future.

And there is no doubt that a well-established concern should have a five- or ten-year plan that it follows.

You, on the other hand, are dealing with a start-up with many unknowns. Your plans should be in the twelve- to eighteen-month range, and your plans should be updated continuously so that you always have a twelve- to eighteen-month forecast in front of you.

To spend the time and effort to create plans beyond that time frame is a waste of time—time that can be put to much better use.

Be aware that investors, particularly venture capitalists, will ask you for three- and five-year financial projections.

Pragmatic comment

Note that even a relatively small start-up such as the software company I employed as an example in this chapter will require a sizable amount of money to get started. Of course, the definition of what is "sizable" is different for each person.

My advice is that if the minimal amount of money required for your start-up is truly beyond your means but you are convinced of the quality of your vision and committed to your entrepreneurial journey, that you persist.

Finding a way to make it through the initial phase will indeed test your entrepreneurial fiber.

236

SUMMARY

I described in detail a practical procedure for generating a business plan.

I discussed different funding strategies that you may employ.

The end result is a business plan that quantifies the funding you will require to meet your goals and the time frame in which these funds will be needed.

I also outlined the financial reports that you need to define and create in order to manage the execution of your business plan.

The important point about the approach presented here is that it is based on monies you can get your hands on, not on monies you wish you could obtain. This approach drastically increases your chances of success.

KEY POINTS COVERED

- Before you create your business plan, you need to have a good handle on all the issues you will incorporate into your business plan.
- You need to decide on the funding approach you want to employ in order to create your business plan.
- You begin creating your business plan by working out your financial issues first.
- Your objective should be to create a business plan that may benefit by obtaining funding from potential investors but will not collapse if you do not obtain such funding.
- You should always have an up-to-date business plan covering the twelve- to eighteen-month period ahead of you.

CHAPTER 11

RUNNING YOUR COMPANY

AN OVERVIEW

In this chapter I am going to cover a number of topics that could have been discussed in previous chapters; however, it is when you are dealing with running a business day-to-day that these issues become apparent.

I will cover ethics, staying power, fixed and variable expenses, employee relations, profit and cost centers, as well as several other topics.

How you handle these issues can have a major impact on your business trajectory.

I will provide guidelines for handling these issues based on my experience.

ETHICS

I am a firm believer that integrity, honesty, and loyalty are crucial to the long-term success of any enterprise and the individuals in it. An enterprise represents the values of its founder. You should treat others the way you would like to be treated.

It is important that the Policies and Procedures Manual that you provide each new employee contain a clear statement of the ethical and philosophical standards the company expects them to follow. Your Policies and Procedures Manual, as well as any training you provide, should cover interaction between employees as well as interaction with customers and suppliers.

Further, you should exemplify the behavior you expect of others. You should never compromise on your principles.

As your company grows, your commitment to these standards will be tested. It will be up to you to be firm in taking whatever actions are necessary to ensure that these standards are met. In the long term both you and your company will benefit; others will want

to work for you and do business with you because they will learn to trust you.

When you find employees and business partners who have similar ethical values, cultivate your relationship with them. They represent important building blocks in your path to success.

The boundary between ethical behavior and good business practices is often thin. You must use your common sense. For example, it is wrong to pay someone a bribe to secure a business deal; however, I believe it is good business to ask a friend who can influence the party with whom you are negotiating a deal to emphasize to this party that you are a person who can be trusted and who delivers on commitments.

STAYING POWER
Staying power means your ability to stay in business.

As simple as it may sound, this is probably one of the most important points I can convey to you in this book. As your business evolves, you will continually be faced with problems that will jeopardize the survivability of your business. It is your challenge to overcome each one of these problems and remain in business as a vibrant company.

You must learn from past mistakes and improve what you do and how you do it. Eventually you will encounter opportunities that will be keystones in your path to success. To take advantage of these opportunities, however, you have to be around. You have to be in business. This is what I refer to as staying power.

Although you have created a business plan, it is easy to stray from it. You must guard against that.

FIXED EXPENSES
Your expenses can be divided into two categories:

1. **Fixed expenses**
 These are your monthly expenses that are fixed regardless of whatever else happens in your business--rent and salaries, for example.

2. **Variable expenses**

 These are your monthly expenses that vary from month to month--sales commissions, travel and advertising expenses, for example.

Fixed expenses are easy to augment but very difficult to reduce. The way you reduce fixed expenses is typically through high visibility actions such as eliminating employees or reducing rented space. Such actions have a negative impact on the morale of your employees. Also, clients who learn about these actions become more cautious when considering whether to buy your products. No one wants to buy from a company that may not be around in the future. Your competition loves to see you in such a situation, and they will take advantage of it.

You must keep your business plan up-to-date, particularly your cash flow projection. You must be continually aware of your fixed expenses and cautious of increasing them. The following story makes the point.

The cost of a sunset

For many years, each summer I got together with friends for a beach vacation with our families for several days.

Every afternoon as we sat on the beach I would look at the beautiful sunset and think to myself, "The sun just set again. I just spent $X."

This $X was the daily allocation of my company's fixed expenses at the time.

My friends often wondered about the magical effect the sunsets had on me. I never explained why I was so absorbed in them.

Variable expenses are easier to control. Reductions in variable expenses typically do not have the visibility that reductions in fixed expenses have.

OUTSOURCING

The key to a business model that relies on an outsourcing strategy is for you to have in place a management structure that is fully in control of the situation. This means that, first, you and your staff have carefully architected all the components of your business and their relationships. Second, for any segment of the business that is outsourced you have a back up plan in case the supplier fails for any reason. Third, you have to continually monitor the progress of your suppliers. If you do not carry out these three steps you are gambling with your possible success, and you will be totally dependent on your suppliers.

In today's global economy, just about everything can be outsourced. Critical issues you must evaluate when deciding whether or not to outsource a specific activity are cost effectiveness and reliability that the work will be done on time and that the work will meet your standards of quality. Also, if applicable, when you outsource to a foreign country you must take into consideration any import duties you may have to pay when bringing your products into the United States.

Other relevant factors include your ability to hire and manage the necessary in-house talent if you do not outsource, the initial outlays of cash that would be required if you were to do the work in-house, the extent to which you will become dependent on the specific firms doing your outsourced work, tax aspects, proprietary issues, and any concerns you may have about moving work to other countries if you are considering that possibility.

It is appropriate to point out that some people advocate the creation of new businesses in which most, or all, components of the business are outsourced [Juds 04]. The following cases offer good examples of this strategy.

Vizio, Inc. [Wang 07, Enga 07]

In 2003, William Wang, an impressive entrepreneur who had had his ups and downs with two previous companies he had founded, started a company now called Vizio, Inc. to build and market flat panel TV sets, both plasma and liquid-crystal-display

(LCD) screens. He went into business with two employees and $600,000 he raised by mortgaging his house and borrowing from family and friends. He was 43 years old.

By 2006, Vizio sales were $700 million and it was ranked as the Number 6 supplier of liquid-crystal-display TV sets in North America with 7% of the market. By the end of 2007, it was projecting over $2 billion in sales and claiming to be the Number 1 supplier of LCD's TV sets in North America. It sells its TV's through an impressive list of retailers including Costco, Sam's Club and Wal-Mart. In 2008, Wal-Mart named Vizio its electronic supplier of the year.

In 2007, Vizio reported that it only employed 80 people, most of them handling technical support out of the company's Irvine, California headquarters. The company outsourced everything else. Manufacturing was done in China, Taiwan and Mexico. Manufacturing in Mexico had the advantage that there is no United States duty to be paid when bringing the products from Mexico.

Vizio runs a truly lean operation. Its overhead is just 0.7 percent of sales. Compare this number with a typical overhead of 10 percent of sales for the big consumer electronics companies.

Contango Oil and Gas Company

Contango is a natural gas and oil exploration company founded in 1999. Its founders stated: "We intend to build Contango by outsourcing as much as possible and running the Company with literally a handful of employees."

For the last six months of 2008 it reported revenues of $118 million. It had a total of 7 employees. Contango is a public company listed in the American Stock Exchange under the symbol MCF.

Smart Balance, Inc. [Lubl 09]

Smart Balance is a food marketing company whose goal is to help people stay lean with 'heart healthy' merchandise, including low cholesterol spreads, peanut butter, popcorn, cooking oil and milk. The company keeps new-product development and marketing

in-house but outsources almost everything else including manufacturing, product distribution, and sales.

For 2008, Smart Balance reported revenues of $222 million with a total of 67 employees.

Another interesting story bringing out important issues concerning outsourcing is the following.

Boeing 787 Dreamliner [Lun1 08, Lun2 08]

According to *Wall Street Journal* articles by J. Lynn Lunsford, on September 6, 2008, some 27,000 machinists went on strike and walked off the job at Boeing. Albeit there were other issues involved in the negotiations between Boeing and the machinist's union, the heart of their disagreement had to do with Boeing's effort to outsource key roles in the production of the Boeing 787 Dreamliner jet. For the union, this was a job security problem.

Boeing had been outsourcing to suppliers in Japan and Italy to help build portions of the new jetliner, with Boeing performing final assembly. These suppliers fell behind in getting their jobs done, and by September of 2008, the 787 program was more than a year behind schedule. Boeing had to go back to its own union workforce to piece together the first few airplanes after they arrived at the company's factory in Washington with thousands of missing parts. The 787 Dreamliner has been a tremendous success for Boeing, with over 900 orders from airlines world-wide. Yet, because of all of these problems Boeing was running over 14 months behind schedule when the strike commenced. The strike lasted for 57 days.

Two interesting points concerning outsourcing are highlighted with this story. First, the reliability of your suppliers is critical to success. Second, current employees worry about the security of their jobs. Interestingly, existing contracts between Boeing and the union contained language that gave the union 180 days to make a bid to keep work that might be outsourced, however, this language did not apply to the 787 Dreamliner program.

The strike was resolved with the machinists winning key concessions, including a promise that Boeing would limit, but not

abandon, its use of contractors for work that had previously been done only by machinists.

To what extent you outsource is a decision you should evaluate with care. At the very least, such an evaluation will provide you with better insight into your business venture.

EMPLOYEES

Your employees are critical for the operation and growth of your business.

I have been fortunate in my business history to have surrounded myself with some truly outstanding, ethical, and dedicated employees without whose help I could not have succeeded.

A HIRING STRATEGY

When I needed to fill a position, I always looked for a person who was at a lower level of responsibility but who I felt was ready to be challenged to move to the next level.

The advantage of this approach is that you will have an employee who will try hard to show that he/she can do the job. Also, this person will be moving to a higher salary and will be well motivated. Further, most people are grateful for the opportunity.

At Softool, most of the senior management moved up in the company in this manner. As long as they demonstrated that they could handle the job, they continued to be promoted. We had some outstanding managers.

A possible drawback of this approach is that you could promote someone to a job that is beyond their capabilities. You need to be sensitive to this possibility and do your best to prevent it from happening. If it occurs, you will have to deal with it.

Although we always tried to promote from within, there are situations where the knowledge and/or experience you seek does not exist inside your company, and you must find it outside. In this case the same strategy still applies.

It is interesting to note that at General Electric, one of the world's best-known American corporations, 80% of the top

executives are reported to have built their entire careers at the company [And2 06]. Other corporations follow different strategies.

ABUSES OF THE LEGAL SYSTEM

Employees can also be the source of many headaches, and you need to be prepared.

Regrettably, some individuals try to take advantage of laws that were intended to help employees rather than to abuse employers. A couple of short stories are appropriate.

The insurance salesman

We had a telesales group selling our software products. At the time, it consisted of around twelve well-compensated, experienced salespeople in a very comfortable and professional setting. Each salesperson had a fully equipped private office.

One salesman was not producing and was well below his sales quota. Our policy was to place such a non-performing salesman on probation so that he understood the seriousness of the situation. Simultaneously, his manager would delve into the problem to determine if the salesman could be salvaged. In a situation of this kind, both the salesperson and the company have a lot invested, and it is to everyone's benefit to get the salesperson on track.

Well, we found out—are you ready for this one?—that this man was using our office and our resources, on our salary, to sell insurance! He had an insurance business that he was operating on our premises. He was terminated immediately.

Then—are you ready for the next installment?—he found a lawyer and threatened to sue us for discrimination. He and his lawyer expected us to pay a certain amount of "nuisance" money to have them go away.

Our policy in a situation like this was never to pay any such "nuisance money." We would incur the necessary costs and go through a trial if that was required. We hired a lawyer, and after we spent several thousand dollars in legal fees, the salesman and his lawyer disappeared.

Not qualified for promotion

We had an opening for a vice president of sales. At the time we had well over twenty salespeople in the sales organization. We were seeking an experienced sales executive with contacts in the business, who would take this sales organization to the next level.

We also had a marketing department that included a staff member who was responsible for various marketing support activities. She was doing a good job.

One morning she walked into my office and told me she wanted to be the next vice president of sales.

I explained to her that we were looking for a person with extensive sales management experience who knew salespeople who could be recruited and who had a successful track record in sales management. I told her I was impressed that she had taken the initiative to come to me and that there was room for her to grow within our company, but this was not the right job for her. She just did not have the background.

That afternoon I was told that without saying a word to anyone, she packed her personal belongings and left.

A few days later we were contacted by a lawyer on this woman's behalf to let us know that she was going to sue us for gender discrimination. They were expecting us to pay a certain amount of "nuisance" money to have them go away.

Our company was truly sensitive to making sure that we always promoted from within first if that was possible and that we promoted or hired the most competent person we could find regardless of any other consideration. We had several women in responsible management positions. Our vice president of marketing was a woman. This accusation was a distasteful one to us.

We hired a lawyer, and after spending several thousand dollars in legal fees, the woman and her lawyer disappeared.

A TERMINATION STRATEGY

As an employer you must not only be fair and ethical with your employees, but you also need to follow employment termination procedures that discourage wrongful-termination lawsuits. When

you are ready to hire your first employee you should talk to an employment lawyer and delineate the procedures your firm will employ to hire and to terminate an employee.

BASIC RULES

When dealing with your employees you should follow some basic rules. They are all equally important.

RULE 1

Treat all your employees with respect and treat them as professionals, regardless of their position in your company.

RULE 2

Treat your employees the way you would like to be treated if you were the employee.

RULE 3

Be fair.

RULE 4

Pay fair salaries.

RULE 5

When there is an opportunity for growth, always try to promote from within the company first.

RULE 6

Reward outstanding employees.

RULE 7

Make certain each employee understands clearly what his/her responsibilities are.

RULE 8

Make certain each employee understands clearly what is expected of him/her.

RULE 9
Listen to your employees with an open mind.

RULE 10
If an employee is not performing satisfactorily, explain clearly to the employee what he/she needs to do to improve and provide a time frame for the improvement to occur.

RULE 11
If you and/or the employee's manager become convinced that the employee is not capable of satisfactory performance, replace the employee as soon as possible.

RULE 12
Keep your employees informed of the progress, the obstacles, the competition, and the short- and long-term goals of the company.

SEPARATE PHILANTHROPY FROM BUSINESS
If an employee is not capable of satisfactory performance and needs to be replaced as discussed above, do it.

You will come face-to-face with situations in which you have met the employee's family or learned about some of the employee's personal problems. You will be aware that losing his/her job will be a hardship for the employee.

If you leave such a person in a job in which they are not performing, you are in essence expecting you and other employees to make up for the deficiencies of this person. That is not fair to you or to anyone else.

You certainly should try to help that employee obtain a suitable position elsewhere.

If your conscience guides you to do so, you always have the option to help that employee from your personal funds if you can.

PROFIT/COST CENTERS

As your company grows, define profit centers and cost centers. What this means is that you designate groups of employees that you can explicitly associate with profits and expenses. You refer to a group of employees that produces direct revenues as a profit center. You refer to a group of employees that produces no revenues as a cost center. Here are some examples of profit and cost centers:

- Your sales organization and the different sales offices are profit centers.
- Your accounting group is solely a cost center.
- In our company we had one person dedicated to expediting collections; she was a profit center.

This allows you to create reports showing how much each center costs to run and how much profit they contribute to the company over a given time period. For each profit/cost center, you can track actual profits/costs vs. projected profits/costs allocated in your business plan.

With properly defined profit/cost centers, you can also specify target performances for different groups and offer incentives such as bonuses to each group that meets or exceeds its objectives.

Some entrepreneurs have regular company-wide meetings in which they release the performance of each group to the whole company. I never did that company-wide, but I did within our management team meetings.

If you are a one-person start-up company you may question this discussion since you would be the sum total of all your profit and cost centers. You would be wearing multiple hats as we have discussed before. It would indeed be helpful to you to think of each hat as a profit/cost center and to analyze how you are performing.

EMPLOYEE BENEFITS

Offering an employee benefits package is a real challenge for a start-up with a very tight cash flow. Besides vacations, holidays and sick leave you need to consider other benefits such as health

250

insurance and retirement plans. Often you must offer a number of fringe benefits to be competitive.

In some industries your employees expect you to provide health insurance for them and their families. In other industries you are not expected to do so. Health insurance premiums represent a major and continually increasing cost for a company, even for an established concern. Many companies today pay part of the cost of health insurance and ask their employees to contribute the remaining cost.

Retirement plans are beneficial to your employees as well as to you. There are a number of tax benefits associated with some retirement plans (e.g., a 401(k) plan). You should check with your accountant and/or a firm that specializes in retirement plans to explore your alternatives.

For a discussion of employee benefits you may refer to [Leso 04, Chapter 24].

Good fringe benefits lead to more satisfied employees and will contribute to reducing employee turnover with its associated costs. Even more important, it will give you satisfaction to know that you are providing a good working environment for your employees.

Fringe benefits go directly to your fixed expenses, and you need to be careful in managing the growth of your fixed expenses.

OTHER INSURANCE COVERAGE

Besides health insurance, there are other types of insurance coverage that you should consider. These include: worker's compensation (required by law); general liability insurance; error and omissions protection; auto and property insurance; and 'key man' insurance.

I recommend that you meet with two or more insurance agents and learn more about the various types of insurance, their coverage and their costs.

Before you select an insurance company, make certain it has a good reputation and track record. For more discussion on insurance coverage, you may refer to [Wilm 06] and to [Leso 04, Chapter 25].

MEASURE WHAT YOU ARE DOING

When I was a graduate student I had a professor who taught me that whenever I perform a task I should allocate a small percentage (say 3%) of my resources to measure how well I am doing that task. That was excellent advice.

This advice applies to any activity in your life. It is particularly important when you are involved in a business start-up.

In the chapter on accounting we discussed reports you should generate on a regular schedule to monitor and run your company. These reports are the tools that you employ to monitor how well you are doing. How do your actual results compare to your business plan?

A BUSINESS IS NOT A DEMOCRACY

A company succeeds because one person—the entrepreneur—has the clear vision, leadership, and persistence to make a dream become a reality. This person is the captain of the ship, and a ship has only one captain.

Whether or not a business becomes a success will to a large degree depend on the people with whom the entrepreneur surrounds himself/herself. When there is a serious problem, however, such as a lack of money to meet cash flow needs, everyone looks to the entrepreneur for the magical solution.

At crunch time, which is a frequent occurrence, the entrepreneur makes the final decision. Period. No more discussion.

Different leaders have different styles. When faced with a problem, the good leader listens to the opinions and reasoning of the appropriate people, then makes a decision. Further, the good leader is forthcoming in explaining the logic of the decision to the people whose support he/she needs. Even if the decision is a gut decision with little logic behind it other than instinct and experience, he/she is not afraid to say so.

A leader must be respected as such. Respect is earned, not legislated.

A good leader understands his/her strengths and weaknesses. This leader surrounds himself/herself with good people as soon as it

makes sense. **The challenge is that to hire good people you have to have a thriving business, and to have a thriving business you must have good people. This is the classic chicken-and-egg problem.**

To succeed, you need to break this circle in an incremental manner. It is doable!

There will be many times when it appears that the ship is sinking and that nothing can be done to save it. If you still believe that this business, your vision, is a sound one, then you have to make it float no matter what. And because you are the leader, you must radiate optimism, even in the face of great danger. You have to find a way to keep the ship afloat.

This is a lonely position and you should prepare yourself for that.

BE PREPARED FOR SURPRISES

When I was an undergraduate student in engineering I took a class from a professor who used to announce on Wednesdays, "Prepare yourselves, because next Monday we are having a surprise test on the material we are covering this week."

I, in turn, would like to warn you that tomorrow, and the day after tomorrow, and the day after the day after tomorrow, and so on, you will face a surprise. I cannot tell you what the surprise will be.

The point is that every day of your entrepreneurial life, particularly during the early phases of your new company, you will encounter surprises. Some will be easy to handle and others will represent major challenges. In either case be prepared for surprises. Learn to remain calm and don't panic.

SUMMARY

I covered a number of topics that become quite apparent when you are dealing with the day-to-day issues of running a business.

In particular, I discussed ethics, staying power, fixed vs. variable expenses, relations with employees, profit and cost centers, insurances, as well as several others.

How you handle these issues can have a major impact on your business trajectory.

I provided guidelines for handling these issues based on my experience.

KEY POINTS COVERED

- Integrity, honesty, and loyalty are crucial to the long-term success of any enterprise.
- You should treat others the way you would like to be treated.
- To take advantage of opportunities, you have to be in business. You must ensure your staying power.
- Fixed expenses are easy to augment but very difficult to reduce.
- Look for employees who are ready for the next level of responsibility.
- Delineate the procedures for hiring and terminating employees.
- Separate philanthropy from business.
- Define and monitor profit and cost centers.
- A business is not a democracy.
- Be prepared for surprises.

CHAPTER 12

EXITING YOUR COMPANY

AN OVERVIEW

The purpose of this chapter is to make you aware that **exiting your company could be the only way for you to realize your financial rewards.** Thus, your exit strategy must be considered and outlined from the start.

You must think through your exit strategy when you identify your business opportunity because the type of business you select may limit your exit options.

You want to feel confident that your company will be as sellable as possible, and you want to maximize its valuation at exit time. There are steps you can take to accomplish these goals.

Understanding what it takes to exit, what is wishful thinking, and what are facts will guide your decision process as your company evolves.

I will discuss in this chapter the importance of defining your exit goals as well as various exit strategies.

This chapter is not intended as a substitute for legal or accounting advice. On the contrary, the objective is to help prepare you for discussions with your attorney and your accountant.

BACKGROUND

Every successful founder will exit his/her company. You will exit because

- you choose to do so on your own terms
- you are forced to exit
- you become incapacitated or die

Of course your preferred choice is to exit on your own terms according to a plan you outlined from the very beginning of your entrepreneurial trek. I assume that this is the case in discussing some of the key issues you should address.

Before I continue, I should mention that there can be exceptional situations in which the company you create will consistently generate large profits, allowing you to fulfill your financial objectives. Or the company may achieve such a high valuation that by selling a minority equity interest, you could fulfill your financial goals. If you are fortunate to be in either of these situations, you may decide to maintain control and remain with your company until you pass the business to your heirs.

SET YOUR EXIT GOALS

From the start you should define your personal exit goals. What is it that you want to accomplish, and what is the time frame in which you want to reach your objectives?

Once you have defined your exit goals, translate them into dollars and time. For example, you may want to have enough money to buy a nice home, to have a summer cottage on the beach, to travel, and to maintain a certain living standard. You also may want to provide an inheritance for your children, and you may want to donate to charities. Assign a dollar value to achieving these goals— for example, you might decide you will need $20 million after taxes. Then select the timing for achieving your goal. Do not make the mistake of waiting so long to exit your company that you might not be healthy enough to enjoy the success you have achieved.

Of course your goals are dynamic and will change as you progress in your business journey. What you cannot do is lose track of reality.

You must have a clear set of exit goals so that when the opportunity opens for an exit that meets your goals, you will be prepared to act on it. The following personal stories make the point.

Paper goals

Softool had a solid growth path. It had some exciting products and was attracting the attention of some of the large companies in the software products industry. After several years in business, we were approached by one such large outfit. After about three months of discussions, the president and a vice president of that company met with us to discuss the purchase of our company. They made a very generous and serious offer that met our goals. I say "our goals" because I had involved our senior management team in the decision.

Thus, we had defined clear goals. We had an opportunity to exit meeting our goals. Yet we did not accept the offer.

It turned out to be a bad decision. We had some difficult times after that due to some mistakes on our part, and it took us time to get back to the same valuation again.

I have analyzed what we did and concluded the following. Our company was growing fast, we were overconfident, and we believed that we would continue to see unimpeded growth. More importantly, although we had set clear goals, we did not take advantage of an opportunity to exit with our goals achieved. With hindsight I consider that an error.

Facing your mirror

When we decided to sell Softool, we went through a careful process of talking to various potential acquirers. Eventually we came to a preliminary non-binding agreement with Platinum Technology, a much larger software products company.

Softool had done a tremendous job in recruiting and keeping a talented and dedicated staff. I was proud of our employees and grateful for their loyalty and dedication.

We used to hold regular internal company meetings where we discussed current accomplishments as well as existing problems.

At the time there was much consolidation taking place in the software industry. At our meetings I was asked more than once if Softool was for sale. I consistently responded to that question by stating clearly that if the company were sold I would worry about the continued employment and growth path of our employees. I

believe I had earned the trust of my employees, and they accepted my response with confidence.

In my discussions with the president of Platinum Technology, in addition to price and other transaction issues, I made it very clear that the future of my employees was of great importance to me. The president had assured me and convinced me that he needed these employees and that they would have ample opportunities for growth. Further, he intended to leave the Santa Barbara operation in place and assimilate our other offices into his existing offices. His plan was to expand and grow. I was familiar with Platinum's mode of operation and his commitments were consistent with their track record.

Right after we entered into the preliminary agreement with Platinum Technology, I was approached by the senior management of a very large European company. They had been tracking us and had been considering making an offer for Softool when they received intelligence we were in negotiations with Platinum (it is very difficult to keep secrets in government or in industry). They contacted me, and I agreed to meet with two senior vice presidents who were flying from Paris just for this meeting. We met at a restaurant in Malibu, California.

It was a long dinner. They had done their homework and were prepared. At the end of the dinner they put an offer on the table for Softool that was about 18% higher than the offer I had preliminarily accepted from Platinum Technology. The European company executives made it clear that their plan was to move the Softool operation to Paris and terminate most of its employees. They wanted to integrate the Softool products into their product offerings. I agreed to give them a reply within the week.

Frankly, I did not have to think long about this offer. I had given my word to my employees that I would worry about their future if I ever sold the company, and I had every intention of keeping my promise. It was very important to me that when I shaved in the mornings, I could look into the mirror and be pleased with the fellow I saw.

I rejected the offer from the European company.

The continuity of employment for our employees was part of my exit strategy. This offer did not meet that criterion.

Postscript to the story. After the acquisition, several Softool employees moved up to senior management positions with Platinum Technologies.

What is the right price?

As mentioned earlier, albeit the selling price is a key component of your exit strategy, it is not the only factor in your decision and you must keep that in mind.

Although you have translated your exit goals into a dollar amount, when it comes time to sell you will wonder if you are selling at the right price. There are a number of ways, besides the quantification of your personal goals, to determine your selling price. I will now mention an approach that I consider quite helpful in making the right decision concerning price.

When I was ready to sell Softool I asked the late David Zerner, a relative, a friend and a successful entrepreneur for his advice. He said to me: **"If you are prepared to pay for your company the amount being offered to you, then don't sell it. Otherwise, sell it."**

I thought this was excellent advice and I followed it.

Next, a very appropriate short story.

Timing your sale [Levy 07]

Sam Zell, a legendary and successful entrepreneur, was asked in an interview by a *Wall Street Journal* reporter in September of 2007 about the timing of his sale of his real estate company Equity Office Properties to Blackstone for $39 billion in February of 2007. At the time of the sale he was criticized by some for cashing out too early. Instead, the sale occurred at the top of the market. Shortly after the sale the real estate market had a major decline.

In his response to the question Mr. Zell explained that he didn't try to deliberately pick a market top so much as weigh the offer against what his own instincts told him was the right price. He then is quoted as stating:

"Somebody made an offer that was wide by a significant margin of my own valuation. So I'm looking in the mirror, and any day you don't sell, you buy, and I wasn't willing to buy at the price they were willing to pay, so I sold it."

You should be aware that there are professional business appraisers whose job is to come up with a dollar value representing what they believe is the fair value of a business. Some of the techniques these appraisers employ include calculations based on the net income that the business generates, the aggregate value of the assets owned by the business and the price at which similar businesses have been sold.

In the sale of the two companies I founded I did not use a professional appraiser.

DO NOT TAKE YOUR EYES OFF YOUR GROWTH PLANS
Before I continue discussing exit strategies I want to emphasize to you what I consider a critical point.
Your first and foremost priority is to meet your sales and growth plans.
If your financials are good, your products are good, and your management team is solid, you will find an acceptable way to exit when you are ready. Furthermore, you will have the luxury of waiting for the correct time to exit.
Keep your attention focused on meeting your plans for growth.

EXIT STRATEGIES
I will discuss the following three exit strategies:

1. Acquisition
2. Creating your buyer
3. Public offering

1. ACQUISITION
Finding a potential acquirer

In an acquisition, another company buys you out.

You find the acquirer yourself, the acquirer comes to you, or an intermediary brings you together.

Often, companies looking to be acquired will hire an intermediary to find a buyer for them. Similarly, companies searching for other companies to acquire often hire an intermediary to assist in the search.

A reputable and experienced intermediary can be very helpful to an entrepreneur who is selling a company for the first time. After doing my homework, I used an intermediary in the sale of Softool. It was a wise decision.

Potential acquirers are companies with competitive or complementary products or companies trying to enter your marketplace. Also, there are financial groups that buy companies purely as investments. In any case, a good intermediary should bring you to the attention of qualified buyers.

Planning for the sale

To help your planning, place yourself in the shoes of the potential buyer to identify the type of company that makes a good acquisition target.

Your company needs to be positioned in an area with great market potential and you need to have good products that address this market potential. The larger and more prestigious your customer base, the better; the stronger your financials, the higher the valuation of your company.

You do not want to try to sell your company when you are having serious financial problems. Your acquirer will discover this promptly and will take advantage of the situation.

Negotiations for an acquisition can be conducted discreetly. This is important because if it becomes public knowledge that your company is for sale, it will demoralize your employees and damage your sales activities.

Structuring the sale—your role

There are different ways in which you can structure your role in the company after the acquisition. There are two principal possibilities:

1. Total disconnect
You walk away after the documents are signed with full payment and no more business connections to the company you sold. You have no further role in this company. This represents a very clean transaction. This is the approach I used in the sale of the two companies I founded and sold—Softool Corporation and Compass Corporation.

2. Earn-out agreement
In this arrangement, the acquisition is structured so that you stay with the company for a period of time. You receive some payment when the sale is closed. You receive additional payments, which are tied to the performance of the entity you sold, during the period of time in which you remain as an employee. Be aware that many earn-out agreements have ended up in court, often because each party has a different interpretation of how the business is to be run after the sale.

Of course, there can be variations on these two strategies. For example, you can do a total disconnect type of transaction, but you could agree to stay for a transition period with a fixed salary.

Structuring the sale—form of payment

There are three principal ways in which you can get paid:

1. *Cash*
You receive cash in payment for your company.
2. *Stock*
You receive stock in the acquiring company in payment for your company. You should have a good handle on the quality of the stock you are receiving.

3. *Notes*

In this arrangement, you accept notes from the acquirer that are due over a period of time, say the next three to five years. You run the risk that you may never collect on these notes.

Of course, the above strategies can be combined in various ways.

It is also pertinent to mention a related strategy used by some acquirers to obtain funds to pay for an acquired company. It is referred to as a "leveraged buy-out." In this approach, the buyer employs assets of the company being bought as collateral on a bank loan to pay the seller. Most small businesses or high technology companies do not own enough assets to secure a completely leveraged buy-out.

An alternative to a leveraged buy-out is one where the employees buy a majority stake in the firm that employs them. The funds originate from a qualified, defined contribution, employee benefit plan. The typical way an employee buyout occurs is through an employee stock ownership plan (ESOP). This strategy may be attractive to the selling shareholder(s) and participants because of various tax benefits they receive.

Structuring the sale—taxes part I

When you receive a cash payment for your company, taxes are due following the transaction as per Internal Revenue Service regulations.

When the payment you receive for your company is all in stock, taxes are deferred until you sell the stock you received. As you sell your stock, you pay taxes in accordance with the amount of stock you sell.

When the payment you receive for your company is a combination of cash and stock, you need to be careful how you structure the transaction. The basic rules are as follows:

- If more than 80% is received in stock and the remainder is in cash, only the cash portion is taxed at the time of the

transaction. The tax on the stock portion is deferred until you sell the stock.

- If more than 50% (but less than 80%) is received in stock and the remainder is in cash, it is possible to structure the transaction so that only the cash portion is taxed at the time of the transaction. There is a risk that this may be challenged by the Internal Revenue Service, so it is essential to seek good tax and legal advice to ensure that this type of transaction is handled properly.
- If less than 50% is received in stock, all of the proceeds—both stock and cash—are taxed at the time of the transaction.

Stock received from an acquisition or merger may be subject to selling or hedging restrictions that may be imposed by the acquirer or by virtue of the fact that the shares received are not registered with the Securities and Exchange Commission (SEC). Normally, stock that is not registered can be registered and sold after one year.

There are other restrictions. For instance, if you received sufficient outstanding shares to be considered "an insider," you will be limited as to how many shares you can sell and how often you can sell them.

Structuring the sale—taxes part II

When you sell your company, you may sell stock or you may sell assets. Each has different tax consequences.

As a seller, it is generally to your advantage to sell stock since the proceeds you receive are taxed at capital gains rates.

If you sell assets, consider, for example, a sale of assets by a C corporation. The sale would trigger double taxation. A pass-through tax entity, on the other hand, can sell assets and be taxed only once. Also, you should be aware that acquirers generally prefer to buy assets since they get a purchase price basis, which typically lowers their taxes.

You will need experienced legal and accounting advice to structure your transaction.

Next, I discuss an acquisition strategy.

2. CREATING THE BUYER

The approach here is to identify potential buyers and to get their attention in a manner that makes it clear it would be to their advantage to buy your company.

There are different ways to accomplish this objective, depending on your specific situation. I will provide an example of an approach I employed successfully.

Stinging the bigger fish

In the early- to mid-eighties the corporate computer market was dominated by large IBM mainframes. An important need of corporate computer centers is to keep track of and maintain different versions of computer programs. Two companies, Pansophic and Applied Data Research (ADR), had been very successful in satisfying the perceived needs of this market. At the time they were two of the larger software products companies in the business, each with annual revenues in the area of $200 million.

Pansophic addressed this market with a product called Panvalet, and ADR addressed it with a product called Librarian, both running solely on IBM mainframes. At the time, these products were the best revenue generators these companies had. Each had about the same number of installations.

An established software products company generates a substantial portion of its revenues through annual or multi-year maintenance contracts that are often paid in advance. Panvalet and Librarian were each generating about $50 million per year in maintenance fees for their respective companies.

Any company that threatened these products got their attention.

Softool had a family of software products that ran on IBM mainframe computers as well as on a number of other smaller computers. We called them CCC (Change and Configuration

Control). Compared with Librarian and Panvalet, CCC represented a new functional generation that did much more and performed better.

We considered Pansophic and ADR natural buyers for our company. We wanted to get their attention, so we decided to give special consideration to sales into their installed customer base. Such an approach, although not without risks of more intense competition on their part, was not in conflict with our plans to increase sales. Our efforts were successful.

After some time, both companies came to us, one with an offer to buy us and one to explore a potential marketing agreement.

Postscript to the story. Eventually, both Pansophic and ADR were acquired by Computer Associates. Softool was acquired by Platinum Technology (at the time a company with about $1 billion in annual revenues), which was in turn acquired by Computer Associates, a company with several billion dollars in annual revenues.

3. PUBLIC OFFERING

This is formally referred to as an Initial Public Offering (IPO). Many entrepreneurs think this is a simple way to cash out. Not so. It is a complicated process fraught with dangers. Let me summarize some key points.

- According to a January 2006 article in *The Wall Street Journal* [Buck 06], the median stock market value of start-ups that were funded by venture capitalists and went public in 2005 was $216 million. The same article quotes an industry expert stating that to stage a successful IPO, a company needs to have $100 million in annual revenues with a potential stock market value of at least $250 million. Such a valuation would require respectable after-tax earnings and a consistent track record of financial performance.
- An IPO is an expensive undertaking. The underwriter (i.e., the investment banker) managing the IPO would charge a fee anywhere from 5% to 10% of the monies raised through the IPO. In addition, legal, accounting, and printing fees could

represent another 5%. Thus your total cost could well be in the range of 10% to 15% of the monies raised through the IPO [Glad 88].

- As a result of the financial crisis that surfaced in 2008 there was a serious decrease in the number of investment banking firms, thus, the bar was raised on the quality of the companies that could find an investment banker to manage their IPO. In fact, only 29 companies went public in the United States in all of 2008, compared with 215 in 2007 [Cowa 09].

- The process of preparing and closing an IPO takes several months and will consume the time of the senior management team.

- After a company goes public, it has to operate under much tighter accounting and legal frameworks that will cost much more and consume a fair amount of senior management time.

- The 2002 Sarbanes-Oxley law requires top executives of public companies to vouch for the accuracy of their financial statement and includes stiff penalties for violations.

- A public company has to disclose much information—your compensation, for example. All the released information will be available to your competitors, your employees, your customers, and your friends and neighbors.

- Once you become a public company, any dealings between you and your company are subject to additional scrutiny and strict laws.

- The market (i.e., the people buying shares of your company) does not like you to sell more than a small percentage of your ownership of the company as part of the IPO. The underwriter managing your IPO will determine the number of shares that can be sold by insiders.

- Subsequent to the IPO there are restrictions on your ability to sell the public stock that your company issues and that you receive as a result of the IPO. For instance, there is a lock-up period after the IPO, typically 180 days, during which you

cannot sell. Thereafter, other restrictions may come into play.

- As you sell your stock your voting power diminishes; you may lose management control, and you are now under the direction of a Board of Directors whose goals may be different from yours.
- After you become a public company, you operate under what has been called the tyranny of quarter-to-quarter earnings expectations. The value of your stock will depend on this quarter-to-quarter performance.
- If your goal is to sell all of your ownership in your company, it will require time, and you will risk that your stock may decrease in value. Keep in mind that if buyers of your stock become nervous when they learn that you are selling large percentages of your shares, this could drive the price of the stock down. (There are stock trading techniques that may be available to you that will minimize the risks of your stock losing value. These techniques incur costs.) Of course, you could sell all of your stock in one single transaction.

There are many advantages to having an IPO and becoming a public company:

- It gives you liquidity, although constrained by the restrictions mentioned above.
- It is a way to raise capital to fuel the growth of your company and alleviate cash flow concerns.
- It creates currency (i.e., stock) for you to use in executing an acquisition strategy of your own. **This represents a formidable benefit if your long-term exit strategy is to grow your company by acquisitions to increase the value of your holdings**.
- It allows you to employ stock to reward existing employees and to attract new ones.

An IPO is not a simple exit strategy. It is a strategy that combines the exit process with performance, growth and time.

Whether or not you do an IPO is not a decision you need to make at this time. If you concentrate on creating a successful company with consistent performance, this exit door will be open for you as long as the country's economic conditions support it.

EXAMPLES OF BUSINESS SITUATIONS THAT LIMIT YOUR EXIT OPTIONS

You could create a business in which your exit options are curtailed for any of a number of reasons. The following two examples illustrate the point.

Lawyers

An entrepreneurial lawyer who has successfully built a substantial law firm with multiple partners has limited exit options. Even though this lawyer might be the founding partner, he/she does not have a company to sell. The firm is owned by all the partners.

One successful lawyer who founded his law firm told me that had he fully realized this problem when he created his business plan, he might have proceeded differently.

Physicians

Physicians have a similar predicament to the one lawyers have.

An entrepreneurial physician who starts and grows a medical practice ends up with a number of partners. When that physician is ready to exit the practice, he/she does not have a company to sell. Again, the exit options are limited.

SUMMARY

Exiting your company will probably be the only way for you to realize your long-term financial rewards. Thus, your exit strategy must be considered and outlined from the start.

The main purpose of this chapter was to emphasize that as part of your planning process, and as you are growing your company, you should keep in mind how you are going to exit.

There are steps you can take to facilitate and optimize your exit strategy.

I stressed the importance of setting your exit goals early, and I presented and discussed in some detail three exit strategies.

You must be aware that after the financial crisis that materialized in the latter part of 2008, exiting your company will be a more challenging task [Tam1 08]. A solid company, however, can always be sold.

KEY POINTS COVERED

- You must think through your exit strategy when you identify your business opportunity because the type of business you select may limit your exit options.
- Exiting your company may be the only way for you to realize your financial rewards.
- You want to be confident that the company that you create will be as sellable as possible.
- You should define your exit criteria when you develop your business plan.
- Your exit strategy should not distract you. Your first and foremost priority is to meet your sales and growth plans. Keep your focus.
- Being acquired offers a clean path to exit your company.
- An Initial Public Offering (IPO), although potentially rewarding, is not a simple way to exit.

CHAPTER 13

SUCCEEDING IN DIFFICULT ECONOMIC TIMES

AN OVERVIEW

The purpose of this chapter is to emphasize the key economic issues that an entrepreneur has to face in the midst of a worldwide financial crisis. Such a crisis came into being at the end of 2008.

In this chapter I:

- Point out that crises also open exceptional opportunities for the astute and aggressive entrepreneur.
- Discuss defensive cash flow planning as a crucial business survival mechanism.
- Encourage you to renegotiate your agreements in search of better terms.
- Describe the new barriers to borrowing and mention some possible alternatives.
- Explain why venture capital funding dries up in bad economic times.
- Outline why an Initial Public Offering (IPO) is not a viable path to exit your business in a harsh financial environment.
- Discuss mergers and acquisitions issues from the point of view of the seller as well as from that of the buyer.

BACKGROUND

By the last quarter of 2008, it became quite clear that a worldwide financial crisis of historical proportions was in progress. This is not the first time that this occurs in American history. We have had a financial crisis roughly every 20 years between 1819 and 1929. After 1929 there was no financial crisis until the market crash of 1987, which had no lasting effect on the American economy

[Gord 08]. According to J. Gordon [Gord 08], the reason for this approximately 60 year period of reasonable financial tranquility (notwithstanding recessions such as in 1973-75 and 1981-82) was the existence of a powerful central bank in the United States which came about in 1934. Then, the debacle of 2008 hit us.

In late September of 2008, The Ewing Marion Kauffman Foundation [Kau2 08] conducted a national telephone survey in the United States. It concluded that Americans see entrepreneurship as the answer to their financial crisis. It reported that more than 70% of respondents stated that the health of the economy depends on the success of entrepreneurs, and a full 80% want to see their government use its resources to actively encourage entrepreneurship in America.

Successful entrepreneurs are respected by their fellow citizens.

DEFENSIVE PLANNING

The approach previously described in Chapter 10 in this book for creating your business plan while minimizing your need for funds from others is a sound way to be always prepared for economic bad times.

In my opinion, **regardless of actual economic conditions, the entrepreneur who wishes to ensure his/her success must act as if economic times are always difficult, and plan accordingly.** The issue of insuring survival must be present in the entrepreneur's mind and planning at all times. Of course, such an approach presents a formidable challenge to remain in business while balancing survival with long term goals for growth. Survival alone, although necessary, is not satisfactory; you must also make progress towards your goals.

Basic survival steps that you will need to consider include:

- Cut expenses. Cut expenses. Cut expenses.
- Eliminate unprofitable activities but be careful not to kill those activities that will fuel your future growth.

- Bring your staff down to the bones but make certain you have left a skeleton in place with which you can recover promptly when your business improves.
- Watch your cash flow like a hawk.

As an entrepreneur it will be tough for you no matter what the state of the economy. If you are in the middle of exceptionally good economic times (e.g., easy credit, much money flowing, unrestricted expenditures by potential clients) then you may develop a false sense of success and security, and chances are high you will not be prepared to survive difficult economic times. Harsh economic periods will be very likely to follow the good times because of an overall malaise in the economy or because of missteps in your business.

The key point here is that you must be prepared for rough economic periods at all times.

THE BAD AND THE GOOD

According to the United States Small Business Administration, historical data indicates that more than half a million small businesses close each year. Two thirds of new businesses survive at least two years, and only 31% survive seven years [Cove 08]. As a financial crisis intensifies these statistics get increasingly worse.

The potential factors contributing to the additional problems that an entrepreneur will face in bad economic periods include:

- Lower sales
- Pressure to lower prices on your products and provide better payment terms
- Delayed collections from customers
- Increase in uncollectible accounts
- Tougher competition
- Higher taxes
- Higher health insurance costs
- Difficulties in maintaining/obtaining credit lines
- Market volatility, which makes it difficult to plan ahead

- Curtailed ability to retain and motivate key employees
- Necessity to let some valued employees go
- Diminished funding to keep product development plans on track

On the other hand, it is a fact of life that one person's problems are another person's opportunities. Great fortunes have been amassed by taking advantage of exceptional windows of opportunity that open up during crises and that may occur only once in an individual's lifetime.

In an interesting paper published in 2008, Kedrosky [Kedr 08] points out that a number of highly successful public companies were founded during economic recessions. He mentions Genentech, Microsoft, Southwest Airlines, and Genzyme as companies that were founded in recent difficult economic times. He also mentions Morgan Stanley, Allstate, Krispy Kreme, and Knoll as companies that trace their founding dates to the Great Depression. Another study published by the Kauffman Foundation [Stan 09] reports that more than half of the Fortune 500 companies were founded during recessions or bear markets. A bear market occurs when there is a substantial drop in stock prices over a period of time, usually accompanied by widespread pessimism.

The potential factors that help create opportunities in a bad economic period include:

- Supplies are available at reduced prices and with better payment terms.
- Landlords are amenable to lower rents and shorter leases.
- Many people are willing to work for lower salaries.
- Interest rates are lower.
- Companies with which you can co-market your products are more open to business arrangements (i.e., leverage deals).
- Competitors can be acquired if you can obtain credit or have cash available (if you are a public company, your stock is your currency).

- **The playing field changes in a major way: business opportunities that did not exist before open up.**

RENEGOTIATING AGREEMENTS

Generally speaking, everything is negotiable, particularly during hard economic times.

You should re-examine all of your contracts with suppliers, landlords and business partners. No one wants to do anything that would eliminate a revenue stream.

Ask your suppliers for discounts, ask your landlord for a lower rent and/or a shorter lease. Re-evaluate any arrangements you have with business partners and try to obtain better terms.

If you have cash to pay in advance or if you have a track record of paying on time, you are in an excellent position to renegotiate all of your agreements. Even if you are asking for more time to pay your bills, you can still negotiate for better terms.

BORROWING

During tough financial times it is much more difficult to borrow. Banks put up very high lending standards and individual lenders such as family members and angel investors become very protective of their monies.

Banks and other lenders will not offer credit to any risky client, while clients with solid businesses, previous relationships with the lender, and more than sufficient collateral may be asked to pay exceedingly high interest rates. In fact these rates can be so high that it may not be possible for a business to withstand them for very long. Moreover, credit lines when provided to borrowers are offered for much shorter time periods. For example, by mid-2009, even the strongest of borrowers had their revolving credit lines shortened from three or five years to just one year.

A revolving line of credit is a commitment by a lender to lend a specific amount to a borrower and to allow that amount to be borrowed again once it has been repaid.

As mentioned earlier, you can lean on your credit cards to bridge temporary cash flow problems; however, in difficult times this may

not be an option. By early 2009, banks cracked down on the credit card funds available to small business owners by trimming their credit lines, closing accounts and raising interest rates [Kim 09]. Banks did this on both business credit cards as well as on personal credit cards.

Smaller community banks and credit unions are typically more open to offering financing to entrepreneurs, particularly in difficult economic periods.

According to a report by Mincer [Minc 09], about 27% of the 8,147 credit unions in the United States offer business loans. In 2008, credit unions loaned about $33 billion to businesses. The average loan size was $215,000.

From a lender's viewpoint, one of the most important factors in order to provide a loan is the cash flow of the borrower, since the lender wants to ensure his/her ability to collect [Cord 08]. You should be prepared to show clearly how you plan to pay back the loan you are requesting.

I have emphasized previously that as an entrepreneur you should always have a solid handle on your cash flow projections, regardless of whether or not you are borrowing. It is simply a key planning tool for survival.

The self-employed entrepreneurs generally have to personally guarantee any loan, and they face additional hurdles when seeking a loan. The reasons include [Timi 08]:

- Their end-of-year earnings report to the Internal Revenue Service (i.e., their W-2 forms or their actual income-tax returns) do not support the level of cash flow necessary to pay back loans, the reason being that they normally pay themselves low salaries to help their business cash flow.
- Their income-tax return tends to be understated.
- Their year-to-year income shows much volatility because they are entrepreneurs
- Typically, they do not have other assets to offer as collateral.

When entrepreneurs are unable to obtain conventional loans from a bank they often turn to loans backed by the Small Business Administration (SBA). During financially tough times SBA backed loans also tend to become unavailable. There are several reasons for the disappearance of this type of loan.

One reason is that lenders (e.g., banks) normally sell their SBA backed loans to other institutions so they can free up capital to issue new loans. The interest rate on these SBA backed loans is pegged to the prime lending rate, which is in turn pegged to the federal funds rate, which during an economic crisis tends to be very low. On the other hand, the institutions that would buy these SBA backed loans pay interest rates pegged to LIBOR for their funds, and during hard economic times LIBOR rates tend to soar. Thus, SBA backed loans become very unattractive investments for their potential buyers [Spo2 08].

Another reason SBA backed loans become more difficult to obtain is that the losses incurred by the SBA from its lending programs increase dramatically during difficult economic times. For example, such losses amounted to $1.3 billion in 2008 [Eckb 09].

A third reason SBA backed loans are difficult to obtain, particularly for start-ups, is that participating banks raise their lending criteria in a substantive manner.

VENTURE CAPITAL MONEY

As previously discussed venture capital (VC) funds raise money from such investors as wealthy individuals, pension funds, insurance companies and university endowments. Often, these investors provide the money to the VC fund in increments as the VC fund needs money to continue to fund the entrepreneurial companies in which it has invested.

During hard economic times VC funds face cash flow crises of their own for the following reasons [Tam2 08, Tam3 08]:

- The IPO market tends to shut down, thus preventing VC funds from taking any of their companies to the public market.

- The mergers and acquisition activity becomes sparse, thus making it difficult for VC funds to sell any of their companies.
- The investors in VC funds have cash flow problems of their own and become much more protective of their monies: consequently, they become reluctant or refuse to honor additional investment commitments to the VC funds.

In order for the VC funds to raise sufficient cash to continue to finance the key companies that they invested in, they may sell the stakes they own on some of their other companies for as low as a few cents on the dollar. (This is terrible for the entrepreneur who started the company where the stake is being sold at a fire sale price; not only does this entrepreneur have to deal now with an unknown new investor, but also the valuation of the venture is reduced dramatically.)

The key point of this discussion on VC funds is that VC funds will be extremely selective in making any new investments, if they make investments at all. Moreover, some VC funds will go out of business. Thus, **in rough economic times it will be much more difficult for entrepreneurs to obtain any VC funding.**

INITIAL PUBLIC OFFERING (IPO)

In an economic crisis, the IPO market tends to shut down. At the end of 2008, the worldwide IPO market was effectively closed.

In 2008, less than 30 companies went public in the United States. Compare that with 365 in 1986, 272 in 1996, 269 in 1999 and 215 in 2007 [Mal2 08, Cowa 09]. Also, the amount of monies raised through IPOs decreased dramatically. In 2007, the total amount raised in the United States was $2.69 billion, while in 2008 it was $931 million [Cowa 09] with the bulk of the funds raised in the earlier part of 2008 before the economic situation deteriorated.

A most important development at the end of 2008 was the disappearance of several of the powerful investment banks that dominated Wall Street and the taming of the ones that remained.

The consequences of this reshaping of the financial marketplace are yet to be determined.

The point here is that in rough economic times an IPO is not a viable path to exit your business.

MERGERS AND ACQUISITIONS

As previously mentioned, the other side of a crisis is that it represents an opportunity to grow your business by merger or acquisition if you can raise the cash to carry out the transaction, or if you can convince the seller to accept your terms and/or stock, or notes payable at a future date.

If you are astute enough to pinpoint specific market opportunities and persuasive enough to convince potential partners, lenders or investors, you may be able to create a substantial business enterprise through mergers and/or acquisitions.

If you are the seller who wishes to exit your company during a period of bad economic times you should be prepared to offer an attractive valuation of your business, and be willing to provide the buyer some of the financing (e.g., accept notes payable). Often, when the seller provides a portion of the financing, the bank or other lender feels more confident about the deal and is willing to make a loan for the rest of the required financing [Dale 08].

If you sell your company for stock you have to worry about the quality of the stock you would be receiving. In bad financial periods stock prices in general go down substantially, and you will have to decide if the stock you would be accepting will continue to decrease in value or will increase in value with time, and if you have the confidence to risk your life's work and your financial future in such a transaction.

In an economic crisis cash is generally quite valuable, thus, if you are the seller you should evaluate taking less cash but taking it at the time of sale.

SUMMARY

In this chapter I discussed some of the important economic issues that an entrepreneur faces in a difficult financial environment. I also pointed out that in a crisis there are exceptional opportunities to prosper for the astute entrepreneur.

I encouraged you to re-examine existing agreements, outlined borrowing problems, mentioned that venture capital funding dries up, and that IPOs are not viable when the country faces an economic crisis.

I also discussed mergers and acquisitions from the point of view of both the seller and the buyer.

In a tough economic environment it is difficult to obtain a job; there is much competition and little job security. So, if you are going to work very hard, sacrifice and take risks you may as well do it for yourself as an entrepreneur. However, you must be confident that you have what it takes to succeed.

KEY POINTS COVERED

In difficult economic times:

- Careful cash flow planning is critical for survival.
- Existing contracts should be re-examined in search of better terms.
- Borrowing standards are set very high by banks and other lenders.
- Family, friends and angel investors become very protective of their money.
- Venture capital funding dries up.
- IPOs are no longer a viable path to exit your business.
- Mergers and acquisitions are difficult to accomplish because of the inability of potential acquirers to borrow or raise money.
- Selling your company may require you to finance part of the transaction.
- Exceptional opportunities open up for the astute and aggressive entrepreneur.

CHAPTER 14

SUMMARY

TWO TIMES AROUND

There is a story about a young entrepreneur who was visiting a city for the first time to see a potential client. He was just starting his company, so money was tight. He stayed at a modest hotel. In the morning he took the city bus to meet his potential client.

He sat next to a nice little old lady who resembled his grandmother. He turned to this woman and told her he needed to get off at State Street and asked her if she could please tell him when to get off the bus. She smiled and responded, "Happy to do it. You just watch where I get off and you get off one stop before."

Well, if this young entrepreneur were to follow the little old lady's instructions, he would have to take notes of the stops the bus was making and wait until the bus was approaching State Street the second time in order to get off the bus. In other words, he would have to travel the bus route twice.

You will get more out of this book if you follow the same approach. Read it twice: first, to get a feeling for the issues you will face in starting your own company and second, to unify your understanding of the issues into a whole.

This book should also serve as reference on an ongoing basis. As you reach different points in your entrepreneurial journey, you may want to refer to specific sections.

A REVIEW

This book is intended for those who would like to start and develop their own business or for those who have already started their own business but welcome the practical guidance of an experienced mentor.

The creation of a new company is a business journey to a faraway destination. It is full of unknowns. This book is intended as

a navigational guide that offers an overview of the issues, the challenges, the people, and the risks you will face. It also shows you the rewards you will receive if you succeed.

There is no formula for success, and there is no psychological test you can take that will tell you if you will succeed. **What you can do is learn from the successes and the mistakes of others who have traveled the path ahead of you. Take note of what those who reached their destination did right. Learn from their accomplishments.**

Learn from the experiences of those who, after reaching their destination, asked themselves, "What could I have done differently to get here more quickly, more effectively, and more successfully?"

THE WORLD AROUND US

Earlier on I mentioned that Malone [Mall 08] postulated that the United States is currently becoming the world's first Entrepreneurial Nation. **It behooves us to be well aware that a number of other countries are aggressively making major strides in fostering an entrepreneurial culture.** Wooldridge [Wool 09] discusses how India, China, Israel, Denmark, Singapore, and New Zealand are creating millions of entrepreneurs.

We must protect our future. It is imperative that our government eliminate legal impediments and facilitate an environment that allows entrepreneurs in the United States to prosper. For example, tax laws that encourage entrepreneurship and laws that prevent frivolous lawsuits would be of great help.

We live in a highly competitive world. We want to ensure that our products have a market and are sought after not only in the United States but worldwide. Entrepreneurs in other countries have similar goals.

THE HOME FRONT

Creating a new business is hard. Every morning you go into the battlefield. If you have a family, you need the support of your spouse and children. Otherwise, you will be engaged in two wars—one in your business efforts and one at home.

Furthermore, an entrepreneur is involved with his/her business all the time. Even when you are not physically at work, the business is on your mind. The result is that your family life is affected by the amount of time and the quality of time that you can devote to family issues.

Based on my personal experience and that of other entrepreneurial friends, if you remain constantly aware of this problem, you will be able to manage it to the reasonable satisfaction of all concerned.

You can be a successful entrepreneur, a successful spouse, and a successful parent.

SUCCESS
If you succeed, you will have

- secured your financial future for yourself and your family
- created job opportunities for many others
- created or advanced a new field or business area
- made contributions to your community and society at large
- contributed to your country's position of leadership
- become a respected member of your community

Entrepreneurs are the engines of our economy. They are the ones who create the majority of new jobs, not the large established corporations.

In the United States [SBA 08, Cove 08], small businesses (those with fewer than 500 employees) represent 99.7% of all employer firms, employ about half of all private-sector employees, pay nearly 45% of total private payroll, generate 60% to 80% of net new jobs, hire 40% of high-technology workers, and ship about 29% of the total exports.

In addition, entrepreneurs contribute much to pay for the cost of government. For example, Google executives alone have paid California over $1 billion in state taxes (e.g., state capital gains taxes) since the company went public on August 19, 2004, or about 1 percent of the state's entire general fund budget [Davi 07]. Of

course, their contribution to the federal budget is a more sizeable one.

The personal satisfaction that comes with entrepreneurial success is exhilarating.

DO I REALLY WANT TO DO THIS?

If you are a born entrepreneur, starting your own business is in your bloodstream. You are destined to do it. Some entrepreneurs know from a young age that they have special attributes that separate them from others, and with time they come to understand the significance of these differences. Others discover their entrepreneurial talents as they assume positions of leadership. To be clear, there is no implication of any feeling of superiority. Simply, entrepreneurs see opportunities where others do not and are willing to act.

THE FINAL DECISION

For those of you at the starting line, this book is intended to help you make the decision as to whether or not you want to embark on an entrepreneurial journey and to help you make an informed decision. If you decide to go forward, this book makes clear the trials and tribulations as well as the personal challenges you will face. It is not an easy trek. It is not for the faint of heart.

There are a large number of would-be entrepreneurs who leave the starting line. There are very few who make it to the finish.

Only you can make the decision. No one else can make it for you!

ENDING COMMENTS

Figure 27 summarizes a collection of thoughts you may find helpful.

FIG. 27 THOUGHTS

- *Most people see an impossible task in an entrepreneurial situation.*

- *An entrepreneur sees and seizes an opportunity.*

- *Others will often discourage your entrepreneurial ideas.*

- *Common sense is very uncommon.*

- *Self-confidence is a birth gift.*

- *How am I going to get the money to make this company succeed? Great question!*

- *Integrity, honesty and loyalty will pay in the long term, and conducting yourself in accordance with high standards in these three areas will make you feel good.*

- *There are different lawyers for different problems. Learn to use lawyers.*

- *Accountants offer a necessary support structure. Learn to use them.*

- *Entrepreneurs earn capital gains.*

- *The fewer employees you have, the better.*

- *Treat others the way you want to be treated.*

- *Twenty percent of your resources are responsible for eighty percent of your results. Continually monitor your efforts.*

- *A business is not a democracy. It is run by a leader.*

- *A leader must be respected. Respect is earned, not legislated.*

- *If you are confident in the business opportunity you are pursuing, there is always a way to cross any wall of fire in front of you. Eliminate the word* retreat *from your vocabulary.*

- *The Internet offers business opportunities that lead to new frontiers. Use it as a source of information and as a component of your business solution.*

- *Do your best to create products that can be sold in the international marketplace.*

- *Crises create exceptional opportunities.*

- *Staying power is a key to success.*

- *You will exit your company. It is only a matter of when and how.*

- *A successful entrepreneur has secured his/her financial future.*

- *A successful entrepreneur has made major contributions to society.*

- *The personal satisfaction that comes with entrepreneurial success is exhilarating.*

I have enjoyed writing this book.
May you find your vision and have a successful entrepreneurial journey.

ENTREPRENEURIAL TRAINING

OVERVIEW

Almost every chapter in this book covers a subject that could be the topic of another book devoted entirely to that subject. This book can be utilized as a unifying framework for further reading and training on each of the topics covered.

In a formal class environment, the faculty member in charge of the course would be responsible for providing an appropriate reading list. The independent student would have to research and select his/her own reading list.

In a class context, the book can serve as a guide for inviting practicing entrepreneurs and other professionals to present and discuss their experiences. Different experiences and opinions could lead to active discussions of the issues in question, both during and after the invited guest presentations. These discussions in turn would nurture much deeper insight into the issues.

The exercises that follow are intended mainly for students when this book is being used as the framework for a course on entrepreneurship. In real life, the problems an entrepreneur continually faces do not typically have precise answers. Rather, they can be addressed in many different ways. Some solutions are more cost effective than others.

The objective of these exercises is to call the reader's attention to specific topics. In many cases, topics lend themselves well to group discussions, particularly under the guidance of the faculty member teaching the course. Some are also suitable for private consideration.

BACKGROUND

According to a 2005 report by Judith Cone of the Kauffman Foundation [Cone 05], "Entrepreneurship since the 1980s has become the fastest-expanding area of study among the nearly 3,000 not-for-profit two- and four-year colleges and universities in the United States."

The 2005 statistics she cited include:

- In 2005, nearly eighteen hundred colleges and universities were offering at least one course in entrepreneurship.
- Course offerings and programs in entrepreneurship range from a single course to baccalaureates, master's degrees, and doctoral degrees.
- Two hundred and seven four-year institutions now require at least one course in entrepreneurship as a requirement for the degree.
- One hundred and eighty-six four-year institutions offer courses in entrepreneurship designed for students not enrolled in business schools.

In an updated article she wrote in 2007 [Cone 07], she added the following data:

- Currently, of the two- and four-year accredited not-for-profit colleges and universities in the United States, more than 80 percent teach entrepreneurship.
- Approximately 90 percent of the United States' 888 accredited master's and doctoral degree-granting institutions now offer entrepreneurship courses, and in most cases, multiple courses and degree options.
- Of the 1,191 accredited two-year colleges, 78 percent offer one or more entrepreneurship courses for credit.
- Over 700 four-year colleges and universities now have entrepreneurship centers to help students, faculty, and community members actually launch new ventures.

Thus, there is no doubt that entrepreneurial training has become an important educational challenge.

EXERCISES

CHAPTER 2 WHO IS AN ENTREPRENEUR?

1. Create a spread sheet with seventeen rows (one for each of the seventeen characteristics of an entrepreneur) and ten columns, labeled 1-10. Employing a scale of 1-10, grade yourself on how well you believe you fulfill each of the characteristics.

2. After completing exercise 1 above, take each of the characteristics one at a time and analyze what you would need to do in order to improve your grade in each of them.

3. Much has been written about leadership and the characteristics of a leader. Identify the principal characteristics of a leader.

4. After completing exercise 3 above, select a well-known non business leader, for example a politician or a labor leader, and analyze/discuss how successful that person would be as an entrepreneur. Explain the logic of your conclusions.

5. Define what the concept of risk means to you. Consider the consequences of success as well as those of failure.

6. Immigrants have founded or co-founded a substantial percentage of the most innovative companies in the United States (e.g., Intel, Sun Microsystems, Yahoo, eBay, Google, CA, Vizio, Oceania Cruises). Identify some of the characteristics of immigrants that have led to so many immigrant success stories.

CHAPTER 3 ASSEMBLING A WINNING TEAM

1. Create a spread sheet with five rows (one for each of the five

characteristics of a team member) and ten columns, labeled 1-10. Select an individual you know that you would like to have on your entrepreneurial team. Employing a scale of 1-10, grade this individual on how well you believe he/she would fulfill each of the characteristics.

2. Arrange with a friend (who also wishes to be an entrepreneur) to run exercise 1 above with you as the potential team member. You in turn run exercise 1 with him/her as a potential team member. Discuss the results with your friend.

3. List what you would do to determine if a person is ethical and honest.

CHAPTER 4 THE VISION

1. List market segments in which you believe you have expertise to create products.

2. List market segments for which you would enjoy making products.

3. Select a market segment from those you would enjoy and list what you would do to determine what products it needs and what products it wants.

4. A famous sonnet titled "Opportunity" by the United States Senator John James Ingalls (1883-1900) [Pren 99] contains the following words:

> Opportunity
> Master of human destinies am I;
> Fame, love and fortune on my footsteps wait.
> Cities and fields I walk. I penetrate
> Deserts and seas remote, and, passing by

Hovel and mart and palace, soon or late,
I knock unbidden once at every gate.
If sleeping, wake; if fasting, rise, before
I turn away. It is the hour of fate,
And they who follow me reach every state
Mortals desire, and conquer every foe
Save death; but those who hesitate
Condemned to failure, penury and woe,
Seek me in vain, and uselessly implore.
I answer not, and I return no more.

This beautiful sonnet makes the point that opportunity only comes once. As I stated at the beginning of Chapter 4, I believe that opportunities are in front of you all the time. Review you own experiences to date and make your own conclusion on this issue.

Chapter 5 Tools to Focus on the Vision

1. Utilizing the variables vs. constants approach (as Nathan Zepell did with his pens) select an everyday item (e.g., a fork) and create and evaluate different designs.

2. Select a process you believe you know well and represent it with a life cycle diagram. Take the diagram to a level of detail that makes you feel comfortable you have an overall understanding of the process.

3. Utilizing the life cycle diagrams you generated for exercise 2 above, identify the binding times for several decisions and evaluate the implications of changing the binding time for each one of those decisions.

4. Referring to the process that you selected in exercise 2 above, identify the various pieces of data manipulated by that process. Draw diagrams of the format of the data as it goes through the different stages of the process.

5. Referring to exercise 4 above, evaluate the possibility of representing some of the pieces of data in a different format. If you can, evaluate how the process would need to change to create the data in this new format. Do the changes in the process simplify or complicate the solution you are trying to represent?

6. In 1990, Schindler, the world's second largest elevator manufacturer after Otis, installed the first 'destination elevator' based on a design of one of its engineers [Angw 06]. In a destination elevator there are no buttons inside the elevator. Elevator riders enter their floor number on a keyboard before entering the elevator. A display then directs them to a particular elevator that will stop at their floor. The elevator system automated software groups riders by floor, limiting the number of stops each elevator needs to make. Schindler reports that its destination elevators reduce the time of an average journey by 30%.Returning to the elevator problem we discussed, analyze where in the solution process we could have come up with the idea of destination elevators.

CHAPTER 6 SELLING

1. You are ready to hire a number of people. For each of the positions listed below, outline the qualifications you will be looking for when interviewing candidates.
 a. Marketing manager
 b. Sales manager
 c. Affiliates program manager
 d. Marketing communications manager
 e. Telesales person to work through the telephone
 f. Telesales person to work through emails
 g. Salesperson to do face-to-face sales

2. Discuss the pros and cons of setting the sales quotas for salespeople:
 a. At the level you believe they should attain
 b. Above the level you believe they should attain
 c. Below the level you believe they should attain

3. Define a bonus plan to motivate your salespeople to achieve their goals. Explain your logic.

4. Select an existing company and get a copy of their corporate brochure. Critique the brochure.

5. Select an existing company (preferably the same one you selected in exercise 4 above) and get the marketing literature for their leading product(s). Critique their product literature.

6. Do a competitive analysis of the company and product(s) you selected in exercises 4 and 5 above.

7. Discuss what sales channel (e.g., face-to-face, telephone, emails, web-based distributors) you would use to sell the product(s) selected in exercise 5 above. Compare your choice to the sales channels that are actually being used to sell the product(s). Explain your logic.

8. Marketing experts tell you to differentiate between a product's benefits and features and that you sell benefits not features. Discuss the logic behind this recommendation.

9. Discuss the pros and cons of going to market with a product that is a pioneer.

10. Most companies have a 'mission statement'. Collect and analyze the mission statement of a number of different companies. Discuss how you would write the mission statement for a new company.

CHAPTER 7 FUNDING

1. Carry out the following exercise suggested by Harasty [Hara 08] to illustrate the differences between debt and equity funding. Suppose you are the sole owner of a business, and on January 1 you need $100,000 to stay in business. You can borrow the money or you can exchange equity for the money. Now, consider two different situations come December 31 of that year: a. You had a great year and you have $1 million in profits in the bank. b. You had a bad year and you have $50,000 in the bank. Discuss how you and the lender or the investor comes out financially on December 31 under each of the above two scenarios depending on whether you borrowed or sold equity.

2. Visit a local bank. Meet with a loan officer and find out what is required to secure a loan from the bank.

3. Assume you are a bank loan officer. List the criteria you would employ to determine whether or not to provide a loan to a given company.

4. Assume you are a venture capitalist. List the criteria you would employ to determine whether or not to invest in a given company.

5. Assume you are an angel investor. List the criteria you would employ to determine whether or not to invest in a given company.

6. Notice that if you meet with a loan officer at your local bank you typically have to be seated in an open area where everyone that comes into the bank sees you. Discuss the pros and cons of such an arrangement.

7. After the financial crisis of September 2008 and the disappearance of the large independent investment banking firms, it has been speculated that private equity companies and hedge funds may become the new financial innovators and move into the investment banking area. Understand what a private equity company is and what a hedge fund is, and then consider what the potential implications of these changes for an entrepreneur searching for funding are.

CHAPTER 8 THE LEGAL FRAMEWORK

1. What is the difference between single taxation and double taxation?

2. When would you use an LP vs. an LLC?

3. When would you use an S corporation vs. an LLC?

4. When would you use an S corporation vs. a C corporation?

5. When would you use a C corporation vs. an LLC?

6. Compare a sole proprietorship to a single-member LLC.

7. Describe under what conditions it would make sense to start as an S corporation and subsequently convert to a C corporation. Explain at what point in the progress of your start-up you would make the conversion.

8. Think of a legal need you might have as an entrepreneur.

9. Write it as a contained request you would present to a lawyer.

10. List the criteria that define a win/win agreement.

CHAPTER 9 ACCOUNTING

1. Compare the tax rates in the United States on ordinary income, corporate income, capital gains, and dividends for the last thirty years. Can you draw any conclusions concerning the correlation between these tax rates and the corresponding state of the economy in the United States?

2. Currently the maximum federal tax rates for corporate and ordinary income are at 35%.
 a. Suppose the corporate tax rate was made higher than the ordinary income tax rate. List some consequences of this change.
 b. Suppose the change was the other way around, that is, the corporate tax rate was made lower than the ordinary income tax rate. List some consequences of this change.

3. Currently the maximum federal tax rate for capital gains is 15%, and the maximum federal tax rate for ordinary income is 35%.
 a. Suppose the rate for capital gains was raised to 35%. List some consequences of this change.
 b. Suppose the rate for capital gains was raised to 40%. List some consequences of this change.

4. Currently the maximum federal tax rate for dividends is 15%, and the maximum federal tax rate for ordinary income is 35%.
 a. Suppose the rate for dividends was raised to 35%. List some consequences of this change.
 b. Suppose the rate for dividends was raised to 40%. List some consequences of this change.

5. Compare the current capital gains rate in other industrialized countries (e.g., France, England, Japan, Sweden, Australia,

Korea, Ireland) with that of the United States. What are the implications for the United States?

6. Compare the current corporate tax rate in other industrialized countries with that of the United States. What are the implications for the United States? Motivational hint: As of 2008 [Wsj3 08], the United States has the second highest corporate tax rate in the world at 39.3% (average combined federal and state). Find out which country has the highest corporate tax rate and discuss their financial situation.

7. Describe a situation where you would employ cash basis accounting and explain why. Hint: consider a physician's practice.

8. Compare the definitions of stockholders' equity and working capital. Can you draw any interesting conclusions?

9. Write down the equations defining current ratio and working capital. Employing some straightforward algebraic substitutions, create the following new equation:
Working capital = (total current liabilities) (current ratio − 1)
If you set the current ratio to 2, then the working capital is the same as the total current liabilities.
If you set the current ratio to 1, then the working capital is zero. Discuss the implications on working capital when the current ratio is 2 and 1 respectively.

10. Think of an accounting need you may have as an entrepreneur. Write it as a contained request you would present to an outside accounting firm you would hire to satisfy this need.

11. Contact someone in an accounting firm and ask him/her to explain the differences between an audit and a review. List the differences.

12. Obtain the balance sheet, the income statement, and the cash flow statement of a public company and analyze them.

13. Research cases in which corporate financial statements were manipulated to perpetrate fraud and analyze how it was done.

CHAPTER 10 THE BUSINESS PLAN

1. Suppose you create your business plan by doing your financials last. What would you do if you were not able to obtain the funding your plan requires?

2. Outline the kind of company and products you could create. List which tasks you could do, which tasks you would enjoy doing, and which tasks you could not do at all.

CHAPTER 11 RUNNING YOUR COMPANY

1. Prepare a statement outlining the ethical and philosophical standards you would want your company to follow.

2. Consider whether or not you would have company-wide meetings in your company and what you would discuss in such meetings. Analyze the rationale for every topic you would discuss as well as for those topics you would avoid. How often would you hold such meetings?

3. If during a company-wide meeting one of your employees asks a question on an issue you do not wish to discuss, how would you handle the situation?

4. How often would you hold management team meetings in your company? Analyze the rationale for every topic you would discuss as well as for those topics you would avoid.

5. How would you handle a member of your management team who is stepping out-of-bounds with his/her behavior during management team meetings?

CHAPTER 12 EXITING YOUR COMPANY

1. Define the exit criteria you would employ if you were creating a business plan.

2. Assume that you are ready to sell your company. List the criteria that would define the acquirer you would seek.

3. Do the necessary research and define the typical IPO process.

4. An article that appeared in Newsweek [Sloa 07] discusses a very astute interplay between selling assets, selling stocks and taxes paid in a $3.9 billion transaction where Great-West Lifeco of Canada bought Putnam Investments from Marsh & McLennan of New York. Read this article and analyze the essence of this transaction.

CHAPTER 13 SUCCEEDING IN DIFFICULT ECONOMIC TIMES

1. Financial crises open up business opportunities that did not exist before. Identify and list three such business opportunities.

2. Contact a credit union and find out what is involved in obtaining a business loan from them.

REFERENCES

In citing works in the text, the following abbreviations have been used:

And1 06 Anderson, C. 2006. *The Long Tail.* New York: Hyperion.

And2 06 Anders, G. 2006. When Filling Top Jobs Inside Makes Sense—And When It Doesn't. *Wall Street Journal.* January 16.

Angw 06 Angwin, J. 2006. To Uneasy Riders, Buttonless Elevators Have Ups and Downs. *Wall Street Journal.* November 14.

Band 94 Bandura, A. 1994. Self-Efficacy. In V. S. Ramachaudran (Ed.), *Encyclopedia of human behavior (*Vol. 4, pp. 71-81). New York: Academic Press. (Reprinted in H. Friedman [Ed.], *Encyclopedia of mental health.* San Diego: Academic Press, 1998).

Beck 08 Beck, M. 2008. If at First You Don't Succeed, You're in Excellent Company. *Wall Street Journal.* April 29.

Bell 08 Bellis, M. 2008. Filing For a Provisional Patent. http://inventors.about.com/od/provisionalpatent/a/provisional_app.htm.

Bers 94 Bersoff, E. 1993. Anatomy of a Software Start-Up. Presentation at the Univ. of Colorado, Colorado Springs. November.

Brav 08 Bravin, J. and J. Scheck. 2008. Justices Get Another Shot At Patent Law. *Wall Street Journal.* January 16.

Brow 06 Brown, E., D. Whelan, and P. Huang. 2006. The Touch. *Forbes.* February 13.

Buch 07 Buchheit, P. 2007. Equity math for startups. http://paulbuchheit.blogspot.com/2007/03/equity-math-for-startups.html.

Buck 05 Buckman, R. 2005. Many Internet Start-Ups are Telling Venture Capitalists: "We Don't Need You." *Wall Street Journal.* October 31.

Buck 06 Buckman, R. 2006. Tougher Venture: IPO Obstacles Hinder Start-Ups. *Wall Street Journal.* January 25.

Buck 07 Buckman, R. 2007. Venture Capital Goes Big. *Wall Street Journal.* October 5.

Card 72 Cardenas, A., L. Presser, and M.A. Marin, eds. 1972. *Computer Science.* New York: John Wiley and Sons.

Carm 06 Carmichael, A. 2006. In Search of an Angel. *Wall Street Journal.* January 30.

Cham 06 Chamy, B. 2006. Judge consolidates two class suits against Google. http://www.marketwatch.com/News/Story/Story.aspx?guid= %7B358BF0B3-3BCD-4DC9.

Char 08 Chartier, D. 2008. Scrabble owners spell L-A-W-S-U-I-T for Facebook knockoff. http://arstechnica.com/news.ars/post/20080725-scrabble-owners-spell-l-a-w-s-u-i-t-for-facebook-knockoff.

Chen 07 Chen, R. 2007. Vonage is Dealt a Setback with Second Big Legal Defeat. *Wall Street Journal.* September 26.

Clar 01 Clark, B. 2001. Doing It the All-Cash Way. Ewing Marion Kauffman Foundation. http://www.eventuring.org/eShip/appmanager/eVenturing/eVenturingDesktop?_nfpb=true&_pageLabel=eShiparticleDetail&_nfls=false&id=Entrepreneurship/Resource/Resource_297.htm&_fromSearch=false&_nfls=false.

Cone 05 Cone, J. 2005. Teaching Entrepreneurship in Colleges and Universities: How (and Why) a New Academic Field is Being Built. *Kauffman Thoughtbook.* Kansas City, MO: Ewing Marion Kauffman Foundation.

Cone 07 Cone, J. 2007. Entrepreneurship on Campus: Why the Real Mission is Culture Change. *Kauffman Thoughtbook.* Kansas City, MO: Ewing Marion Kauffman Foundation.

Cord 08 Cordeiro, A. 2008. Small Firms Get Local Loans. *Wall Street Journal.* November 11.

Cove 08 Covel, S. 2008. Slump Batters Small Business, Threatening Owners' Dreams. *Wall Street Journal.* December 26.

Cove 09 Covel, S. 2009. Keeping Borrowers Afloat. *Wall Street Journal.* February 23.

Cox 08 Cox, C. 2008. International Financial Reporting Standards: The Promise of Transparency and Comparability for the Benefit of Investors Around

the Globe. Address to the Annual Conference of the International Organization of Securities Commissions, Paris, France. May 28. http://www.sec.gov/news/speech/2008/spch052808cc .htm.

Cowa 09 Cowan, L. 2009. As IPOs Dry Up, So, Too, Do Fees. *Wall Street Journal.* January 5.

Cro1 08 Crovitz, G. L. 2008. Patent Gridlock Suppresses Innovation. *Wall Street Journal.* July 14.

Cro2 08 Crovitz, G. L. 2008. Closing the Information GAAP. *Wall Stree Journal.* September 8.

Cro1 09 Crovitz, G. L. 2009. Wikipedia's Old-Fashioned Revolution. *Wall Street Journal.* April 6.

Cro2 09 Crovitz, G. L. 2009. Why Technologists Want Fewer Patents. *Wall Street Journal.* June 15.

Cuti 05 Cutillas, M. 2005. The Bacardi Story. Presented as part of the series: *Making Money in America—The Cuban-American Story.* Miami: Institute for Cuban and Cuban-American Studies, Univ. of Miami. September 7.

Dale 08 Dale, A., and Covel, S. 2008. Sellers Offer a Financial Hand to Their Buyers. Small Business Link. November 13. http://online.wsj.com/article/SB12265441807642350 7.html?mod=djemSB.

Davi 07 Davis, A. C. 2007. Google bankrolls plenty of projects for Golden State. *Santa Barbara News-Press.* January 7.

Dela 07 Delaney, K. J. 2007. Web-Address Theft Is Everyday Event. *Wall Street Journal.* September 25.

Down 87 Downes, J., and J. E. Goodman. 1987. *Dictionary of Finance and Investment Terms.* Woodbury, NY: Barron's Educational Series.

Drom 90 Droms, W. G. 1990. *Finance and Accounting for Nonfinancial Managers.* Reading, Massachusetts: Addison-Wesley.

Eckb 09 Eckblad, M. 2009. Problems Spring Up in Small-Business Loans. *Wall Street Journal.* February 3.

Eeta 07 EE Times Asia. 2007. Acer countersues HP for patent infringement. July 24. http://www.eetasia.com/ARTP_8800473154_499495.HTM.

Enga 07 Engardio, P. 2007. Flat Panels, Thin Margins. *BusinessWeek.* New York: McGraw-Hill. February 26.

Enri 06 Enrich, D. 2006. Lessons from a Lender. *Wall Street Journal.* May 8.

Fam 07 Fam, M. 2007. Verizon, Vonage Rumble Over Patents. *Wall Street Journal.* February 22.

Farz 05 Farzad, R. 2005. Filthy Rich, But Froogle. *BusinessWeek.* New York: McGraw-Hill. December 5.

Fenw 93 Fenwick & West LLP. 1993. Copyright Protection. Palo Alto, CA.

Fenw 04 Fenwick & West LLP. 2004. Trademark Selection and Protection for High Technology Companies. http://www.fenwick.com/publications/.

Fenw 05 Fenwick & West LLP. 2005. Patent Protection for High Technology and Life Science Companies. http://www.fenwick.com/publications/.

Gate 06 Gates, B., and P. Otellini. 2006. End of the PC Era? Hardly! *Wall Street Journal.* May 15.

Gian 05 Gianforte, G., and M. Gibson. 2005. *Bootstrapping your Business.* Avon, MA: Adams Media.

Glad 88 Gladstone, D. 1988. *Venture Capital Handbook.* Englewood Cliffs, NJ: Prentice Hall.

Goli 03 California CPA. 2003. What's your type—of business entity? (Tax Implications). http://goliath.ecnext.com/coms2/gi_0199-3194238/What-s-your-type-of.html.

Gord 08 Gordon, J. S. 2008. A Short Banking History of the United States. *Wall Street Journal.* October 10.

Guth 08 Guth, R. A. 2008. Ruling Bolsters Open-Source Software. *Wall Street Journal.* August 14.

Hara 08 Harasty, Z. A. 2008. An Overview of Entrepreneurs and Capital Formation. SCORE. September. www.score-santabarbara.org.

Hata 08 Hatamoto, M. 2008. Scrabulous returns to Facebook as 'Wordscraper' with circular board. *BetaNews.* July.

Haye 08 Hayes, T. and M. S. Malone. 2008. Marketing in the World of the Web. *Wall Street Journal.* November 29.

Hein 06 Heinzl, M., and A. Sharma. 2006. RIM to Pay NTP $612.5 Million To Settle BlackBerry Patent Suit. *Wall Street Journal.* March 4.

Hold 90 Holden, J. 1990. *Power Based Selling.* New York: John Wiley and Sons.

Ipwa 08 IPWatchdog.com. Google Pays $125 Million Copyright Settlement. http://www.ipwatchdog.com/2008/11/08/google-pays-125-million-copyright-settlement.

Jask 08 Jasliewicz, S. P. 2008. Determining Your Company's Legal Structure. http://www.regions.com/small_business/planning_guides.rf.

Jone 09 Jones, T. F. 2009. The family that bakes together. *The Costco Connection.* February.

Juds 04 Judson, B. 2004. *Go It Alone!* Harper Collins. http://www.brucejudson.com.

Kauf 06 Ewing Marion Kauffman Foundation. 2006. *Kauffman Index of Entrepreneurial Activity.* http://www.kauffman.org/resources.cfm?topic=economicdevelopment&itemID=665.

Kau1 08 Ewing Marion Kauffman Foundation. 2008. *Kauffman Index of Entrepreneurial Activity, 1996-2007.*

http://www.kauffman.org/research-and-
policy/kauffman-index-of-entrepreneurial-activity-
2007.aspx.

Kau2 08 Ewing Marion Kauffman Foundation. 2008.
*Americans Believe Entrepreneurs Will Revive
Economy.*
http://www.Kauffman.org/newsroom/americans-
believe-entrepreneurs-will-revive-economy.aspx.

Kawa 06 Kawamoto, D. 2006. VoiceSignal Technologies on
Thursday announced that it has filed a patent
infringement case against Nuance Communications
over the popular Dragon NaturallySpeaking voice
recognition software.
http://news.zdnet.com/2100-3513_22-6134016.html.

Kedr 08 Kedrosky, P. S. 2008. Entrepreneurs and Recessions:
Do Downturns Matter? Ewing Marion Kauffman
Foundation.
http://www.kauffman.org/uploadFiles/entrepreneurs_
and_recessions_121508.pdf.

Kim 09 Kim, J.J. 2009. Credit Woes Hit Home. *Wall Street
Journal.* April 4.

Know 08 KnowThis.com. 2008. KnowThis Tutorial: Marketing
Method Patents.
http://www.knowthis.com/tutorials/marketing/market
ing-method-patents/14.htm.

Lawt 07 Lawton, C. 2007. H-P Sues Acer Over Patents
Related to PCs. *Wall Street Journal.* March 28.

Leso 04 Lesonsky, R., ed. 2004. *Start Your Own Business,*
Entrepreneur Media.

Levy 07 Levy, C. 2007. Professor Risk. *Wall Street Journal.* October 20.

Lich 07 Lichtenhaler, U. and E. Holger. 2007. Think Strategically About Technology Licensing. *Wall Street Journal.* December 1-2.

Lowe 07 Lowenschuss, O. 2007. Personal communication. October 20.

Lubl 09 Lublin, J. S. 2009. Smart Balance Keeps Tight Focus on Creativity. *Wall Street Journal.* June 8.

Lun1 08 Lunsford, J. L. 2008. Outsourcing at Crux of Boeing Strike. *Wall Street Journal.* September 8.

Lun2 08 Lunsford, J. L. 2008. Boeing Begins Gearing Up Following Strike. *Wall Street Journal.* November 3.

Mal1 08 Malone, M. S. 2008. The Next American Frontier. *Wall Street Journal.* May 19.

Mal2 08 Malone, M. S. 2008. Washington Is Killing Silicon Valley. *Wall Street Journal.* December 22.

McDo 08 McDougall, P. 2008. Open Source Copyrights Legally Enforceable, Appeal Court Rules. *InformationWeek.* http://www.informationweek.com/news/software/opensource/ *showArticle*.jhtml?articleID=210004154.

Mill 85 Miller, R. B. and S.E. Heiman.1985. *Strategic Selling.* New York: Warner Books.

Minc 09 Mincer, J. 2009. Small Businesses Find a New Source for Funding. *Wall Street Journal.* March 3.

Moor 91 Moore, G. A. 1991. *Crossing the Chasm.* New York: Harper Business.

Nels 06 Nelson, F. 2006. Deckers Settles Trademark Lawsuit. *Santa Barbara News-Press.* April 22.

Ocea 07 Oceania Cruises. 2007. Apollo Management L.P. Makes Strategic Investment in Oceania Cruises. February 26.
http://www.oceaniacruises.com/T_MainContentPage.aspx?PageUID=489f3ca6-532c-459e-8973-9a65aee32b85.

Oce1 08 Oceania Cruises. 2008.
http://en.wikipedia.org/wiki/Oceania_Cruises.

Oce2 08 Oceania Cruises. 2008.
http://www.oceaniacruises.com/T_MainContentPage.aspx?PageUID=489f3ca6-532c-459e-8973-9a65aee32b85.

O'Re 05 O'Reilly, Tim. 2005. What is Web 2.0.
http://www.oreilly.com/pub/a/oreilly/tim/news/2005/09/30/what-is-web-20.html.

Oroz 08 Orozco, D. and J. Conley. 2008. Shape of things to Come. *Wall Street Journal.* May 12.

Oswa 05 Oswald, E. 2005. Calif. Company Hits Yahoo with IP Suit.
http://www.betanews.com/article/Calif_Company_Hits_Yahoo_with_IP_Suit/1128112854.

Pari 08 Parise, S, Guinan, P. J., and Weinberg, B. D. 2008. The Secrets of Marketing In a Web 2.0 World. *Wall Street Journal.* December 15.

Poly 45 Polya, G. 1945. *How to Solve It.* Princeton, NJ: Princeton University Press.

Pren 99 Prentis, N. L. 1899. *History of Kansas.* Winfield: E. P. Green.

Pres 72 Presser, L., and J.R. White. 1972. Linkers and Loaders. *ACM Computing Surveys* (September*).* 4:149-167.

Pric 08 PricewaterhouseCoopers. 2008. Thinking about IFRS now is a good idea. http://www.pwc.com/extweb/pwcpublications.nsf/do cid/79BCA6195F364A9E852574BA00476313.

Reil 06 Reilly, D. 2006. SEC Obtains Record Penalties From KPMG Auditors of Xerox. *Wall Street Journal.* February 22.

Reil 08 Reilly, D. and N. Koppel. 2008. Cendant Case Costs Ernst Almost $300 Million More. *Wall Street Journal.* February 16.

Reut 04 Reuters. 2004. ScanSoft files patent suit against Voice Signal. http://www.forbes.com/technology/newswire 2004/02/23/rtr1271502.html.

Ries 86 Ries, A. and J. Trout. 1986. *Marketing Warfare.* New York: McGraw-Hill.

Ries 89 Ries, A. and J. Trout.1989. *Bottom-Up Marketing.* New York: McGraw-Hill.

SBA 08 SBA Office of Advocacy. 2008. Frequently Asked Questions.
http://www.sba.gov/advo/stats/sbfaq.pdf.

Schr 08 Schreiner, B. 2008. Col. Sanders' KFC recipe closely guarded secret. *Santa Barbara News-Press.* September 10.

Seid 89 Seidman, L. W., and S.L. Skancke. 1989. *Productivity: The American Advantage.* New York: Simon and Schuster.

Sha1 07 Sharma, A., and M. Fam. 2007. Vonage Loses Verizon Patent Case. *Wall Street Journal.* March 9.

Sha2 07 Sharma, A. and C. Boles. 2007. A Blow in Court Adds to Threats Facing Vonage. *Wall Street Journal.* April 7.

Sha3 07 Sharma, A. 2007. Vonage Settles Verizon Patent Lawsuit. *Wall Street Journal.* October 26.

Shuk 08 Shukla, S. 2008. Acer and Hewlett-Packard settle patent litigation.
http://www.topnews.in/law/acer-and-hewlett-packard-settle-patent-litigation.

Shwi 08 Shwiff, K. and M. Maremont. 2008. Xerox, KPMG Settle Shareholder Suit. *Wall Street Journal.* March 28.

Silv 08 Silver, S. 2008. RIM Updates the Blackberry. *Wall Street Journal.* May 12.

Sing 06 Singer, P. 2006. Capital Ideas. *Wall Street Journal.* May 8.

Sloa 07 Sloan, A. 2007. Death is Inevitable. Taxes? Maybe Not. *Newsweek.* February 19.

Soft 89 *Software Magazine.*1989. Who's Who in Software. March.

Sohl 09 Sohl, J. 2009. The Angel Investor Market in 2008: A Down Year in Investment Dollars but not in Deals. Center for Venture Research, University of New Hampshire. www.unh.edu/cvr.

Spee 06 Speech Technology. 2006. On Familiar Ground: Yahoo and Nuance Settle Suit. http://www.speechtechmag.com/ Articles/ReadArticle.aspx?ArticleID=26365.

Spen 06 Spencer, J., and K. Scannell. 2006. Gemstar Ex-CEO Is Ordered to Pay $22.3 Million. *Wall Street Journal.* May 9.

Spor 06 Spor, K. K. 2006. Trade You a Laptop? Online Sites Promote The Art of the Barter. *Wall Street Journal.* November 14.

Spo1 08 Spor, K. 2008. Small Talk. *Wall Street Journal.* January 29.

Spo2 08 Spors, K., Flandez, R., and Dvorak P. 2008. SBA-Backed Loans Dry Up at Crucial Time for Businesses. *Wall Street Journal.* November 4.

Stan 09 Stangler, D. 2009. The Economic Future Just Happened. Ewing Marion Kauffman Foundation. June 2.

Stec 07 Stecklow, S. 2007. Despite Woes, McClatchy Banks on Newspapers. *Wall Street Journal.* December 26.

Stei 07 Steiger, P. E. 2007. Read All About It. *Wall Street Journal.* December 29.

Stei 08 Steinberg, E. A. 2008. New Accounting Standard Offers Benefits, Problems. *Wall Street Journal.* September 10.

Sven 07 Svensson, P. 2007. Vonage settles patent suit with Sprint. *The Associated Press.* http://news.yahoo.com/s/ap/20071008/ap_on_hi_te/s print_nextel_vonage.

Tam 06 Tam, Pui-Wing. 2006. Fresh Crop of Investors Grows in Silicon Valley. *Wall Street Journal.* May 1.

Tam 07 Tam, Pui-Wing. 2007. The Struggle to Cash Out. *Wall Street Journal.* January 31.

Tam1 07 Tam, J. 2007. Hands-On Mobile. Personal communication, October 4.

Tam1 08 Tam, Pui-Wing. 2008. No Exit: Venture-Tied IPOs, Mergers Dry Up. *Wall Street Journal.* October 1.

Tam2 08 Tam, Pui-Wing. 2008. As Cash Stops Flowing Venture Capitalists Get Creative. *Wall Street Journal.* November 28.

Tam3 08 Tam, Pui-Wang, Worthen, B, and Guth, R. A. 2008. Silicon Valley Finds It Isn't Immune From Credit Crisis. *Wall Street Journal.* October 10.

Temp 04 Templeton, B. 2004. 10 Big Myths about copyright explained.
http://www.templetons.com/brad/copymyths.html.

Timi 07 Timiraos, N. 2007. Businesses Battle Over Patent Law. *Wall Street Journal.* June 9.

Timi 08 Timiraos, N., and Simon, R. 2008. Self-employed Are Frozen Out Of Mortgages. *Wall Street Journal.* December 2.

Trac 94 Tracy, J. A. 1994. *How to Read a Financial* Report. New York: John Wiley and Sons.

Trac 09 Trachtenberg, J. A. , and Silver, A. 2009. E-Book Market Heats Up. *Wall Street Journal.* March 25.

Turn 04 Turner, L. M. 2004. *The Unofficial Guide to Starting a Small Business.* Hoboken, NJ: Wiley Publishing.

UCLA 01 The Digital Millennium Copyright Act. 2001. The UCLA Online Institute for Cyberspace Law and Policy. http://www.gseis.ucla.edu/iclp/dmca1.htm.

Valu 08 Value Investing Congress. 2008. An Overview of the Housing/Credit Crisis, Why There is More Pain to Come, and Three Investments Ideas. October 8. www.valueinvestingcongress.com.

Vara 07 Vara, V. 2007. Divine Intervention? Indians Seek Help From the 'Visa God'. *Wall Street Journal.* December 31.

Varg 08 Vargas Llosa, A. 2008. The Family Spirit. Book review. *Wall Street Journal.* September 12.

Vent 07 Venture Capital Investing Hits $25.5 Billion in 2006. The Money Tree™ Report by PricewaterhouseCoopers and the National Venture Capital Association based on data from Thomson Financial. January.

Vent 08 Q4 2007/Full-Year 2007. The Money Tree™ Report by PricewaterhouseCoopers and the National Venture Capital Association based on data from Thomson Financial.

Vent 09 Venture Investment in Clean Technology Accelerates Significantly in 2008, Despite Economic Uncertainty. The Money Tree™ Report by PricewaterhouseCoopers and the National Venture Capital Association based on data from Thomson Financial. January.

Voic 07 VoiceSignal Technologies. 2007. Trade Secret Misappropriation Case Against VoiceSignal Dismissed. http://www.voicesignal.com/news/press/release_2007_08_22.

Wall 08 *Wall Street Journal.* 2008. How to Trademark a Company Name. http://guides.wsj.com/small-business/starting-a-business/how-to- trademark-a-company-name.

Wang 07 Wang, W. 2007. How I Did It. Inc. com. http://www.inc.com/magazine/20070601/hidi-wang.html.

What 06 Digital Millennium Copyright Act. 2006. http://whatis.techtarget.com/definition/0,,sid9_gci904632,00.html.

Wiki 07 U.S. Prime Rate. 2007. Wikipedia, the free encyclopedia.
http://en.wikipedia.org/wiki/U.S._Prime_Rate.

Wik1 08 Federal Reserve System. 2008. Wikipedia, the free encyclopedia.
http://en.wikipedia.org/wiki/Federal_Reserve.

Wik2 08 Federal funds rate. 2008. Wikipedia, the free encyclopedia.
http://en.wikipedia.org/wiki/Federal_funds_rate.

Wik3 08 Libor versus Prime rate. 2008. Wikipedia, the free encyclopedia.
http://www.wikicfo.com.

Wik4 08 Digital Millennium Copyright Act. 2008. Wikipedia, the free encyclopedia.
http://en.wikipedia.org/wiki/Digital_Millennium_Copyright_Act.

Wilm 06 Wilmott, H. 2006. How To Start A Business in Santa Barbara County. SCORE. April.
www.scoresantabarbara.org

Wool 09 Wooldridge, A. 2009. Special Report on Entrepreneurship. *The Economist.* March 14.

Wrig 06 Wright, L. 2006. 2005 Angel Market Exhibits Modest Growth. Whittemore School of Business and Economics, Univ. of New Hampshire.
http://www.wsbe.unh.edu/Centers_CVR/2005pressrelease.cfm.

Wrig 07 Wright, L. 2007. Angel Market Grows 10 Percent in 2006. Whittemore School of Business and Economics, Univ. of New Hampshire. http://www.wsbe.unh.edu/Centers_CVR/2006pressrelease.cfm.

Wrig 08 Wright, L. 2008. Angel Investors Becoming More Cautious in Uncertain Economy. Whittemore School of Business and Economics, Univ. of New Hampshire. http://www.unh.edu/news/docs/2007AngelMarketAnalysis.pdf.

Wsj1 07 Acer Files Patent Action Against Hewlett-Packard. 2007. *Wall Street Journal.* November 1.

Wsj2 07 Closing the GAAP. 2007. *Wall Street Journal.* December 12.

Wsj3 08 America the Uncompetitive. 2008. *Wall Street Journal.* August 15.

Yaho 07 Yahoo Inc. 2007. Vonage targeted by AT & T patent suit. http://news.yahoo.com/s/ap/20071019/ap_on_hi_te/vonage_holdings_suit.

INDEX